The
Dramatic
Portrait

THE ART OF CRAFTING LIGHT AND SHADOW

Chris Knight

rockynook

THE DRAMATIC PORTRAIT
The Art of Crafting Light and Shadow

Chris Knight
www.chrisknightphoto.com

Project editor: Ted Waitt
Project manager: Lisa Brazieal
Marketing coordinator: Mercedes Murray
Copyeditor: Susan Rimerman
Interior design, layout, and type: WolfsonDesign
Front cover design: Charlene Charles-Will
Cover production: Mike Tanamachi
Lighting diagrams created with Sylights software

ISBN: 978-1-68198-214-4
1st Edition (3rd printing, April 2018)
© 2017 Chris Knight

Rocky Nook Inc.
1010 B Street, Suite 350
San Rafael, CA 94901
USA

www.rockynook.com

Distributed in the U.S. by Ingram Publisher Services
Distributed in the UK and Europe by Publishers Group UK

Library of Congress Control Number: 2016944456

This book is printed on acid-free paper.
Printed in Canada

ACKNOWLEDGMENTS

First and foremost, thank you Mom and Dad for your support, pragmatism, and fostering my creativity from a young age. Thank you to Ted and Susan for making sense of my verbosity and dealing with a need for validation through an overuse of commas. Justin, Connelly, Rick, and Navid, your input and contributions were invaluable and I'm grateful. Thank you to everyone who contributed to this book in some way, either as subjects or an ear when I needed it. Last but not least, thank you Lindsay for being the engine behind this book; it would not exist without you. You continually impress me, and I couldn't ask for a better partner, cheerleader, and confidant. Thank you for being on this journey with me.

ABOUT THE AUTHOR

Chris Knight was born in Wiesbaden, Germany, and hardened by the sweaty, nearly chewable humidity of Florida. He combines his unconditional love of art history with his conditional love of technology, topping it off with a flare for the cinematic and an uncompromising eye for detail.

His work has appeared in or on *Vogue, People,* MSNBC, ABC, Ocean Drive, *GQ,* and elsewhere.

Chris is an instructor at Pratt Institute as well as the New York Film Academy.

CONTENTS

CHAPTER ONE A HISTORY OF PORTRAITURE 1

More Fun Than It Sounds

The Evolution of Style . 4

The Evolution of Art and Portraiture . 5

Ancient Egypt (3100 BCE–332 BCE) 5
Greek Style (800 BCE–600 CE) 6
Onward to Rome (753 BCE–476 CE) 7
Medieval Times (476–1500) 9
Early Netherlandish (1420–1550) 10
The Italian Renaissance (1341–1600) 11
The Rebirth 12
Low Renaissance (1400–1479) 12
High Renaissance (1475–1525) 15
The Renaissance in Other Countries 22
Minding Your Mannerism (1520–1580) 25
Going for Baroque (1580–1750) 27
Heating Up the Dutch Oven (1600–1680) 30
You Go, Glen Rococo (1700–1785) 35
Neoclassicism, or: Why You *Can* Go Home Again (1750–1860) 37
Romanticism (1800–1850) 38
The Birth of Photography (1826–1827) 40
Pictorialism (1885–1915) vs. Modernism (1910–1950) 42
Photography Comes into Its Own (1962–Present) 43

Wrap-Up . 45

CHAPTER TWO TECHNICAL LIGHTING 47

The Tools to Control Light

How We See . 50

Contrast 53
Shadow 58

Qualities of Light . 59

Modification of Light . 64

Relative Size of Light .67

Relative Position of the Background .70

Giving Your Light a Job. .72

Lighting Ratios to Control Contrast .76

Lighting Ratio: 1:1 77
Lighting Ratio: –1 Stop Fill 78
Lighting Ratio: –2 Stop Fill 78
Lighting Ratio: –3 Stop Fill 79
Lighting Ratio: –4 Stop Fill 79

Why Size Matters. .81

Why Shape Matters. .83

How Falloff Controls Contrast .86

Putting Light Where You Want It.... .88

...Blocking It Where You Don't—the Flag .93

The Special Order Menu .95

Wrap-Up .99

CHAPTER THREE TAKING SHAPE 101

Shaping the Light, Mood, and Face

Seeing the Patterns. .103

Paramount 104
Loop 105
Rembrandt 105
Split 106

Relative Position of the Light. .107

Broad Light Versus Short Light. .108

The Vertical Axis .110

Which Mood, Which Light? .111

Wrap-Up .111

CHAPTER FOUR HOW MANY LIGHTS 113

Using One, Two, and Three Lights to Further the Purpose

The Purpose-Driven Light .115

Studio Versus Location Shooting .116

The Single Versus Multi-Source Approach .117

One Light. .120

Two Lights .123

Three Lights .126

Wrap-Up .128

CHAPTER FIVE COLOR 131

Directing the Eye and Influencing People

How Color Manipulates .133

Describing Color 134
Color: Symbolism and Emotion 134

Making Colors Play Nice .143

Monochrome 143
Complementary 144
Analogous 146
Triadic 146
Memory Colors 147

Wrap-Up .147

CHAPTER SIX STYLING 149

Making Good Visual Choices

Strengthening the Purpose .151

Wardrobe .152

Backgrounds . 155

Depth of Field 155

Contrast 156

Lighting 156

Environment Versus Studio 156

Textures . 160

Hair and Makeup . 160

Props . 162

Wrap-Up . 163

CHAPTER SEVEN POST-PRODUCTION 165

Adding the Polish

How the Image Sausage Is Made . 167

RGB Versus CMYK . 171

Additive 171

Subtractive 171

The Components of Color . 174

The Raw File . 175

The Histogram 176

Developing the Raw File 179

What It Means to Develop for the Print 181

Workflow . 182

Culling and Editing 182

Developing 183

Retouching 186

Final Steps . 205

Wrap-Up . 207

CHAPTER EIGHT **PERSONAL STYLE** 209

You Do You

Developing Your Personal Style .211

Building a Cohesive Body of Work .212

Gear Does Not Matter (But It Kind of Does) .213

Gear Hang-ups 213
Why Gear Matters 214

The Narrative of the Image .215

Case Studies .216

Portrait of Linda 216
A Fighter by His Trade 218
Queen of the North 221

Wrap-Up .223

FINAL THOUGHTS 224

INDEX 225

INTRODUCTION

A picture of someone is all well and good, but when a portrait is created with intent—a purpose—it gives an image depth and helps it to stand the greater test of time. We may regularly forget to ask ourselves *why* we are creating a photo, but the whys—the meaning behind our photographs—are at the core of what makes an image expressive and unforgettable. Often, the whys get skipped (or at least glossed over) in the early stages of learning photography because techniques like lighting and post-production are more concretely attainable skills.

This book is meant to help you express your intent and create imagery that is more than just a picture that looks good (though that is definitely covered here). The process of intent—through the universal tools of lighting, styling, and com-position—is meant to apply to all kinds of photographs and photographers, whether you are shooting portraits, fashion, weddings, fine art, or nearly anything else. The goal here is to give you the tools to say whatever it is you, as a photographer or artist, want to say. The point is only to say *something.*

Why should one choose the manner of a dramatic portrait to express a visual idea of a person? A portrait, after all, is an image of a person. In truth, it is largely the reason you have this book in your hands in the first place—personal choice. With a wide range of visual styles available, the decision to create in one voice or another is all about what *you* want. The tools and the language are universal, but the perspective of creation is uniquely your own.

This book is for the photographer looking to take their portraiture to the next level. It explores the components of light, from qualities to modification, and includes lighting patterns, diagrams, and real-world scenarios. The visual sensibilities we know and love today are entrenched in thousands of years of art that have come before us. Understanding our visual origins—from ancient civilizations to modern photography—helps us to see what has worked and continues to work in portraiture, and how these principles assist our understanding of photographic portraiture and lighting today.

We will examine color and styling, the ways they evoke a psychological response, and how they contribute to drama and the end result. An overview of my post-production workflow looks at the *whys,* not just the hows, to understand the *idea* of post-production and what it can do for your own vision. All of this addresses how these tools and techniques are meant to be woven into the creative process to reach your goal of a finished image.

The dramatic portrait can be elegantly simple or beautifully complex. The visual elements can be steeped in narrative or taken 100 percent at face value. The approach is entirely yours. Hopefully this book guides you on your journey in reaching your destination.

CHAPTER ONE
A HISTORY OF PORTRAITURE

MORE FUN THAN IT SOUNDS

Throughout history, portraits have celebrated the rich, the powerful, and/or the glorious—whether they were rulers, wealthy merchants, athletes, or Bono. The immortalizations of such figures were often commissions, paid for by the subject (or their family) or perhaps by a mild plundering of the coffers of said subject's kingdom. As a result—and perhaps a telling example of where early civilizations placed importance—many of the oldest surviving portraits are of emperors, kings, and nude athleticism.

Over time the ability to have portraits made became more and more accessible for the non-ludicrously wealthy. It is something that transpired over a relatively long timeline, beginning as a glint of an idea with the ancient Greeks and truly hitting its stride during the Dutch Golden Age. This, of course, brings us to today and what some might consider a saturation point. There are more portraits (usually of the self-inflicted variety) than ever before being made in the most fashionably up-to-the-minute of ways.

Traditionally speaking, a successful portrait often demonstrates one of two things: the subject through the eyes of the artist (often revealing an inner truth) or a kind or complimentary representation (with the help of expertly crafted techniques, lighting, posing, and Photoshop). Aristotle said, "The aim of art is to present not the outward appearance of things, but their inner significance; for this, not the external manner and detail, constitutes true reality." So a portrait does not necessarily capture subjects how they literally are, but how they *seem* to be—either to themselves or the artist. One only has to decide on the perspective they wish to represent.

As this is obviously a photography book, we could delve into only the history of portrait photography, but that in itself seems rather limiting when looking at the scope of portraiture—and art for that matter—as a whole. Often portraiture was a smaller component within a larger artistic movement, and stepping back to view these movements as a whole is necessary to more firmly grasp what was actually happening and influencing progress.

In addition, photography only speaks on behalf of a small sliver of time. The visual style it represents is more limited than many of us would like to believe. Although we create and refine and cull and shape and direct, we as visual artists are still dealing (for the most part) in a medium that is representational; we are capturing what is there. Painters, such as Rembrandt, Picasso, and Michelangelo, have historically covered a far wider and more experimental gamut when translating the world and the human form onto a two-dimensional substrate. And so, the history of art has had a profound impact on photography and established our sensibilities about what a portrait—and to a degree a photograph—even is.

This is because once photography came around, our understanding of portraiture as a means of visual communication was already in place. It is easy for us to look at photography and recognize the endless variety, but almost all of those varieties are rooted in the foundations established thousands of years before. This is an abridged look at those foundations.

THE EVOLUTION OF STYLE

Whether one is looking at the history of portraiture through painting or even how it has evolved within modern photography, there is a certain underlying current through all of the work. That current is the artist's style, narrative, or point of view, and the strongest work has traditionally been the result of their trying to answer some sort of question or make some kind of statement. This has been spelled out historically through something called the "hierarchy of genres," and although it is not something that sits atop the pedestal it once claimed (it was considered more definitive before the 19th century), it is still a fascinating way to look at how art has been regarded over the years.

The hierarchy was established from artists seeking to gain recognition of painting as a liberal art. As a byproduct, painting was not only accepted, but it managed to position itself in a place of superiority *over* architecture and sculpture. One argument being that it was far more difficult to render three-dimensionality on a two-dimensional plane than it was to simply sculpt or build something with dimensions that were already there in space.

Topping the list of the hierarchy is history painting, which includes religious and allegorical works, often with a clear narrative, multiple subjects, and a strong use of gesture. Next is portrait painting, followed by genre painting—or work that captures everyday life—then landscape, animal painting, and still life. Obviously, this hierarchy does not exist in its classic form today, and through the course of this chapter you get to watch it slowly die.

If one were to update the ancient hierarchies into the modern world of photography, history painting would be adjusted to what is considered "fine art" or idea-driven work. Portrait, landscape, and still life are all self-explanatory. Genre could be amended to include documentary photography.

In the history of art, Renaissance art is considered the epitome of what the hierarchy was trying to express partly because the work defined the very genres they are categorized in. So much of the great Renaissance art includes multiple figures, historical and religious narratives, expressions, and gestures. All this, according to many artists of the time, following the dictates of Leon Battista Alberti in

his *Della pittura* (On Painting), 1435, has the greatest potential to move the viewer and therefore is the noblest pursuit. As you will see later, the Renaissance has more lives than a cat.

Even though the hierarchy has since dissolved (the period of Romanticism in the 19th century was largely the final nail in the coffin), we can recognize certain ripples from the old hierarchy concepts that are still felt throughout art today, specifically the significance and value placed on concept- or idea-driven work.

Portrait photography is not immune to this. The most successful portrait photographers create work that is concept-driven at its core. Annie Leibovitz's work, for example, is often theatrical, creating a persona for the subjects (often actors) that she photographs. She frequently includes lights, background stands, and other elements that break the "fourth wall." The work is often meta, or self-aware, creating commentary on Hollywood itself.

In Richard Avedon's white background portraits, he was looking to create a platform where there were no distractions between himself and the subject. A large component of his portrait work *was* the connection between himself and his subject. As he became a larger personality, it changed the work, because a large part of what he was actually photographing *was* the dynamic between him and the subject.

Martin Schoeller borrows his close-up portrait philosophy from Bernd and Hilla Becher. Not visually or in his choice of subject matter, but in his approach. His concept is to place his subjects on the same visual platform as a way to more easily recognize what makes everyone similar and what makes them unique.

This is why, even though a photographer's style may be duplicated, the photographs cannot. The images represent a vision, a narrative, a voice, and a component of personal history. There is, however, tremendous value in following the process. By knowing where photographers (or any artists) start and where they end, we can study the progression, how history may have affected their decisions, and how so many artists have been heavily influenced by those who came before them.

THE EVOLUTION OF ART AND PORTRAITURE

Although humans have existed for millions of years, we only began using symbolic imagery as creative expression roughly 100,000 years ago. The oldest surviving human portrait is over 26,000 years old (**Figure 1.1**). It was discovered in the Czech Republic, dates back to the Ice Age, and is carved from mammoth ivory. It later became the inspiration for Tilda Swinton. Comparatively, the oldest examples of cave art are found in southwest France and are about 17,000 years old.

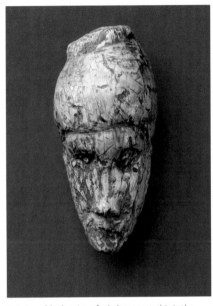

1.1 Roughly the size of a baby carrot, this is the oldest known portrait in the world.

ANCIENT EGYPT (3100 BCE–332 BCE)

Fast-forwarding several centuries to Ancient Egypt, the story begins roughly 5,000–6,000 years ago. When considering Ancient Egyptian portraiture and Western art, it is important to remember that each sought different goals, and therefore cannot be compared using similar standards. Whereas the ambition of modern portraiture is to capture the subject's physical likeness in connection with inner characteristics, the goal of Ancient Egyptian art was rooted in religious, political, and even magical experiences and had a vastly different purpose. This art was firmly entrenched in Idealism (representing things as perfect, driven by spirituality). Depictions of figures were not concerned with capturing any kind of literal likeness; they downplayed imperfections so that these (vaguely approximate) likenesses could be a worthy vessel for the soul in the afterlife (**Figure 1.2**). The likenesses were so far removed from reality that an inscription of the name was used as a way to identify the subject.

Today we don't take the idea of immortality quite as literally, but it is not uncommon to hear that a subject is considered "immortalized" in a great portrait. Working under a strict set of societal rules, Egyptian artists were rarely able to freely interpret the details of the subject, working solely to please the patron of the piece, and often producing unoriginal work indistinguishable from that of the dynasty before. We've all been there.

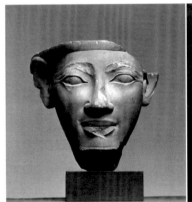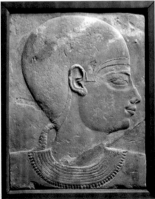

1.2 Left: *Model of a Male Face*, ca. 1550–1069 BCE. Right: Model with sweet rat tail, ca. 746–335 BCE.

GREEK STYLE (800 BCE–600 CE)

Around 600 BCE, Greek art becomes the next great cultural chapter and influential point in portraiture, and in the process forms the foundations of Western art. Gone were the flat, two-dimensional works of the Egyptians. The Greeks created sculpture portraits that were alive with movement and captured the fluidity of the human stance. Greeks had established a presence in Egypt sometime in the 7th century BCE and were well aware of Egyptians' cultural imagery. The Greeks leaned partially on this when developing their own. However, a key characteristic of Greek thought at this time was an increased interest in the individual—more specifically the idea that *man* is the measure all things. This was a dramatic departure over previous civilizations, like the Egyptians, that put gods and kingdom above all, with man's primary purpose being to serve both.

The earliest Greek sculpture is believed to be an imitation of the Egyptian aesthetic (**Figure 1.3**). This can be seen in Archaic Greek figures known as *kouros* (male subjects) and *kore* (female subjects) as their dimensions (like the Egyptians) favored idealism and symmetry over realism. A key characteristic of this work (and a parallelism to Egyptian statues) is the stance—often one foot in front of the other, with structured, vertical hips, equally distributing the weight between the legs. However, a major development took place in 480 BCE with the statue *Kritios Boy*, by Kritios (**Figure 1.4**). The world-changing feature of the work is something known as *contrapposto*, an Italian word that was later applied, and which literally translated means counterpose. Though probably not the first piece to use contrapposto, it is the oldest surviving example of the human body being used to project a psychological disposition, and therefore it is one of the most significant works in the history of Western art.

The contrapposto pose ("O.G. Lean") puts the subject's weight on one leg (known as the engaged leg) while the other leg appears more relaxed (known as the free leg), resulting in both a more dynamic and—at the same time—relaxed pose and implying the suggestion of past or future movement. The tension of the body is carried on opposite sides—the engaged leg versus the opposite shoulder and lateral muscles. This pose later evolved into the more exaggerated S-curve. Although the Greeks still focused more on the idealism aesthetic—believing that the subjects must be beautiful—their progress in capturing and refining the more natural pose was revolutionary.

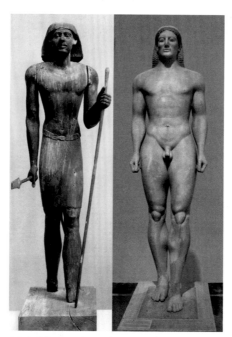

1.3 Left (Egyptian): Standing Statue of Merti, ca. 2381–2323 BCE. Right (Greek): Kouros burial statue, 6th century BCE.

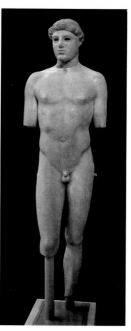

1.4 *Kritios Boy* by Kritios, ca. 480 BCE. Contrapposto via a fierce hip pose.

There was a single painter from ancient Greece who is regarded with a nearly mythological ethos. Apelles was fabled to be a "perfect" painter—someone capable of rendering reality so accurately that a painted fly on a wall was mistaken for the real thing. Apelles was Alexander the Great's court painter—an important position because its

motives signaled the shift toward the individual (even though the renderings were likely idealized). Centuries later, Apelles would be the standard for Renaissance painters to compare themselves to, despite the fact that none of Apelles's work survived in their original state. His work emphasized details, accuracy, and realism—characteristics that would later help define the Renaissance.

ONWARD TO ROME (753 BCE–476 CE)

Whereas the Greeks loosely borrowed from the Egyptians, the Romans borrowed from the Greeks with the maniacal fervor of a late-'90s Puff Daddy. Ancient Greek and Roman art are usually situated in the same wing of most museums, but their relationship is rather complicated and their respective contributions are equally unique.

The Ancient Greeks in their time were known for their writing, art, and relative success at being a civilized society. The Ancient Romans were known for roads, inefficient ways of writing numbers, and being characters in Shakespeare's plays. (Shakespeare, therefore, deserves all the blame for present-day Hollywood's decision to give practically every Roman character an English accent.) The Romans had an incredibly skilled and trained military force. The Greeks—with the exception of Alexander the Great—mostly just fought with themselves, as they were basically a collection of city states. The Romans were a more cohesive and singularly governed entity. The Romans had an insatiable hunger to expand their empire, and when they decided they really wanted olives, Greece (whose populace was mostly lovers and nary fighters) hardly stood a chance. Upon losing the Battle of Corinth, they commenced with the establishment of Roman Greece in 146 BCE. All of this is rather important to the understanding of why the aesthetics of Greek and Roman art closely resemble each other. Rome plundered Greece, appropriating and repurposing their art, religion, and waterfront property. Rome was the jock that beat up Greece's nerd, stole his book report on *Coriolanus*, and wrote Rome's name at the top.

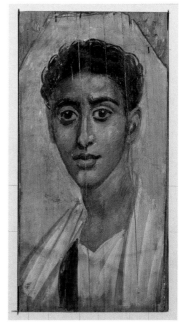

1.5 *Mummy Portrait*, ca. 1st century CE. During Rome's occupation of Egypt, naturalistic portrait paintings were sometimes used in place of the traditional masks.

Although Rome was founded in 753 BCE, the golden age of the Roman Empire as we know it through Joaquin Phoenix started in 27 BCE with the proclamation of Octavian as Augustus, Rome's first emperor. (Fun fact: Octavian was the adopted son of Julius Caesar, who is recognized for first promoting fine art exhibitions in public and had nothing to do with salads.) Octavian was also responsible for defeating Antony and Cleopatra in Egypt, annexing Egypt into the Roman Empire, and giving future drag queens perhaps the most fabulous and tragic Elizabeth Taylor character of all time. Clearly, the Egyptians, Greeks, and Romans were all very much aware of each other at this point in history, amalgamating and appropriating any part of another's culture as they saw fit (**Figure 1.5**).

While Roman government was a remarkably expansive and successful enterprise, Roman *society* was growing more interested in the individual due to the continued influence of Greek philosophers. This carried through to philosophies in art. While the Greeks were concerned with anatomical accuracy (in terms of general artistic importance), the Romans valued authenticity of the face, denoted quite literally through the incredible realism in how they captured the features (**Figure 1.6**). Some believe this approach evolved through the use of wax death masks—castings of wax, bronze, marble, and terracotta were used to accurately capture the deceased's head.

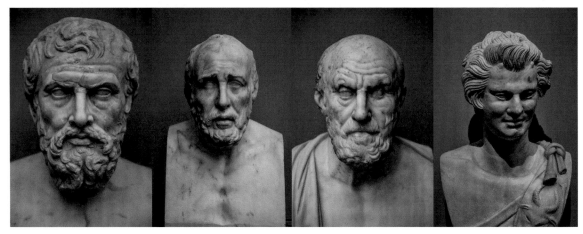

1.6 Roman busts, ca. 1st–2nd century CE.

As for painting, regrettably much has been lost to time. Romans, especially those of Greek origin, were also painters—creating both frescos (**Figure 1.7**) and easel paintings. Unfortunately, none of the latter has survived. Of the frescos that have been recovered (some of the best preserved in Pompeii), they were mostly ornamental and often highly sexual—like a trophy wife. Although historians are still missing a large part of the story, it appears frescos were seen as more of a craft than an art, making sculpture the dominant form of artistic portraiture.

Augustus was hip to the fact that art could be used as propaganda for the masses, not only as a way to communicate but also to adorn walls, beautify temples, and more or less remind everyone of the glory and power of Rome. In the process, art became ubiquitous, even more democratized, and regarded with such commonality that tourists could go home with souvenir versions of larger-scale pieces

1.7 Roman fresco, ca. 50–40 BCE.

NOTABLE ARTISTS

Notable artists from the Roman period include: Quintus Pedius, Spuris Tardis, Gaius Fabius Pictor, and Arellius.

found throughout Rome. Imagine your Eiffel Tower keychain ending up in a museum in 3,000 years, and you kind of get the idea.

The "Fall of Rome" is often imagined as a glorious crash, but in truth it fizzled out more slowly than Nicolas Cage's credibility as a leading man. The last emperor of Rome was overthrown in 476, but the marker is largely symbolic. The Empire (to drastically oversimplify) had grown too large, spread itself too thin, and the land was slowly encroached upon by outside armies. With the fall of the Western Roman Empire, Europe hit a reset button and high culture, learning, and the arts came to an apparent end. Many of its cultural and technical contributions were not to be rediscovered for 1,000 or more years. In the meantime, there were a lot of paintings of Jesus, the painstakingly chiseled groins of antiquity were often shrouded or castrated, and Disney got some creepy source material for *The Hunchback of Notre Dame*.

MEDIEVAL TIMES (476–1500)

In 313 CE, Roman Emperors Constantine I and Licinius issued the Edict of Milan (both were emperors at the time of the two halves of the Roman Empire, Constantine in the west and Licinius in the east) ending the persecution of Christians and more or less putting the "Holy" in the Holy Roman Empire. This is the first critical moment for subsequent art in this period, because by allowing public worship, it opened the floodgates for the deluge of Christian art that followed. The second crucial moment happened in 330, when Constantinople was dedicated as an artistic—and more importantly, Christian—center of the eastern half of the Roman Empire. Although most early constructions from this period in Constantinople's history have not survived and the city has changed hands and cultures numerous times since its origins (and can be further divided into separate periods), it remained an important nerve center and hub for the Byzantine Empire for over 1,000 years until it fell in 1453.

Whether you consider the Middle Ages (or the Dark Ages if you're a glass half-empty kind of person) a reset button or a slide backward, the period was a complicated time for the Western world. Cultural development stopped and an entire civilization went "emo," locking itself in a room and self-flagellating (not as fun as it sounds), because burning heretics was a better way to pass the time than philosophizing and orgies. Society, at this time, was like the *Peanuts* character Linus with his safety blanket, bringing his blanket (Christianity) everywhere and letting everyone know why he needed it. The only difference was that the most powerful members of society at the time (the Church) would imprison or torture you if you didn't want the blanket too. This is actually an integral component of understanding Medieval art, specifically how it relates to portraiture.

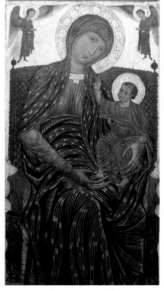

Either through fear or a lack of knowledge (the ability to read was less important than in the past), religious art took a front seat to everything else. Interestingly, the period incorporated many of the same ideologies and even base aesthetics of Egyptian art (specifically the flatness, lack of accurate dimension, and deficiency of realistic proportion). Medieval art was not meant to be true to life; instead it aimed to create imagery to guide the mind toward a more spiritual truth (à la the Egyptians). Although the symbolism was not as literal as with the Egyptians (the works were not *literally* believed to be divine divining rods), the artwork was revered enough to be seen—at the very least—as conduits to sacred enlightenment. Most portraits during this period were of Christ, Mary (**Figure 1.8**), the saints, authors,

1.8 *Madonna and Child* by the Master of the Magdalen, ca. 1270.

and artists (usually shown doing artsy activities to establish credibility), and occasionally other normal, living people (usually donors to the Church). "Normal, living people" were almost always pictured in some form of religious activity: going to mass, kneeling in prayer, and generally doing churchy things.

Though this period spanned approximately 1,000 years, it was not a particularly rich and compelling time for artistic endeavors; the most impressive and significant contributions of this period artistically were architectural (Notre-Dame Cathedral, for example). The art during the latter part of this period is referred to as Gothic art.

EARLY NETHERLANDISH (1420–1550)

As the Middle Ages were ending, Early Netherlandish painting began, overlapping slightly in time with the early Renaissance. Noting this period first allows for a more recognizable transition from the two-dimensional, almost cartoonish style of the Middle Ages to the dramatic increase in realism (both in facial features and perspective) during the Renaissance.

This period cultivated painters such as Jan van Eyck and the fantastically named Hans Memling. Van Eyck is perhaps the most famous from the period, known mainly for his piece *The Arnolfini Portrait* (**Figure 1.9**) and making massive contributions to the aesthetic of the *Game of Thrones* wardrobe department.

Whereas a large portion of van Eyck's oeuvre is made up of religious scenes (his attention to detail and imagery is steeped in symbolism), his donor portraits are integral to the narrative of portraiture. Van Eyck bridged the gap between the unrealistic proportions of the body favored during the Middle Ages and combined it with his detailed and realistic interpretations of the face.

Portraits of this period were often of the bust (head and shoulders in length), on a much darker background (often black), and with the face straight on (full face) or turned to a three-quarters position (**Figure 1.10**). The Netherlandish painters were an important transitional link between the Medieval and Renaissance periods, with one foot solidly in the world of religious fundamentalism and the other set upon more accurately interpreting the world in which they lived.

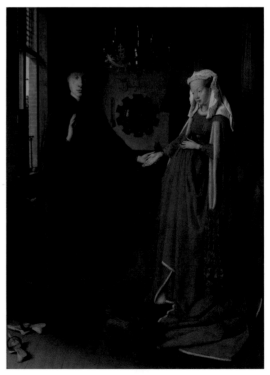

1.9 *The Arnolfini Portrait* by Jan van Eyck, ca. 1434. The invention of the "low five."

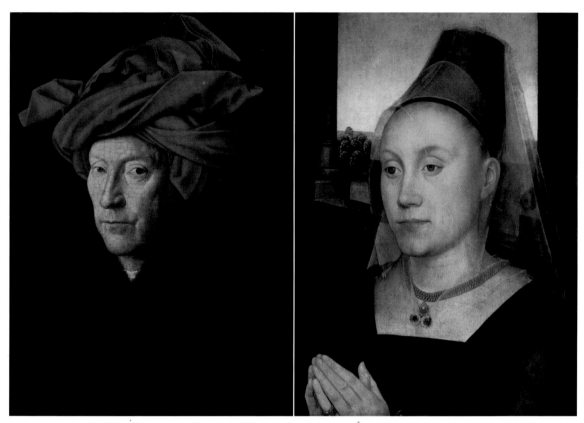

1.10 Left: *Man in a Red Turban* by Jan van Eyck, ca. 1433. Right: *Portrait of Barbara van Vlaendenbergh* by Hans Memling, ca. 1480. Judging the man on the left but still enjoying the show.

THE ITALIAN RENAISSANCE (1341–1600)

This section on the Renaissance will be the longest in the chapter. You may wonder if this is because the Renaissance is objectively better and more eminent than its historical counterparts. It is. History takes many things into consideration when deciding who (or what) will be remembered—but particularly who is remembered *the most*. In *But What If We're Wrong?*, Chuck Klosterman discusses this very effect. Reductive remembrance is largely decided on by the collective and popular opinions of historians based on cultural reductions that take place many years after the fact, once the generation to experience it as popular culture has died off.

The Renaissance, however, is remembered differently, and that has to do largely with the fact that the average person today can name more than one artist from this period. Outside of individuals with a vested interest, any significant era (or genre) is historically reduced to a single artist in the cultural consciousness—we think of Homer as *the* writer of Greek poetry, or Freud as *the* psychiatrist we allude to when we blame our significant other for not being able to commit already. But ask the average person to name Renaissance artists, and they can regularly list at least two—four if they loved the Ninja Turtles.

The true litmus test of merit comes from answering this question: outside of the generation directly connected to the art, can it hold up 200 years later? Historically, artists who touted their brilliance were at best tangential to the artists making the genuine, period-defining work. (Did you know that, Kanye? Did you?) What makes the Renaissance so particularly unique is that many of the artists that were great at the time—and had no problem claiming their greatness—also stayed great over time, their diminished returns only marginal. Michelangelo was revered in his time as the greatest artist on the planet (an amended title he posthumously held for hundreds of years after his death). Today, historians *still* recognize Michelangelo as monumentally, world-changingly great. Da Vinci is also afforded this status, as are numerable others. Greatness is their starting point whenever they are injected into the conversation. It is to this effect that this chapter unabashedly gives more real estate to this time period than all others. It would be objectively incorrect not to.

THE REBIRTH

The 15th century marked both the end of the Medieval period and the beginning of the Renaissance, covering a hundred years, when all other countries were afraid to ask Italy if something special was happening or if it was just getting fat. The Renaissance—literally translated means "rebirth"—was a perfect storm of events forming what many consider to be the most significant period of development in the modern history of the western world, heralded in by the greatest abundance of genius the western world had, and perhaps will ever, know. The contributing factors to the materialization of the Renaissance were complex and codependent on the relative success of each other's impact.

Following the fall of Constantinople, many Greek philosophers and artists migrated to Italy (at the time a collection of city states similar to ancient Greece), which subsequently led to a rediscovery of Greek philosophy by the Italians—most importantly the renewed interest in the natural world. Gutenberg's printing press allowed for a vastly quicker dissemination of ideas and techniques to a much greater mass of people. Humanism as a method of learning was an important development of the time—a movement meant to study the texts and philosophies of ancient Greece and Rome and to apply those values to their lives, with a primary focus on studying the humanities (now considered by many parents to be a mostly useless degree).

A favored theory that adds to why this came about centers on the survivors of the Black Death (plague) being surrounded by so much death that they chose to spend the remainder of their lives focused on living and not what came after (YOLO). This is not to say that religion was cast aside. In fact, the most sought after artistic commissions were highly devoted to Christianity. It was not, however, regarded with the same dedication by members of the intellectual class.

The final piece in the foundation of the Renaissance arose slightly earlier: capitalism. To be more specific, the Medici family. As the Medici Bank was the largest and most respected in Europe, it brought unfathomable wealth (and created what some consider to be the earliest form of the check), allowing the Medicis to become the largest benefactors to artists at the time and maybe of all time.

LOW RENAISSANCE (1400–1479)

Historians agree that the Renaissance was born in Florence, home of the Medicis, and the years that followed are further divided up into smaller, more distinctive periods: the Early Renaissance, the High Renaissance, and the Renaissance in other countries (the Netherlands, Germany, France, Spain, and the rest). The new Golden Age was born of nothing if not poetically divine origins. Greece and Rome were its Garden of Eden, followed by nearly 1,000 years of darkness, then the subsequent

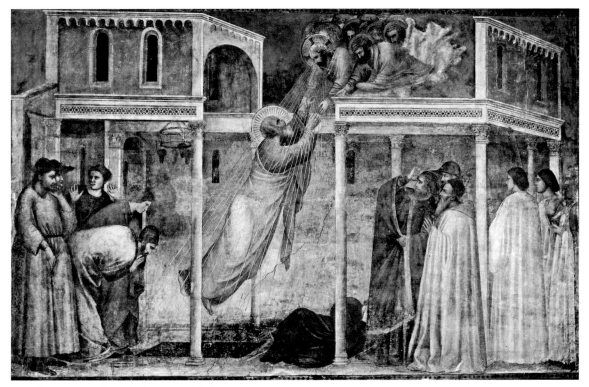

1.11 *The Ascension of St. John the Evangelist* by Giotto, ca. 1320.

rebirth as we know it, which happened in Tuscany when a young painter named Giotto was taken under the wing of a painter named Cimabue. Giotto (**Figure 1.11**), whose work predates the timeline of the Low Renaissance by about a century, stepped considerably away from the traditionally flat, Byzantine style of art toward imagery with a more dynamic sense of perspective and shading. (This period from about 1300–1400 is referred to as the Proto Renaissance.) This sensibility was slightly different from the Early Netherlandish painters, giving dynamic *gestures* to figures while placing them in realistic spaces. What made the revulsion from the abstractness of the Medieval style so significant was not only the leaps made in technical ability, but in the purpose to which it was used—the desire of man to recognize himself and his world in the work—making the visceral impact of the art more palpable.

The instruments used to facilitate this idea were the study of the nude human form (anatomy and facial characterization), the life study of plants and animals, perspective and foreshortening (showing objects closer or farther to give a perceived sense of distance), lighting, the atmospheric effect, and the influence of antiquity (Greek and Roman art and ideas). The pagan man (man before the Medieval Ages) was seen as the most natural representation of man, and therefore the return to antiquity was a return to nature itself. In this state, man was incorruptible and at peace with the world. A return to nature was, in essence, a return to man. It's the circle of life without a catchy theme song. The continued exploration of the individual is elemental to the modern frame of how one approaches the underpinning characterizations of a portrait. Through the continued study of the individual, they shaped the foundation of modern portraiture in the Western world.

Although Giotto and his few contemporaries had students that were continually developing this new style, it existed in a relative vacuum. Beyond this small group of artists, the moment had not fully taken root. The symbolic moment that establishes the beginning of the Early Renaissance was a sculpture competition for a pair of bronze doors in the Baptistry of the Florence Cathedral, which drew entries from many notable sculptors, but went to 23-year-old Lorenzo Ghiberti. Assisting in the creation of the doors was Donatello—a notable master of contrapposto, and recognized as the greatest sculptor of the Early Renaissance for his gentler version of *David*—the first sculpture of a nude man since antiquity (**Figure 1.12**).

A notable painter of this time was Antonello da Messina (**Figure 1.13**) who used oil paints for portraits and religious paintings far earlier than his counterparts. Oil paints allowed for his dramatic and nuanced use of shadow. He was described by John Pope-Hennessy as "the first Italian painter for whom the individual portrait was an art form in its own right." Oil painting would eventually become one of the dominant mediums during the Renaissance, although fresco was still used frequently.

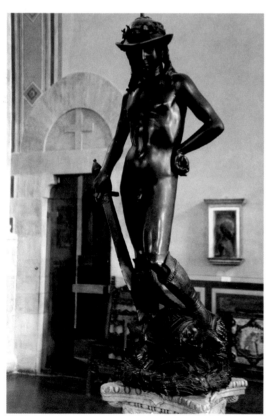

1.12 Donatello's *David,* ca. 1430–1432. Photo courtesy Patrick A. Rodgers.

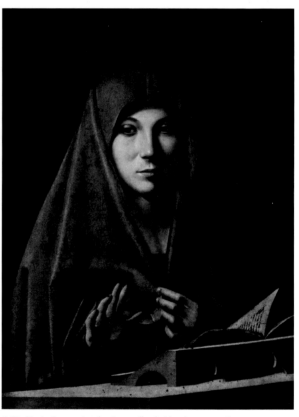

1.13 *Virgin Annunciate* by Antonello da Messina, ca. 1476.

One does not have to look further than sculpture portraits to see how directly the Renaissance was influenced by Ancient Rome. Although early busts of this period were commonly created of saints (subject matter borrowed from the Medieval Age), the portraits steered away from the idealized characterizations of the previous age and strove to authentically capture how the subject was in life, and in the case of commissioned work of the living, down to the fashions they wore. Toward the end of the Early Renaissance, another iconic commission took place—the building and decorating of the Sistine Chapel. Four artists were commissioned to adorn the walls: Botticelli (not the opera singer), Ghirlandaio (not the chocolatier), Perugino (also not a chocolatier), and Rosselli (not a mobster...probably). They did fine, but no one has their action figures. Their work is quite literally the lowest tier of work in the room, with the most celebrated augmentations not added until years later (**Figure 1.14**).

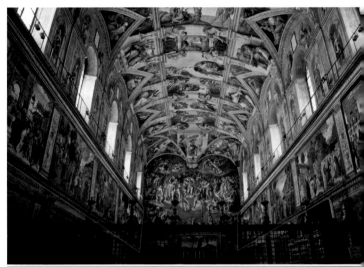

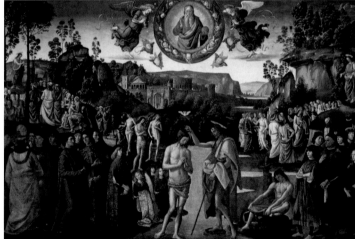

1.14 Top: The Sistine Chapel. Bottom: *The Baptism of Christ* by Perugino, ca. 1481–1483. Located on the Northern wall.

NOTABLE ARTISTS

Notable artists from the Low Renaissance period include: Donatello, Antonello da Messina, Botticelli, Ghirlandaio, Cosimo Rosselli, Pietro Perugino, Bernardo Rossellini, Giovanni Bellini, Filippo Lippi, Cimabue, Giotto, Andrea del Verrocchio, Masaccio, and Piero della Francesca.

HIGH RENAISSANCE (1475–1525)

By the end of the Early Renaissance, Florence was a far different place than it had been less than 100 years before. Industry, high finance, intellectual study, and ethical fortitude dominated the ascendancy of everyday life. When many people think of the Renaissance *this* is the period they have in their mind. The "holy trinity" of this time was made up of Leonardo da Vinci, Michelangelo, and Raphael.

It is easy to think of Leonardo da Vinci as a great artist; however, that is simply not enough. Da Vinci was renowned for his artistic merit, yes, but more renowned as an intellectual. We acknowledge and appreciate the technique of his craft, but his genius was found in his process. The world is fortunate to know even some of that process through the study of his journals, revealing a more complex mind than could be derived from the work alone. Da Vinci, perhaps more than anyone, embodies the term "Renaissance man," becoming, if not an expert, than having a capacious interest in: painting, sculpture, drawing, architecture, anatomy, engineering, invention, yadda, yadda, yadda.

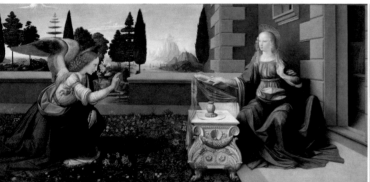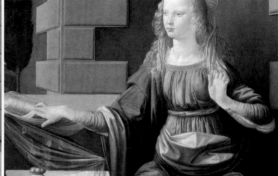

1.15 Left: *Annunciation* by Leonardo da Vinci, ca. 1472–1475. Right: Closeup of Mary's freakishly long arm.

Take the example of perspective. Even with it being an important element in the visual style of many artists up to this point, it remained rather linear. It was not until Leonardo da Vinci in the 1470s that it was challenged as an antiquated sensibility—instead, he chose to create perspectives based on subjective appearance rather than geometry. In his earliest known completed work, *Annunciation* (**Figure 1.15**), there is what seems to be an error of perspective; the extended arm seems out of proportion. However, when one considers the painting was meant to be viewed from the lower-right angle, the arm appears more natural to the viewer's perspective.

Part of this exploration (and the device responsible for the enormous uptick in realism in representational painting) was the use of the camera obscura—a device capable of projecting light from a scene into a dark room or box. Although there is evidence of the device as early as the 6th century, da Vinci's publication of *Codex Atlanticus* in 1502 was the first *clear* description of a camera obscura, and his widespread use of the device as a way to capture realistic imagery was game-changing. The Hockney-Falco thesis (*Secret Knowledge*, 2001) even goes so far as to claim that the advances in realism during the Renaissance were *primarily* the result of the camera obscura (and other similar instruments like mirrors), and not, as many other historians would rather believe, a result of sheer artistic skill.

It is worth noting that da Vinci, as well as Michelangelo, were highly regarded in their time, giving them special permissions. Those permissions included the ability to study cadavers and perform dissections. The reason these artists could craft the form better than anyone else is because they simply understood it better—from the literal inside out. Using this knowledge, we can look at *St. Jerome in the Wilderness* (**Figure 1.16**) and recognize that the aged figure of St. Jerome feels more like a skeletal and muscular structure with a thin layer of skin stretched across it, the realistic expression on the face haunting, resembling a cross between Vin Diesel and the Cryptkeeper. It's like looking into the future of *The Fast and the Furious* franchise.

Even though technology throughout time has pushed art to greater heights and vice versa, this was especially true during the Renaissance. That said, a technically superior creation does not singularly make the image compelling. Take the *Mona Lisa*, for example (**Figure 1.17**). Advances in technology allowed for advances in techniques, and the ones used here can be easily identified: use of the Golden Ratio, chiaroscuro (creating composition through the use of dramatic highlight and shadow), an aerial perspective, and sfumato (the soft focus and haze that mimics the atmospheric effect).

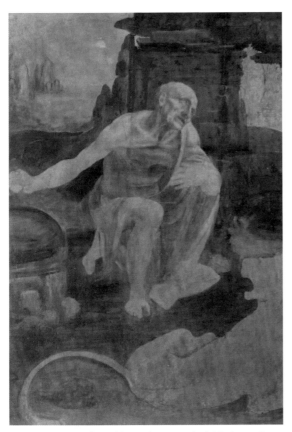

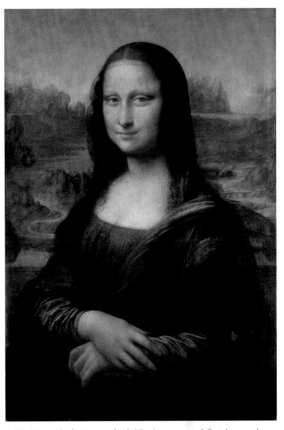

1.16 *St. Jerome in the Wilderness* by Leonardo da Vinci, ca. 1480.

1.17 *Mona Lisa* by Leonardo da Vinci, ca. 1503–06 (but he may have futzed with the painting until 1517).

What those techniques aren't capable of explaining are the mysteries that draw us to try to make sense of what we are looking at. How does the light on the subject's face seem to glow from within, instead of emanating onto her? Why are we so close? Is that why she is posed self-consciously? What does the smile mean? Why is she sitting in front of a strange, desolate landscape? What do all these things mean when viewed as a cohesive whole? The *Mona Lisa* is a visual wonder— and even though we can recognize the techniques of its creation, what makes the work so captivating are the questions it causes us to ask ourselves, and for that it remains as clichély enigmatic as the shape of her mouth.

On the other hand, maybe we are never meant (or able) to grasp its true greatness. Da Vinci was not only the smartest guy in the room; he was the smartest guy in *any* room. Perhaps ever. He had conceivably one of the history's keenest senses of observation, understanding of anatomy, perspective, architecture, and (seeming) underpinnings of the very cosmos. The *Mona Lisa* is what happens when the world's most sapient, demiurgic mind breathes into existence a singular, definitive chef d'oeuvre, taking all of one's knowledge of the world and filtering it through years of refinement. We look at it with awe and wonderment, and the painting looks back—literally following the viewer from every angle. Maybe its ineffability is what

makes it so compelling; because maybe our brains are not even capable of truly understanding the very concept that the *Mona Lisa* is not *just* a painting of a woman but actually a pictoric interpretation of the way da Vinci saw the world—all at once—and that one simple notion is what defeats us from the onset. Maybe *that's* what makes it great. Then again, maybe it is all just hype.

While Leonardo was busy being the most famous left-handed and (alleged) asexual artist of all time, Michelangelo, a younger artist (23 years younger than da Vinci) was tirelessly perfecting *his* study of the human form. The explorations of da Vinci were largely scientific, but Michelangelo's figures reached for a transcendence that existed beyond the limits of the physical man. He did so by looking inward, and in the process captured the expression of an individual's soul, whether it was beautiful or otherwise. Anatomy and muscular structure were his tools with which he crafted this message. In doing so, the traditional values of antiquity were inconsequential. His work was not "classical" in the traditional sense, but instead was a translation of classical ideals into a "modern" form.

Michelangelo was considered the greatest artist of his time *while he was alive*. This viewpoint remained unchallenged for hundreds of years; many still hold this perspective. He was a virtuoso in multiple categories of art including sculpture, with two of the most famous pieces in history—*David* and the *Pietà*, both before the age of 30 (**Figure 1.18**); painting—scenes from Genesis and *The Last Judgment* in the Sistine Chapel; and architecture—St. Peter's Basilica, considered to be one of the greatest achievements of the Renaissance. His work would be influential for generations to come, inspiring the Mannerism movement and many artists during the Baroque period.

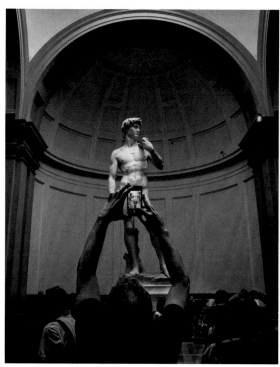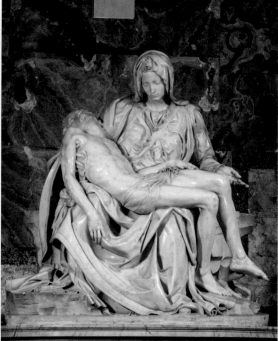

1.18 *David*, ca. 1501–04, and the *Pietà*, ca. 1498–99, by Michelangelo.

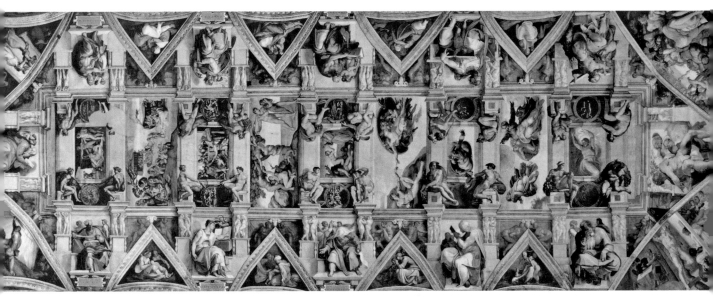

1.19 Michelangelo's Sistine Chapel ceiling, ca. 1508–1512. Photo by Amandajm.

In less than 100 years, largely due to Michelangelo's influence (and some help from Raphael), nudity went from being something shunned by the Church to adorning the very walls of the fanciest church in the land. The Catholic Church has felt guilty about this for the last 500 years, but historically speaking they've been pretty cool about it. By making the nude ubiquitous, the sensuality of the form was removed and the body served no elevated purpose beyond decorative ornamentation. It is important to note that Michelangelo's achievement of this was not without obstacles. After adorning the ceiling of the Sistine Chapel (**Figure 1.19**) with Adam's peen (and many others), multiple popes announced their protest. One referred to the room as a "vulgar bathhouse" and another had curtains painted over the most sacred of parts in *The Last Judgment* (**Figure 1.20**) because, God forbid, anyone faces his or her last judgment with more trepidation than a middle school locker room.

The story of the Sistine Chapel is nothing if not remarkable. At the time, Michelangelo was a sculptor rather than a painter, despite apprenticing (at the ages of 13 and 14) under Domenico Ghirlandaio. However, in 1506 Michelangelo was pressured by Pope Julius II to take the commission of painting the ceiling of the chapel (d-bag architect Bramante is theorized to have been behind this move in order to remove Michelangelo from competition for several years, only to fail). Michelangelo balked, largely due to the fact that he had never completed a fresco before. Four years later, he unveiled a masterpiece. Nearly 30 years after that he returned to paint *The Last Judgment* on the altar wall. Suck it, Bramante.

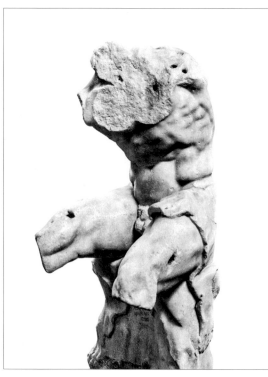

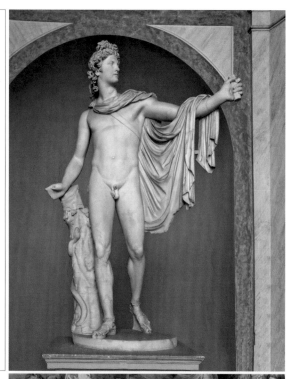

1.20 Above left: Torso fragment of what is believed to be Hercules by Greek sculptor Apollonius, ca. 1 BCE–1 CE. The Belvedere Torso was Michelangelo's favorite sculpture in the Vatican's collection. Michelangelo was requested by the Pope to rebuild and complete the torso, but, deeming it too beautiful, he used it as inspiration for *The Last Judgment* instead. Above right: Michelangelo, so enamored with the Apollo Belvedere's depiction of male beauty, used Apollo's face for Jesus in *The Last Judgment*. Bernini also used this for his *Apollo and Daphne*. Right: Closeup of Jesus in *The Last Judgment*.

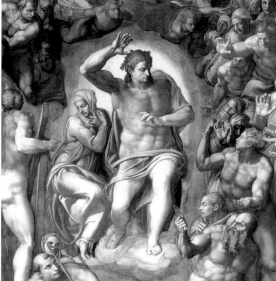

NOTABLE ARTISTS

Notable artists from the High Renaissance period include: Leonardo da Vinci, Michelangelo, Raphael, Titian, Giorgione, and Tintoretto.

The third most notable artist from this time is Raphael, whose work differed from da Vinci (who was largely scientific) and Michelangelo (who was largely introspective) by focusing primarily on beauty and the pursuit of aesthetic perfection.

Raphael is probably most famous for the image of the two adorable cherubs that everyone's grandmother has hanging up in her bathroom, which is actually a small part of a large altarpiece called the *Sistine Madonna* (**Figure 1.21**).

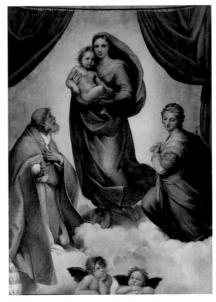

Raphael set out to depict beauty in its most refined form, focusing on balance, grace, restraint, and elegance in their purest senses (**Figure 1.22**). If one were to know only one other fact about Raphael, it would be that he died unusually young at the age of 37 from a misdiagnosis of a sex overdose. Supposedly, on his 37th birthday, Raphael spent what was apparently a very vigorous night with his longtime mistress and muse and contracted a fever. After not making his doctors aware of the cause (if said fever lasts more than four hours, consult a physician), they prescribed the wrong treatment, which ultimately led to his death nearly two weeks later. The other possibility for the cause of death was just plain old malaria, but that's way less fun to speculate about. Raphael's death marked an unofficial end to the renascence of antiquity, and for the sake of this paragraph, the tapered terminus of the High Renaissance. His ideals would go on to be a driving influence in Mannerism and the Baroque period.

1.21 *The Sistine Madonna* by Raphael, ca. 1512–1513.

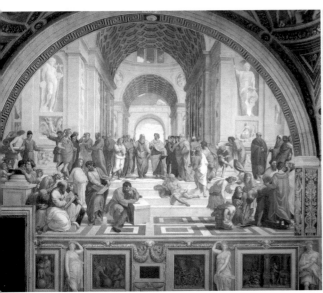
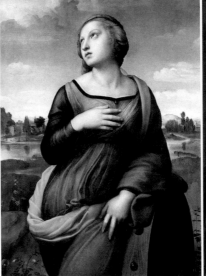
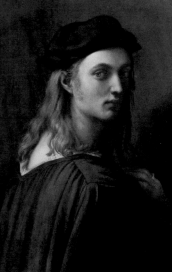

1.22 The art of Raphael. Left: *The School of Athens,* ca. 1509–1511. Middle: *Saint Catherine of Alexandria,* ca. 1508. Right: *Portrait of Bindo Altoviti,* ca. 1512–1515.

THE RENAISSANCE IN OTHER COUNTRIES

With the advent of the printing press, ideas and techniques spilled through the rest of Europe (largely Germany, Spain, Belgium, the Netherlands, and France), though it did take longer for some countries to catch on than others. Although this period took place alongside the High Renaissance or up to a century later, it is not decorated with the same prestige—its severe and brooding tones are a far cry from the heavenly depictions found in Italy. It is, however, still an important stepping stone in the narrative.

The German Renaissance's primary contributions to art—the Protestant Reformation and the printing press—shaped the world in their own unique way. As Italian painters symbolically lifted their subjects to the heavens, the Germans grounded their work with the heaviness that lingered from the Gothic sensibilities of the Medieval Ages. This period produced three people of influence: Martin Luther, Johannes Gutenberg, and Albrecht Dürer.

Martin Luther started the Protestant Reformation and helped make the Bible more accessible to the people. Johannes Gutenberg, inventor of the printing press, is largely responsible for the quick dissemination of ideas and techniques throughout Europe. And Albrecht Dürer, a painter active in the late 15th and early 16th centuries, is arguably the most widely known of the German Renaissance artists. He is regarded as the German contemporary of da Vinci and Raphael. His work merges the gothic sensibilities of traditional German art with many of the characteristics of the Italians. Although Dürer is most widely recognized for his self-portrait (**Figure 1.23**) as a sexy, steely-eyed Jared Leto–type, his written work on visual theories of the portrait was instrumental for many artists going forward. His *Four Books on Human Proportion* were deeply intricate and mathematical case studies involving hundreds of subjects that set out to establish idealized proportions (and movement) of the male and female form through extensive analysis and formulaic applications. His marriage clearly resulted in no children.

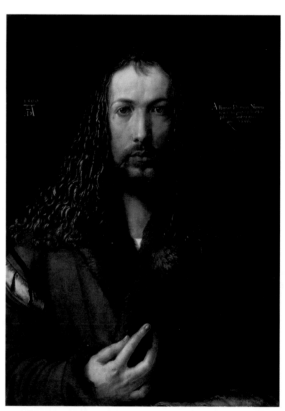

1.23 *Self-Portrait at 28* by Albrecht Dürer, ca. 1500.

NOTABLE ARTISTS

Notable artists from this period in Europe include: Albrecht Dürer, El Greco, Hieronymus Bosch, Pieter Brueghel the Elder, and the School of Fontainebleau.

In Spain, the Renaissance was occurring with a slightly different accent, and a few years later. The Spanish Golden Age was visually similar to the Germans' and rooted in Gothic origins, but often had more vibrant colors and a drift toward more organically abstract proportions. The prevailing artist of this period was El Greco, a Greek-born Spanish painter whose work did not gain true appreciation and notoriety until the 20th century (**Figure 1.24**). El Greco is known for taking heavier gothic themes and combining them with bright, bold colors and contrast. He favored grace over proportion, choosing to elongate the body, and he was remarkable in his ability to express a subject's character. His work is often described as mannerist—the years of the Spanish Golden Age overlapping with mannerism—and his visual style is more in line with that than the Renaissance. His work is considered the precursor to the Expressionism, Impressionism, and Cubism movements that occurred 300+ years later and directly influenced Cézanne and Picasso.

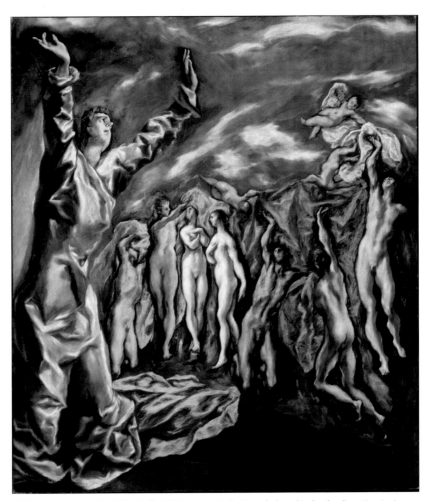

1.24 *The Opening of the Fifth Seal* by El Greco, ca. 1608–1614, is believed to be the direct inspiration for Picasso's *Les Demoiselles d'Avignon.*

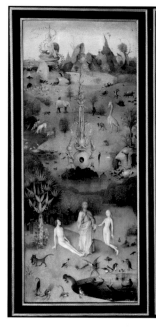
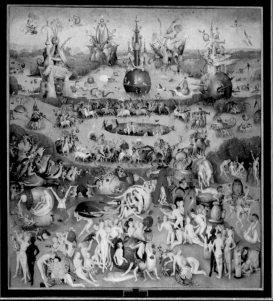
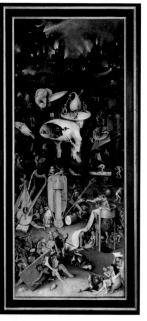

1.25 Above: *The Garden of Earthly Delights* by Hieronymus Bosch, ca. 1500. Below: Closeup of the inner right wing.

The Renaissance in the Low Countries consisted of movements in Belgium and the Netherlands. This style was an evolved take on the Early Netherlandish period with a dash of Italian spice mixed in. Two important artists from this period are Hieronymus Bosch (**Figure 1.25**) and Pieter Brueghel the Elder. Bosch's most famous work, *The Garden of Earthly Delights*, comes across as a depiction of a bad acid trip, becoming a driving influence of surrealism and both Salvador Dalí and Max Ernst. Brueghel, on the other hand, produced many distinguished genre paintings, but intentionally inverted the hierarchy of genres. He often placed peasants and elements of everyday life in the foreground and figures from allegorical tales in the background, as he did in his most known work, *Landscape with the Fall of Icarus*. Genre painting with a focus on peasants was unusual for the time, mostly because no one thought poor people mattered. These ideas, however, continued to permeate the work of Dutch artists, ultimately hitting their true stride during the Dutch Golden Age, when genre painting was at the height of popularity.

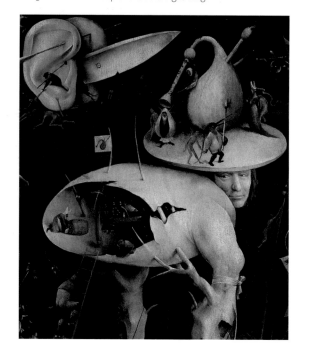

Finally, in the early 1500s, da Vinci arrived in France with multiple pieces of art—the *Mona Lisa* being among them—foreshadowing their current resting place at the Louvre (later the home of work produced by many artists in this book). French Renaissance work was often a derivative of Michelangelo's and Raphael's paintings with more erotic undertones. The renowned byproduct of this period was the School of Fontainebleau, which basically became an entire artistic movement dedicated to the adornment of a single royal residence and gave the world this gem of two sisters just hanging out (**Figure 1.26**).

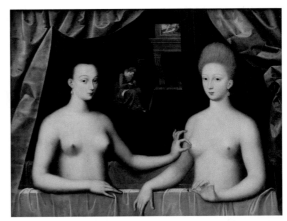

1.26 *Gabrielle d'Estrées and One of Her Sisters*, School of Fontainebleau, ca. 1594. Being totally normal sisters in 16th century France—don't worry about it.

MINDING YOUR MANNERISM (1520–1580)

Mannerism is the often-overlooked middle child of art history. The Italian Renaissance is the brilliant, beautiful, over-achieving firstborn, and the Baroque is the youngest (at least for this analogy)—a hip wild child with a penchant for the theatrical. Mannerism is Jan Brady. Sure, Jan has a bit of the characteristics that the others have, but she mostly just tries too hard to be like the older, more talented (and honestly, favorite) sibling and never creates a substantially unique identity.

Defining Mannerism is complicated because historians agree to disagree on what it actually is—a style, a movement, or a period. As the High Renaissance was ending, the artists incubated under the influence of their antecedents (Michelangelo, Raphael, and the lot) and continued developing the visual style of the popular artists of the time. Although Mannerism is a term once used to negatively describe the work that followed the High Renaissance due to what was considered a decline in quality, the period is now viewed as an important phase on its own.

Mannerism literally means "style" style. The etymology of the word is rooted in the very idea of "style over substance," making it an entire movement (if that is what one is calling it) dedicated to the idea of being cool and trendy but without the cultural depth. In another word: hipsters.

As a style, it still influences artists to this day—especially portrait photographers. Dramatically illuminated scenes, elaborate clothes and compositions, elongated proportions, highly styled poses, and lack of clear perspective (**Figure 1.27**). Mannerism wanted to rebel from its older sibling, but its artists just weren't ballsy enough to commit. It was anti-classical, if only as a natural evolution from the ways in which the Renaissance was classical. As it developed, mannerists highlighted intellectual conceits and artistic virtuosity expanding on the skills refined during the High Renaissance. This was a departure from the very period it idolized, which used technical skill as a means to communicate Humanist ideals. The Renaissance was art imitating nature; Mannerism was art imitating art (**Figure 1.28**).

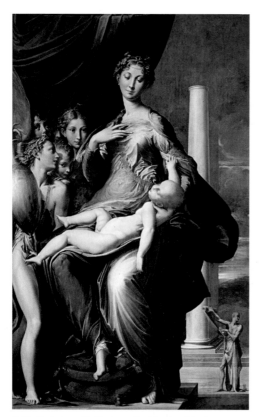

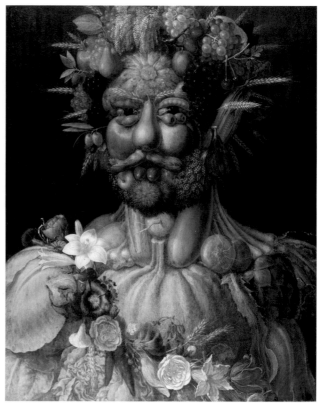

1.27 *Madonna with the Long Neck* by Parmigianino, ca. 1535–40. Beware of the tiny man with a big scroll.

1.28 *Vertumnus* by Giuseppe Arcimboldo, ca. 1590–1591. At the far end of Mannerism with a firmly entrenched connection to nature was Arcimboldo. His almost surrealist portraits derived from still-life—which paved the way for (and influenced) artists such as Salvador Dalí.

Mannerism sought to exaggerate elegance, paying great attention to surface and detail. It regularly featured hyper-stylized, porcelain-skinned figures with nearly farcical proportions, basked in tempered and finely controlled, almost theatrical light. Artists rarely displayed emotion on their subjects' faces, presenting them as (at best) aloof or (typically) cold. Clearly, mannerists were the first fashion photographers.

NOTABLE ARTISTS

Notable artists from the Mannerist movement include: Parmigianino, Pontormo, Bronzino, Titian, El Greco, and Guiseppe Arcimboldo.

GOING FOR BAROQUE (1580–1750)

European art prior to the Renaissance maintained a relative ubiquity no matter the country it came from. It was not until the printing press and the rock-star status (and money) afforded to Renaissance artists that several countries began developing their own unique styles—many of which, for the sake of brevity, are grouped into this category. This was perhaps the first moment in history when art saw the development of national distinctions. Keeping this in mind, it is best to view this period as a collective whole, as a linear chronology of its spiderlike development is virtually impossible to follow.

Baroque, a Portuguese term meaning "irregular pearl," was initially used as a disparaging nickname for the art created during this time, and the nickname stuck. The Baroque movement was a reply to the overly stylized work of Mannerism and owes its origins to the Council of Trent (1543–1563), the Catholic Church's response to the Protestant Reformation. The Council set out to reform Church doctrine including the handling of religious art, which is to say the Church would use a method of "cultivating faith" (i.e. propaganda). Art commissioned by the Church was to be powerful and moving, easy to understand, and rooted in realism, giving the viewer a sense of direct relatability to the struggles the average person faced regularly.

The characteristics that identify the Baroque period are: exaggerated, dramatic movement and gesture, a sense of space through the use of dynamic and exaggerated contrast of light, impactful asymmetric and diagonal compositions, and a high degree of realistic detail. The work was often heavily tied to the leanings of the Church but with clothing contemporary to the time.

Caravaggio, born Michelangelo Merisi (**Figure 1.29**), is perhaps the most identifiable figure of this period. The name we know him by is actually the town where he grew up. Caravaggio painted with profound gravity, giving mass to previously elevated characters. His subjects emerged from shadow with an emotional and physical presence that helped define an entire movement. His work had an almost photorealistic sense of naturalism. The extreme contrast (a defining characteristic of Baroque) he used was supported by what almost appears to be theatrical lighting. This method of using harsh, abrupt transitions of light from shadow to highlight as a compositional device is known as chiaroscuro (lighting subjects with a dramatic shaft of light from an unseen source) and was used about 100 years before Caravaggio, but he rocked it harder. This style of painting would become known as Tenebrism, which literally means "murky," and is credited to Caravaggio as the creator even though other notable artists used it earlier (Dürer, El Greco, and Tintoretto, for example).

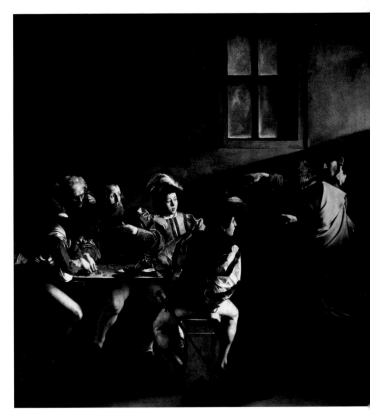

1.29 *The Calling of Saint Matthew* by Caravaggio, ca. 1599–1600. Notice the hand and its similarity to Michelangelo's creation scene on the Sistine Chapel ceiling.

The use of dramatic light and hefty compositional weight of shadow is central to our foundations of the dramatic portrait and is considered by some to be the nascence of modern painting.

There is an obvious duality within Caravaggio's work: we see a notable attempt to capture and perhaps rectify the turmoil (or at least the struggle) between personal (if even self-inflicted) torture and the quest to glorify the divine. The work sometimes appears to be a writhing battle of light and darkness with its human figures performing (or dying) in the midst of that battlefield. Caravaggio's life was not without that same, twisted contrast. As he was successfully working on commissions for the Church, he was something of a rebel. And by rebel, I mean he killed a guy. A

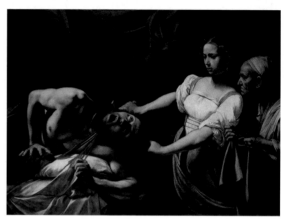

1.30 *Judith Beheading Holofernes* by Caravaggio, ca. 1598–1599.

bit of a hothead, Caravaggio was known to get into a brawl or a swordfight. He was a violent man—slashing a courtesan on the face (called a *sfregio*, a devastating mark for someone in the skin trade) for her refusal to sleep with him—and his work was sometimes just as violent. His *Judith Beheading Holofernes* (**Figure 1.30**) is brutal in its rendering of a decapitation, blood spurting from a neck with the enthusiasm of a Tarantino movie.

He used both male and female prostitutes as models (reportedly he indulged in both), including one (possibly his mistress) as Mary in *The Death of the Virgin*. Caravaggio was also known to show the bottoms of feet in his work (considered unseemly for respected subjects), as seen in the first version of *Saint Matthew and the Angel*. After receiving a death sentence by the pope for killing a guy, he fled Rome, leaving in his wake brawls and confrontations across Italy and one with a knight in Malta. That knight and his friends caught up to Caravaggio, attacking him in a tavern and cutting his face (which seems vaguely appropriate), in turn irreparably scarring his reputation and feelings. On his way back to Rome to receive a pardon for his earlier murder (because even then, all would be forgiven if one had talent...), he succumbed to his tavern injuries (some theories suggest long term lead poisoning contributed to his inability to recover), died on a boat, and was buried in an unmarked grave.

NOTABLE ARTISTS

Notable artists from the Baroque period include:

- British: William Dobson
- Flemish: Peter Paul Rubens, Anthony van Dyck, and Jan Brueghel the Elder
- French: Nicolas Poussin, Valentin de Boulogne, and Charles Le Brun
- Italian: Caravaggio, Giovanni Baglione, Artemisia Gentileschi, and Gian Lorenzo Bernini
- Spanish: Diego Velázquez, Francisco de Zurbarán, and Claudio Coello

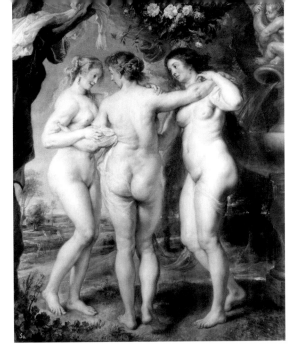

1.31 In Italy, Velázquez painted multiple works including *Portrait of Juan de Pareja*, ca. 1650, the subject of which is his former slave turned free man and assistant (and who became a painter in his own right).

1.32 *The Three Graces* by Rubens, ca. 1635. Rubens liked big butts.

In Spain, Diego Rodríguez de Silva y Velázquez was, along with El Greco, one of the most significant painters of the Spanish Golden Age (**Figure 1.31**). His early work draws recognizable similarities to Caravaggio's naturalism. Around 30 years old, Velázquez left Spain twice to study in Italy, where he was heavily influenced by Tintoretto and Titian. Upon his return, he became a court painter for Philip IV of Spain, culminating in his masterpiece, *Las Meninas*. He would go on to influence Manet, Picasso, Bacon, and Dalí. Dalí even modestly conceded, "Compared to Velázquez, I am nothing, but compared to contemporary painters, I am the most big genius of modern time..."

Additional artists of note include Flemish painters Peter Paul Rubens (**Figure 1.32**) and Anthony van Dyck. Rubens was classically educated in the humanist ideals of the Renaissance. He created over 1,400 works of art, was a diplomat, designed his own house, and married his dead wife's 16-year-old niece at 53 years of age. He was a classy fellow.

Rubens' most important student was Anthony (or *Antoon* if one is picky) van Dyck (**Figure 1.33**), who was something

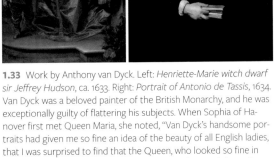

1.33 Work by Anthony van Dyck. Left: *Henriette-Marie witch dwarf sir Jeffrey Hudson*, ca. 1633. Right: *Portrait of Antonio de Tassis*, 1634. Van Dyck was a beloved painter of the British Monarchy, and he was exceptionally guilty of flattering his subjects. When Sophia of Hanover first met Queen Maria, she noted, "Van Dyck's handsome portraits had given me so fine an idea of the beauty of all English ladies, that I was surprised to find that the Queen, who looked so fine in painting, was a small woman raised up on her chair, with long skinny arms and teeth like defense works projecting from her mouth..."

of a teenage prodigy. Although one can recognize similarities to Rubens' work, van Dyck's sensibilities show more restraint, especially when depicting the human form, and even more specifically the individual subject's essence—the personality extending beyond the confines of the sitting's formality. Once garnering some success, van Dyck followed up with a valedictory hand gesture of "deuces" and pranced off to England, where he was celebrated, famous, knighted, and owned vacation

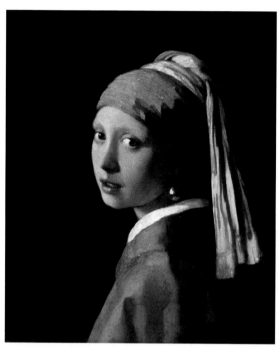

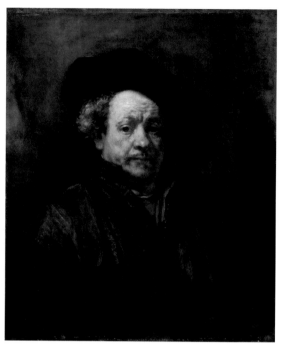

1.35 *Girl with a Pearl Earring* by Vermeer, ca. 1665. The black background helps to create separation from the subject and a three-dimensional effect. Notice the soft pose, how casual and fleeting—a direct counterpoint to the directness of her gaze. Her lips part as if about to speak. But then she doesn't because she's a painting.

1.36 *Self-Portrait*, Rembrandt, ca. 1660.

Not fully appreciated until the 19th and 20th century (with the rise of Impressionism), Johannes Vermeer (**Figure 1.35**) now stands as one of the greatest Dutch painters of all time. Of the 35 or 36 surviving pieces (it is believed he may have painted up to 60), at least eight are considered masterworks—a ratio that perhaps no other artist can claim. Vermeer was not tremendously popular in life, but has become an icon in death—the value of his work not fully appreciated until it could be viewed with a contextual eye. At first glance, it can be easy to dismiss Vermeer as boring in much the same way that William Eggleston is boring. But upon further study, the window opens.

Vermeer was a product of his time in nearly every conceivable context, which gives us the ability to view the daily life of the Dutch in an honest way. He captured what was there, quite literally if one considers the probability that Vermeer used a camera obscura or mirror system to reproduce tonal and shadow gradients that would be nearly indistinguishable to the human eye. There is nothing overt, shocking, or even dramatic about the work; there is not supposed to be. There is no hurry. No tension. As the Dutch were reserved, introspective, and exercised restraint to an extreme degree, Vermeer's work was a reflection of those ideals. The people within his scenes harmoniously contribute to the composition, adding balance without overpowering it. Nearly every (if not every) element (person or object) lends itself to a compositional *and* contextual purpose. As a good portrait seeks to portray a subject's inner essence, Vermeer sought to do so with environments

(although he often used the same one). His eye for detail, whether crafting reflections, shadows, highlights or textures, was uncanny. Despite coming from money and being a respected artist, art dealer, silk trader, and landlord about town in his time, dire economic conditions and having 15 children (10 of which survived beyond baptism) meant he died poor and left his widow broke and with mountains of debt. But people think he's important now, so that helps.

Finally, Rembrandt (**Figure 1.36**). His work, though perhaps the definitive embodiment of the Dutch Golden Age, has transcended the period from which it was conceived, and while it technically exists within the Dutch Golden Age movement in the Baroque period, Rembrandt exudes impact far beyond his humble origins. Unlike artists of the Renaissance, Rembrandt van Rijn appeals to the everyman. Looking at something like the Sistine Chapel (or a virtual multitude of most things created during that time), trying to process the scope alone can be overwhelming; it is difficult to fathom the creation, which astounds the viewer at the onset, much less the work itself. This coupled with the aim to elevate the form to its purest and most elegant ideals can leave many unable to relate.

Rembrandt is different. He does not paint with grand allusions to antiquity, nor does he portray the beauty of the form; it is the opposite. Rembrandt is honest in the way he captures the subject. Rembrandt did not care to make the subject look noble or glorified or perfect, but his genius in capturing the nuances of human expression make him innately more relatable to everyone in the cheap seats.

Whereas the Renaissance is the "Perfect 10" that causes words to incoherently mumble out of the mouth of anyone trying to ask someone to a movie (I'm looking at you, 1980s Rob Lowe), Rembrandt is the trope next door. He's Winnie Cooper, Topanga, and Joseph Gordon-Levitt all rolled into one.

We believe Rembrandt's portraits because he, to many, created with a sensibility whose core is rooted in the viewer's ability to relate to it. His rejection of those ideas and pursuit of "truthiness" spoke to those who did not (or didn't care to) understand the High Renaissance art that was elevated to a pedestal without their consent. Rembrandt captured his subjects as they were, with no apologies or elevation. In doing so, however, dignity and reverence were often generated as a byproduct. Of course, Rembrandt also drew a woman peeing (**Figure 1.37**).

Rembrandt and the painters of his period were a significant departure from the Baroque artists and what was being developed in the wake of the Renaissance. In fact, Rembrandt's contemporaries, the Calvinist Dutch, had more in common (at least theologically) with Medieval sensibilities—despite the fact that its visual manifestation was natively more dimensional (like the Italians). Even though the Dutch strove to depart visually from

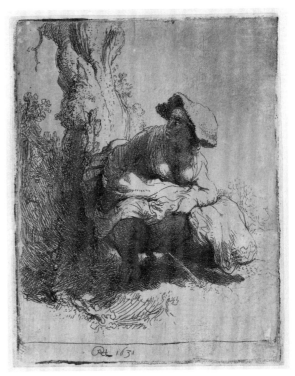

1.37 *A Woman Making Water* by Rembrandt, ca. 1631. Actually a thing.

their ostentatious predecessors, they could not deny that making people look three-dimensional was just a little bit cooler.

One of Rembrandt van Rijn's most significant contributions to portraiture was the manner in which he depicted the emotional gravity of his subjects. Even in his religious works, which were historically portrayed by other artists with stately, unapproachable formality, and which seem more accessible, the emotions of even the most divine congregants were weighed down by the severity of the human condition. Dutch artists captured how people lived, and Rembrandt, like Hals, captured the emotional component of that living. Unlike Hals, Rembrandt's work was considerably more solemn—most likely due to his rather depressing life. In his early 20s, Rembrandt moved from his hometown of Leiden to Amsterdam, where he married into a wealthy family. This led to substantial comfort, a home, a collection of art and antiques, and at some point becoming one of the most sought-after painters in town. About a decade later, his wife died, rendering him a widower with a one-year-old boy. His life promptly went south due to mismanagement of money (and a diminished revenue stream), which saw his debt burying him, his collection of art and antiques auctioned off, and his existing patrons being unimpressed with his largest commissions—ironically work that is now viewed as some of his most important.

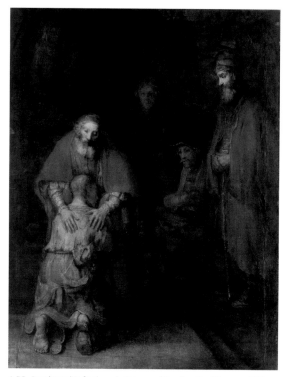

1.38 Rembrandt's final work, *Return of the Prodigal Son*, ca. 1668, is a master class in emotive expression. In a simple setting, utilizing restrained, harmonious coloring, our attention falls solidly on the event, a well-known story told through familiar eyes of homecoming, forgiveness, and the illumination given by spirituality in an otherwise dark world, granting mercy to those who would ask for it.

He lived out the last 20 years of his life relatively cut off from the world. During these hardships, he was taken in by a friend who supported him and his son. Growing more and more introverted—and outliving his friend by six years and his son by one—he died the Dutch way: poor, alone, and in an unmarked grave. However, in spite of all the sadness, Rembrandt's work continued to develop expressively (though not stylistically) until the very end—something very few great artists are able to posthumously claim (**Figure 1.38**).

Rembrandt's light is perhaps what photographers today know him best for—the triangle of light under the unlit side of the face—created with the soft light from a window (**Figure 1.39**). The light as a compositional device—commonly associated with Baroque artists—is visible in Rembrandt's work, especially in his biblical scenes—appearing with a narrative purpose (à la God himself). Rembrandt's teacher, Pieter Lastman, studied in Italy, so the impact of Caravaggio would have been substantial. Even in Rembrandt's portraiture, light is an important compositional element both for the subject and the separating of the subject from the background.

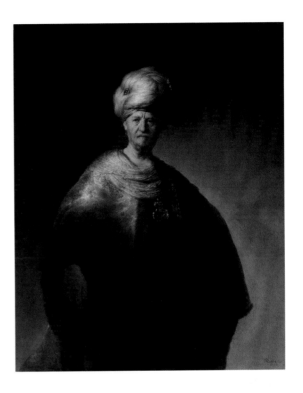

1.39 Above: Rembrandt's studio in Amsterdam, The Netherlands. Right: *Man in Oriental Costume*, ca. 1632.

NOTABLE ARTISTS

Notable artists from the Dutch Golden Age include: Jan Stein, Frans Hals, Johannes Vermeer, Rembrandt van Rijn, Pieter de Hooch, Pieter Claesz, and Gerard van Honthorst.

For Rembrandt, no matter which style he was painting (portrait, allegorical, or genre), the motif throughout was man. His biblical stories were less grandiose and more personal. His portraits were expressive and often solemn. He created nearly 100 self-portraits over 40 years made up of paintings, drawings, and etchings—not a form of vanity, but an exploration of self-awareness and introspection. If the thread throughout his work was man, "knowing thyself" (the one person we have the capability of knowing more than any other) was Rembrandt trying to understand the human condition through his own experience. Self-awareness is not only crucial in the evaluation of one's work, but invaluable in the channeling of a creative vision through that experience. Rembrandt's work speaks to the viewer in a wholly personal way, because it speaks to what humans, no matter the time and place, have and will always feel.

YOU GO, GLEN ROCOCO (1700–1785)

Sometimes referred to as Late Baroque, the Rococo period is a highly ornate and decorative movement that developed in France during the early part of the 1700s as a direct response to the heavy, imposing style of the Baroque period. Although this period is most notable as a style of interior design, its influence (like the Baroque period before it) permeated architecture, furniture, gardening, sculpture, music, and painting. Its swirls, curves, and (perhaps overly) ornamental design have garnered criticism, calling it frivolous, excessive, and ostentatious. Famously, Versailles is the embodiment of this period, and it became an avatar of a revolution.

Coinciding with this artistic period was the Age of Enlightenment—a philosophical and intellectual movement that originated in France (historians mark the span of time as starting with the death of Louis XIV in 1715 and ending with the French Revolution, which began in 1789). This period embraced a modern, unique set of ideas: liberty, religious tolerance (a far cry from the Catholic Church's influence during the Baroque period), science, reason, and logic. This is an important tangent to Rococo art; as sociopolitical authorities were loosening their grips on society, art was used less and less as a propagandist tool and was being created largely for the sake of it. Hence the vacuous, yet super pretty, aesthetic of the Rococo period.

This is not to say art was dismissed culturally—quite the opposite in fact. When a generation has an expanding middle class, more people seek education in the arts. This coupled with the cultural adoption of coffeehouses (you thought meeting in coffeehouses was a modern invention?) resulted in people from all walks of life being more receptive to conversing with other like-minded individuals to further intellectual pursuits and facilitate their morning constitutionals. This was an important facet of introducing gender diversity as well. Women, for the first time in history, were common figures on the art scene.

Visually, this period employed lighter sensibilities with curvaceous flourishes; the heavy, dark colors of the Baroque gave way to pastels and flowery bits (**Figure 1.40**). The textures of clothing began to appear different, often having a noticeable sheen or sheerness; even the pieces that may still be heavy and cumbersome at least *appear* lighter. Painting overall employed less shadows, and even the ones with shadows are much brighter. In addition to its visual stylings, the content often included (relatively mildly) scandalous themes—basically over-the-clothes stuff only, and nothing below the waist. This style of art was criticized by art critics (which seems a little redundant—one wonders if their very etymology allows them to have anything nice to say at all) and many Rococo artists evolved their style into what is now referred to as Neoclassicism.

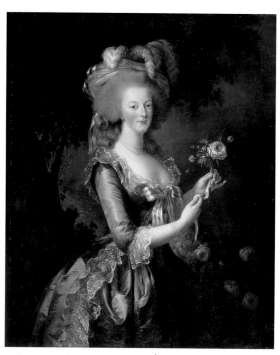

1.40 *Portrait of Marie Antoinette* by Élisabeth Louise Vigée Le Brun, ca. 1783.

NOTABLE ARTISTS

Notable artists from the Rococo period include: Jean-Antoine Watteau, Élisabeth Louise Vigée Le Brun, Jean-Honoré Fragonard, François Boucher, Sir Joshua Reynolds, Jean-Baptiste Greuze, Jean François de Troy, Maurice Quentin de La Tour, Charles-André van Loo, and Pompeo Batoni.

NEOCLASSICISM, OR: WHY YOU *CAN* GO HOME AGAIN (1750–1860)

The birth of Neoclassicism (**Figure 1.41**) occurred when the Age of Enlightenment reached Rome (elevating reason and dignity), which led to Italian artists' rejection of the excessive Rococo style currently all the rage. Neoclassicism was a resurgence of 16th century Renaissance Classicism (*neo* means new and *classic* means of the highest rank). By now, you may be catching onto the inception happening here: the Renaissance was a revival of antiquity, and Neoclassicism was a revival of the Renaissance, turning this particular timeline of art into one giant session of "*self-congratulating.*" Kind of like how Hollywood keeps remaking movies for lack of original ideas.

NOTABLE ARTISTS

Notable artists from the Neoclassicism period include: Anton Raphael Mengs, Elizabeth Alexeievna, Jacques-Louis David, Jean-Auguste-Dominique Ingres, Angelica Kauffman, and Antonio Canova.

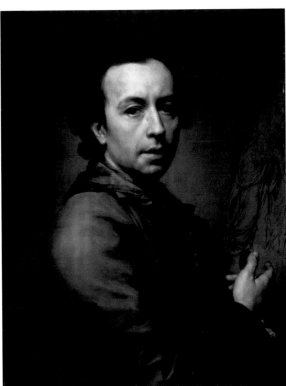 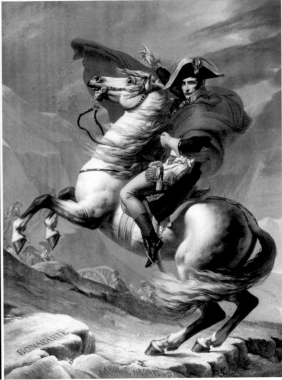

1.41 Left: *Self-portrait* by Anton Raphael Mengs, ca. 1774. Right: *Napoleon Crossing the Alps* by Jacques-Louis David, ca. 1802.

A contributing factor to the spread of this movement was something called the Grand Tour. Evidence has shown tours dating back to the late 1600s, but the idea of young men and women of means traveling Europe from France to Italy, soaking up art and culture, reached a fever pitch during the mid-1700s. The rediscovery of "classic" art led to an increase in antiquing and styling homes and architecture in the Renaissance way—which was really just ancient Greek and Roman.

Neoclassicism favored simplicity and symmetry over elaborate embellishments (à la Rococo) and dynamic gesture and movement (à la Baroque). The term is used to describe painting, sculpture, architecture, fashion, and interior design, but architecture, sculpture, and design are where its most notable contributions lie. As this movement is simply a copy of a copy, it does not garner the pedestal of other artistic movements. The moment petered out near the end of the 19th century, but ironically, as an architectural movement, it stuck around much longer. Neoclassicism was a significant stylistic component of the American Renaissance (a self-guided notion that America was the heir of Greek democracy) from the late 1800s to early 1900s, and many large buildings in Washington, DC, were built in this style.

ROMANTICISM (1800–1850)

As artists have feelings—and as the Age of Enlightenment was meant to be an age of logic and reason—Romanticism (**Figure 1.42**) came about as a sort of "Counter-Enlightenment" meant instead to celebrate emotion and imagination, with its grandest ideas derived from the Medieval Ages instead of the classical Renaissance—King Arthur medievalism instead of Machiavellian classicism. Not only a response to the Enlightenment, Romanticism also counteracted the Industrial Revolution and society's emphasis on the masses over the individual. The movement largely projects a necessitation of strong emotional response as the core of what it is trying to communicate, from horror to awe—the latter of which is especially prevalent in landscape painting. It is at this point in history that the hierarchy of genres is challenged and formally done for (landscapes were previously near the bottom). A contributing factor was a new ideology among artists that rejected the scholarly pursuits and academies, instead perusing personal creativity and feelings as the genesis of "great" art. An artist creating work from the ether was crucial to this movement, as not being original was tantamount to "sin."

Romantic artists held a high regard for nature; this is especially noticeable with the landscape paintings during this time. They are nothing short of epic with heroic mountains and the storms that would battle them (**Figure 1.43**). An artist's work, similar to today's climate, was created with a personal voice—a voice that could be *felt* by the viewer of the work.

NOTABLE ARTISTS

Notable artists of the Romantic period include: Francisco Goya, Théodore Géricault, Eugène Delacroix, Thomas Cole, William Blake, Louis Janmot, Anne-Louis Girodet de Roussy-Trioson, and Caspar David Friedrich.

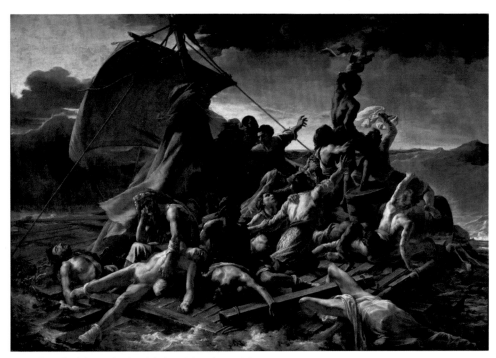

1.42 *The Raft of the Medusa* by Théodore Géricault, ca. 1818–19.

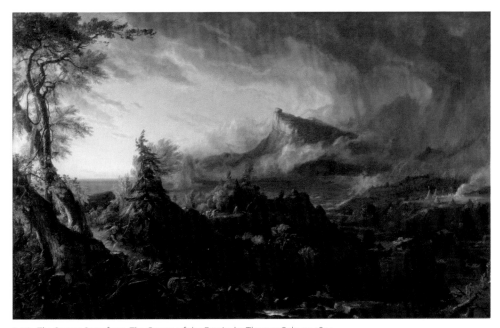

1.43 *The Savage State* from *The Course of the Empire* by Thomas Cole, ca. 1834.

THE BIRTH OF PHOTOGRAPHY (1826–1827)

With the proliferation of photography today it can be easy to forget that as a medium it is still in its relative infancy compared to the visual arts that have been around for thousands of years. As of this writing, photography is not even 200 years old and yet is the most common (and perhaps most important) visual medium in the world.

For a medium with overwhelmingly technical origins, the duality of what drives photography (and what it means) will continue to evolve. In 1826 or 1827, Nicéphore Niépce created a photograph—the oldest surviving one—called *View from the Window at Le Gras* (**Figure 1.44**). It was a long exposure (Niépce noted eight hours, but researchers, using his notes, estimate it at several days) from his window in France. Few people were shown his result, and due to his unwillingness to divulge his processes, he failed to garner any notoriety and died shortly after.

In 1839, Louis Daguerre and Henry Fox Talbot both announced their processes for recording images (at this time referred to as daguerreotype and talbotype—or calotype), which had yet to fall under the same umbrella term of photography. Daguerre's process created a singular image on a thin copper sheet whereas Talbot produced a negative on paper, which could be used to create duplicate images. Daguerre professed his invention "free to the world"—and it spread hungrily. Talbot, on the other hand, sought to nickel and dime the world and sold individual patent licenses for his process. Talbot was the "airline charging for your first checked bag" of early photography. Imagine which method took off.

Daguerreotypes (**Figure 1.45**) were largely portraits; this played an integral role in developing the way modern photography exists in the world—and especially why it is unique from all other art forms. In the beginning, photography—compared to the classic arts—was marginalized. This was due partly to commerce being injected into its very DNA. Money (afforded by commerce, not value) was an early motivator to the purpose.

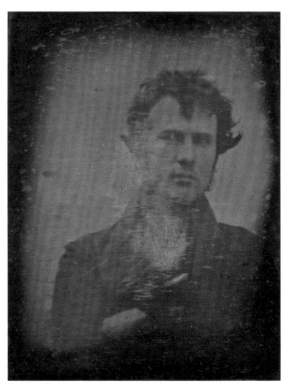

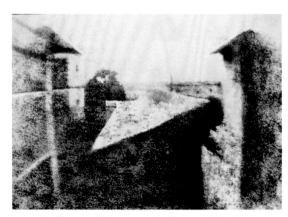

1.44 *View from the Window at Le Gras* (enhanced) by Nicéphore Niépce, ca. 1826–27.

1.45 Robert Cornelius, the first portrait (and self-portrait), ca. 1839.

Photography is a representational medium. It was originally meant to document and do so without subjectivity, and in the case of portraiture (which was the subject matter for a vast number of early photographs), it was simply intended to document the very idea that the sitter existed. In the past, only people of means could afford to have a portrait painted, but photography's democratization changed that. And with all these portraits being commissioned the commercial aspect of the medium could not be ignored. By the beginning of the 20th century, for the first time, someone regardless of social status could know what his or her ancestors looked like.

Photography's popularity created professionals converted from a multitude of other trades, many of whom had no formal skill, training, or adherence to the old ways of doing things. It was a time of tinkering, perseverance, and accident—all of which were often required to develop as a photographer. By the mid-1850s, millions of images were already being produced every year—so many and so often that few stopped to think about "art."

The early days of photography had many photographers trying to replicate sensibilities of other visual mediums—some saw this as the only way to give

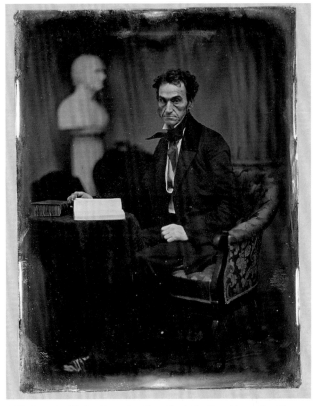

1.46 *Portrait of Rufus Choate* by Albert Sands Southworth, ca. 1850. The pose, environment, and props are mimicking the more traditional, formal portrait painting.

credibility to the form (**Figure 1.46**). Talbot's work developed out of an inability to sketch a landscape, which independently can be viewed from the perspective of creating "art" without the skill. It was not for many years that photography would be taken seriously as its own unique brand of art.

Then a giant leap happened. In 1905, Alfred Stieglitz opened *291* (originally called Little Galleries of the Photo-Secession) in New York City, the first important photo gallery. This gallery did not just exhibit photography; it also showed the work of Matisse, Rodin, Cézanne, and Picasso. In doing so, it helped to elevate and firmly establish photography's place as a reputable artistic medium. The *291* gallery showed us the first glimpse of what photography would later become. It was from this location in 1910 that a purchase by the Albright Gallery in Buffalo would give credibility to photography as an art form worthy of a museum. Photographic art became a credible commodity and shifted where the value existed. This changed photography's motivation and approach. A painting or sculpture can only exist in a singular place. A photograph can appear in a magazine, and the *same* photograph can appear on a gallery wall. Stieglitz reinforced this exact concept by starting a magazine called *Camera Work* that would do just that. This is the first duality of photography—the duality of purpose—and part of what makes it so special; it belongs to the masses as much as it belongs to the arbiters of fine art.

PICTORIALISM (1885–1915) VS. MODERNISM (1910–1950)

Toward the end of the 1800s and into the early 1900s, Pictorialism was the driving stylistic movement of photography. This was one of the earliest ideas about what photography was declaring itself to be beyond a literal recreation of what was *just* in front of the camera. Pictorialism refers to the movement when photographers set out to create the image, adding intent, narrative, and purpose (with an artistic lean) to their work. This stirred debate in the art community about photography's true purpose; was it to document reality or to produce art?

The differences between what made a "good" photograph and an "artistic" one were debated in the public forum by the turn of the century. Visually, Pictorialism was often soft or out of focus (alluding to the impressionistic style popular with painters), toned with color (one or many), and sometimes texturized with brush strokes in the development process (**Figure 1.47**). Pictorialists were the first significant group of photographers viewed as artists, and they did it without goatees and fedoras.

Toward the end of the Pictorialist movement—in the first two decades of the 20th century—the idea of creating art with borrowed sensibilities evolved, and photography came into its own by embracing the medium in a way only a photo could—with sharpness. Creating imagery with the (relative) sharpness of (then) modern cameras was a radically new idea. This involved rejecting most previously established conventions and shifting toward an entirely new kind of artistic expression. This phase marked the turning point for painting in particular.

Once it was established that a photograph could capture reality in a realistic way, painting largely gave an "Irish goodbye" to the party of representational art and left to greener pastures of moments unique to the medium. It had spent generations honing the craft representing a scene or person, and then photography shows up late, nails reality, and captures it in a relatively short span of time. Painting has a revolution of expression and creates work that photography cannot: Impressionism, Fauvism, Surrealism, etc. Some photographers were able to create work within these movements (Man Ray, for example, was a Surrealist), but the movements belong largely to the painters.

NOTABLE PHOTOGRAPHERS

Some notable photographers of this period include: Louis Daguerre, Henry Fox Talbot, Nicéphore Niépce, Alfred Stieglitz, Edward Steichen, Edward Weston, Brassaï, Ansel Adams, Henri Cartier-Bresson, Man Ray, Margaret Bourke-White, Alfred Eisenstaedt, Robert Capa, Dorothea Lange, Yousuf Karsh, Diane Arbus, Robert Frank, and Walker Evans.

1.47 *A Study Head* by Eva Watson-Schütze, ca. 1901.

1.48 Left: *Migrant Mother* by Dorothea Lange, ca. 1936. Right: *Portrait of Georgia O'Keeffe* by Alfred Stieglitz, ca. 1918.

Photography's revolution was its doubling down on reality—grit, brutal honesty, and above all, sharpness. Embracing sharpness meant the photographer could describe a moment better than the human eye. Modernism (**Figure 1.48**) was "pure" photography—no soft lenses, no unique printing or developing methods. It embraced what a camera could do and then pushed it further. Many great photographers began in Pictorialism and transitioned to Modernism (like Alfred Stieglitz, Edward Steichen, and Edward Weston). *Group f/64,* an assembly photographers that included Ansel Adams and Edward Weston, was born of the Modernist movement—seeking to represent the world as dynamically as possible (both through sharpness and often dynamic range). Adams's zone system was born out of a desire to capture the world in a more realistic way. Keep in mind the goal was not technical proficiency but rather was a means to express the idea they were trying to articulate. After nearly 100 years of adolescence, photography began to understand what it was and where it belonged in the world.

PHOTOGRAPHY COMES INTO ITS OWN (1962–PRESENT)

For several decades, photography continued to mature its voice within culture and society, inspiring and being inspired by other mediums developed within the global village. Photography expanded its impact across many genres (its beginnings were largely commercial portraiture), but especially in documentary work. Interestingly, documentation (which now exists as its own category within the medium) has always been photography's great war. Originally, for many, photography served as

proof of life—a document that the individual existed. When it shifted to *291*, photography had a different voice. That voice developed from Pictorialism into Modernism—a movement that formed so much of how photography is utilized today.

In the 1960s modern photography as we know it was defined, and that development is largely credited to one person. In 1962, Edward Steichen, Director of Photography at The Museum of Modern Art (MOMA) in New York, selected as his successor John Szarkowski, someone who would change the world of photography. Szarkowski's largest contribution was perhaps the advancement of the idea of the narrative within photography. Of course, one is not dismissing that photographers had to create the work itself, but Szarkowski was the foremost authority on what was happening in photography at the time and had the greatest singular impact on guiding it.

The origin of the medium was technical—to document reality objectively. Szarkowski championed (and defined) the narration of the photograph and shifted the social consciousness from pure documentation to an *idea* of reality. He taught people how not to just look at a picture of someone's grandma, but how to look at that same image as a visual metaphor of *one's own* experience. Welcome to postmodern photography—beyond reality into subjective reality.

In 1978, "Mirrors and Windows," the show curated by Szarkowski, divided images into two categories: those that would reflect and reveal a meaningful experience of the world, and those that would allow the viewer to observe a pure documentation. These components, whether one is conscious of them or otherwise, are the engines of the "whys" of photography.

Another of his significant contributions to photography was the celebration of the mundane. Banality was a way to fight the idea of what photography was born as—something commercial—and revel in the opposite. Photography was a visual medium and until then had been viewed and judged with the same criteria as the classic forms; Szarkowski believed that photography was different—born of a modern age, it should be judged by modern conventions.

Paintings were made from pigment and materials and created from the ether, but a photograph was taken; it was selected. His approach for curation? Szarkowski claimed, "...an answer would not be found by those who loved too much the old art forms.... These new ways might be found by men who could abandon their allegiance to traditional pictorial standards—or by the artistically ignorant, who had no allegiances to break." His approach was entirely new.

In his time, Szarkowski defined photography's intent and did so loudly. He curated many shows featuring the work of some of the greatest names in the last 100 years of photography. In 1976, he controversially exhibited the first show of color photography at MOMA by an unknown photographer named William Eggleston. The images were called "banal" and "boring" by *The New York Times*. Szarkowski knew better. He called them "perfect." Until then, the art community was oblivious to what photography had the power to reveal—that it could elevate the importance of something seemingly insignificant. Szarkowski defined the idea that the banal can be poetic. It is through that banality that more meaning can be revealed and drawn—showing the beauty or significance of even the most cursory moments. Perhaps no other single person has been more influential in modern photography—and not even because of his own images but because of his vision of what photography was and would become.

NOTABLE PHOTOGRAPHERS

Some notable photographers of this period include: John Szarkowski, Irving Penn, Richard Avedon, William Eggleston, Garry Winogrand, Elliott Erwitt, Saul Leiter, Bruce Davidson, Martin Parr, W. Eugene Smith, Nan Goldin, Helmut Newton, and Sally Mann.

WRAP-UP

If you've made it this far, congratulations. A flyby of the history of visual arts—with a focus on portraiture—is no small endeavor, and to truly appreciate where we are going it helps to have a general sense of where we have been. Art has existed as a way of understanding, recording, or beautifying the world since we lived in caves. It has its own rich language full of depth, history, and nuance, and it has been contributed to by some of the greatest human minds—some through incredible struggle, blood, sweat, tears, and even death. The process has helped lead us to a greater awareness of visual ideas, so that the visual decisions you make going forward can embrace the past or outright reject it. At least now you can make that choice consciously. What you create is your interpretation of all these struggles.

The beauty of photography is its unique ability to communicate in a way unlike other visual mediums. It is meant to be a fraction of time, yet a moment frozen for as long as the photo exists. It can transport a stranger somewhere they have never been or record an intimate personal memory of the creator. A film or movie (which is just many photographs viewed together quickly) can tell the viewer a whole story with a beginning, middle, and end. A photo does not need you to know the end. If filmmaking is the long-form narrative, then photography is poetry. And poetry does not require a resolution—the ending is your interpretation, your applied narrative. What you choose to do now is up to you...but hopefully it involves reading the next chapter.

CHAPTER TWO
TECHNICAL LIGHTING

THE TOOLS TO CONTROL LIGHT

The lighting portion of the book is split between the technique and the application of that technique—first answering "how" something is done and then answering "why." The hows and whys are inextricably entangled in a successful photograph, and hitting both of those points shows mastery of the technical medium. In this chapter, the hows will allow us to delve into concepts like modifiers, positioning, and lighting ratios. The whys will allow us to explore the concept of light more deeply and thoughtfully, as well as how we choose to use it as a tool for visual communication and accomplishing our visual goals.

The purpose of this chapter is to establish (or act as a reminder of) the foundations of our knowledge of technical lighting and how these concepts narrate how we think about light. The placement of light, shaping of light, ratios, and all these other terms will become our language as we communicate through dramatic portraiture. Lighting is an integral part of the end goal and an essential tool to convey mood and to help direct the eye where to look.

Think about what the concept of drama means to you. Is it darkness and shadow? Contrast? Expression? Mood? Kevin Dillon? A combination of all these things except Kevin Dillon? Mastering the ability to control these elements is a crucial step in creating drama for yourself. If you can understand, practice, and implement the concepts and techniques covered in this chapter, you will be ready to tackle the more advanced ideas ahead. Your visual narrative, although possibly complex, is spoken in a language fundamentally made up of only a few words. This section focuses on those words.

It is also important to note that whether you are using continuous lights, speedlights, or any number of strobes, there is one point that cannot be stressed enough—*light is light*. Someone capable of seeing and manipulating light can make a $50 Home Depot light look like a million dollars just as much as someone that does not know what they are doing can make a mess of a $10k lighting kit. Bigger may be better (and it usually is), but it still will not help you if you do not know how to use it. That said, there is great equipment available that can make your life easier, but this is a luxury and not a necessity. Other factors to consider when choosing lights: build quality, size, customer support, and choice of modifiers.

Lighting is more pure and simple than people who truly know it care to admit. Put light where you want it; block it where you don't. The trick, if one were to even call it that, is only knowing what you want.

HOW WE SEE

Before we can explore the different ways to use light, we must first look at not just how we see light, but how we see a photograph. What is it that we subconsciously notice first? The human brain is wired to pick up on certain things when first looking at an image:

1. **THE MIDDLE** We notice things in the center of the image first and work toward the edges (**Figure 2.1**).

2. **THE BRIGHTEST PART** Our eyes are attracted to the most luminous part of the image (**Figure 2.2**).

3. **AREAS OF CONTRAST** Our eyes also gravitate to contrast—either through luminance or complementary colors (**Figure 2.3**).

4. **HIGHLY SATURATED COLORS (WARM COLORS MORE THAN COOLS)** The more saturated a color is, the more our eyes notice it (**Figure 2.4**). Be careful not to overwhelm your viewer by making the entire image highly saturated. Use pockets of saturation to draw the eye exactly where you want it to go.

5. **HUMAN FACES** We recognize faces, even those that are out of focus or obscured (**Figure 2.5**).

6. **PATTERNS** We are drawn to patterns and shapes that don't occur naturally or often in nature (**Figure 2.6**). Additionally, we are not wired to appreciate the pattern but instead seek to find the break in the pattern. We find these "anomalies" visually compelling.

2.1

2.2

2.3

2.4

2.5

2.6

2.7 As our eyes are first drawn to the large area of white, it takes us a split second to recognize that the subject is the person walking up the stairs.

By knowing what the eyes and brain gravitate toward, we can choose to either reinforce those things, thereby not fighting the expectations of our visual perception, or hide elements in the parts of the image that may take the viewer a little longer to notice (**Figure 2.7**). This is known as delayed perception.

What we look at first is important. Stepping back and asking ourselves the question, *What is the purpose of the shot?,* is essential to the process. It is a seemingly simple concept, yet it is one that is often forgotten. In portraiture, the most significant part of the image is the person (their face in particular). In dramatic portraiture, we use the components of drama—darkness, shadow, contrast, expression, and mood—to shape our perception and feelings about a photograph, so it is fundamental to know how to direct that response.

CONTRAST

Much more than just a way to manipulate a photo in post-production, contrast not only visualizes shadows and highlights, but it also helps to translate the idea of depth. Dimensionality, the perception of an object's depth in an image, which is two-dimensional even though the real-world source is three-dimensional, is translated through highlight and shadow. Mastering this concept will help you control how to make elements pop out or recede into the background. Shaping contrast in your images is possibly something you are already doing without even realizing it.

Understanding contrast is quite simple and can all be explained through the histogram (**Figure 2.8**). In an image with higher contrast, there is greater disparity between the information in the highlights and shadows and less information in the midtones. In a low contrast image, there is *more* information in the midtones and less in the highlights and shadows.

2.8 Compare the two histograms. Left: high contrast. Right: low contrast.

Part of how we create contrast in portraiture is simply done by lighting the face (the highlights) with the other part being done by a lack of light on the background or unlit side of the face (the shadows). By doing this, we are guiding the viewer, simply, to look at the face. Through this particular method (lighting the face mostly and little else), we are also creating a low-key image (**Figure** 2.9). This concept can be done in reverse—with a high-key image. Either type of image is still dramatic portraiture. Drama is about mood, contrast, and depth, and there are many paths to achieve that goal.

LOW-KEY VS. HIGH-KEY PORTRAITS

LOW KEY Most of the information in the photo's histogram is to the left of center. This is not done through underexposing the image, but intentionally due to *dark* subject matter.

HIGH KEY Most of the information in the photo's histogram is to the right of center. This is not done through overexposing the image, but intentionally due to *light* subject matter.

2.9 Low-key (above) and high-key (facing page) dramatic portraits

Compositionally speaking, the concept of a lit subject on a dark background (or a dark subject on a light background) is the implementation of the Gestalt Principle (see sidebar) known as "Figure/Ground," which gives a clear distinction between the subject and background (**Figure 2.10**). This helps the brain clearly differentiate the foreground from the background by separating them using bright and dark tones (the foreground and the background can be either, as long as the other one is opposite). This can also

GESTALT PRINCIPLES

A set of theories developed by German scientists in the 1920s to explain how the human brain perceives and interprets visual information. They are divided into six ideas: Figure/Ground, Proximity and Grouping, Similarity, Continuity, Closure and Symmetry.

be accomplished through complementary colors and focus. Think of Richard Avedon's white background portraits (dark subject on a light background), Vermeer's *Girl with a Pearl Earring* painting (lit subject on a dark background; see Figure 1.35 in Chapter 1), or even the Edgar Rubin's "face/vase" illusion that plays on our brain's ability to subconsciously decide which tones are prioritized in order to determine which element is the figure and which is the background.

2.10 In the first image (above), we have a dark subject on a light part of the background. In the second image (facing page), the principle is illustrated in reverse with a lit subject on a dark background.

SHADOW

In addition to contrast, the next component of creating drama is shadow and darkness. In a dramatic image—especially ones in the studio—the unlit areas are just as important as the lit areas. They are the underexposed yin to your exposed yang (use caution when exposing said yang). Without shadows, we could not have the presence of depth, as highlight and shadow together work to give dimension. So, what exactly is a shadow? Let's refer to Ansel Adams's Zone System to categorize the tones of an image (**Figure 2.11**).

Imagine this numerical scale overlapping the histogram, dividing it up into 11 sections with zone five being the midpoint (middle gray). Using this as a gauge, we see that shadows live in zones zero through four. Zero, of course, reads pure black, and we ideally do not want any part of the image reading *clipped* in the original exposure. Pure black reads as a loss of information, and although it is not a bad idea to stretch out your histogram in post-production, it is preferred not to have it in the native raw file. When shooting low-key, dark images, it is advantageous to keep most of the shadow information in zones two through four to keep the shadow information malleable when developing the raw.

2.11 The 11 zones in Ansel Adams's Zone System.

CLIPPING

"Clipped" information is either pure black or pure white and represents the loss of detail from either underexposure or overexposure.

QUALITIES OF LIGHT

To control highlight and shadow in our images, we must first control light. Generally, the two most common descriptors of light are "hard" and "soft." Hard light is produced from a relatively small light source and creates light with hard-edged, well-defined shadows and specular highlights (**Figures 2.12** and **2.13**). Hard light also tends to accentuate detail in whatever surface it shines upon. That can work well when, for example, shooting a smooth object, but keep in mind that anything with texture (i.e. a human face) will have every detail exaggerated when shot with light even remotely to the side (which when used in portraiture, more post-production is generally required). This light can be very beautiful, but is not necessarily flattering—like the popular kids in high school, except that the light doesn't grow up to work at a tire store.

SPECULAR HIGHLIGHTS

The bright spot of light when it hits shiny objects (like skin) is a specular highlight. These highlights provide visual context for the light and help to illustrate the shape of the object that is lit and the relative location of the light source.

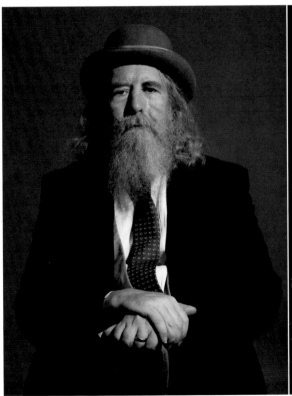

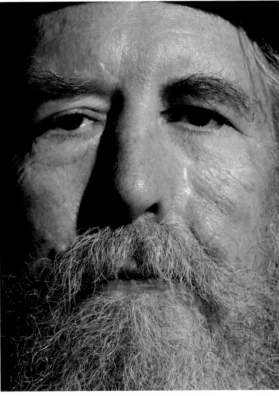

2.12 Hard light. Notice the crisp edges of the shadows and the quick transition from highlights to shadows. The shadows are dark almost instantly.

2.13 Notice the pronounced highlights and the prominence of skin texture.

Soft light, on the other hand, can still produce contrast, but the edges of the shadows are less defined and more gradual, and the highlights are less pronounced. Softer light is typically more flattering on most skin types (**Figure 2.14**).

There is, however, a wonderful gray area where light is neither truly hard nor truly soft—light that has contrast and specularity *and* is flattering and semi-soft. Certain modifiers produce this natively—parabolic (shaped like a parabola), silver-lined modifiers like the Broncolor Para 88 or the Westcott Zeppelin. This light is punchy and dynamic, but still manages to fall across your subject like a lady on a brass bed in a Bob Dylan song.

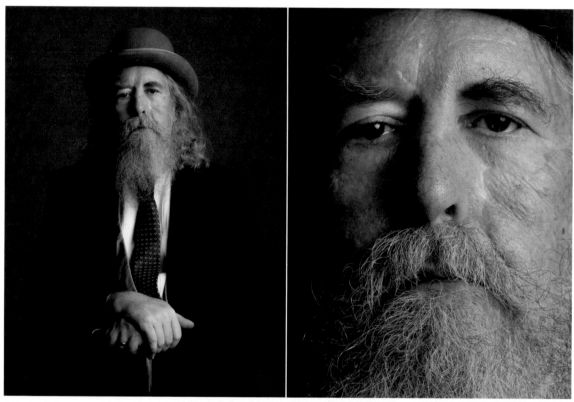

2.14 Soft light produces a less abrupt transition into the shadows and is generally more flattering on many skin types.

It is important to think about light not only as something we see the effects of, but also as something that moves through physical space and can be manipulated as such. Therefore, we need to consider that light is a shape (a cone) and we must modify and direct the light based on that shape (**Figure 2.15**). Once that is established, we can then decide on the light's position and angle.

2.15

TIP *Many modifiers can be manipulated to produce similar characteristics. A softbox with the outer diffuser removed—but with an inner diffuser attached to soften the hotspot—will look similar. An Elinchrom Rotalux with a reverse mount (see "The Special Order Menu") will give you this light without a harsh spot in the middle (**Figure 2.16**). One can even combine multiple lights to create this effect—a hard key with a soft fill, for example, will achieve this. All of these methods will produce similar end results—with most of the variations hinging on how the hotspot of the light is handled.*

In the center, the light is a little bit brighter. This is known as the *hotspot*. The edge of the light is known as the *falloff*. The area between the hotspot and the falloff is great, solid, usable light. For me, the light right at the edge allows for maximum evenness and control—and is more successful at keeping light from spilling onto the background (**Figure 2.17**). Using this edge as the light that falls on your subject is known as *feathering the light*. By using the edge of the light, we can have a more consistent spread of light and a more evenly lit subject.

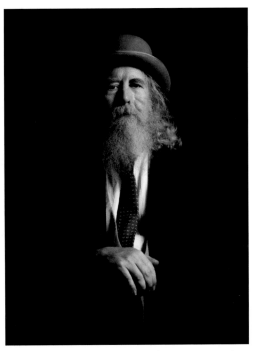

2.16 Rotalux with reverse mount, producing pronounced highlights, strong contrast, and soft edges of the shadows.

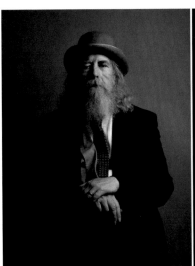 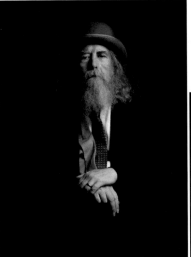 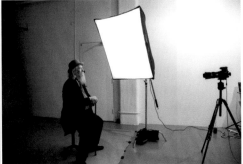

2.17 The first image has more light on the background and a noticeably brighter right cheek. The second image has less light on the background and a more even cast of light.

In diffused reflection, light travels toward the reflective surface, in the case of **Figure 2.24**, the white side of a v-flat (see below), and upon hitting it, reflects unidirectionally. The light falloff here is much greater than direct reflection, but results in a more natural, less "obvious" style of reflection. Diffused light is generally regarded as the softest of the three types (direct, diffused, and reflected light), as it is the most even and lacks a traditional hotspot. The tradeoff,

however, is an extreme loss of power so that diffused reflection is more often used as a way to fill (brighten) shadows instead of acting as a main (key) light, but not always. Diffused reflected fill is seen in the first image. As a key, the second image uses v-flats, which results in even light, yet also lights the background more than a smaller light source.

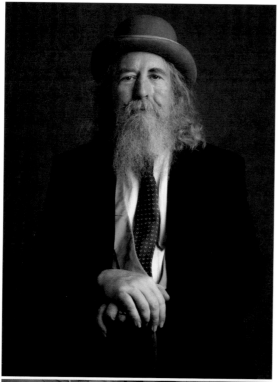

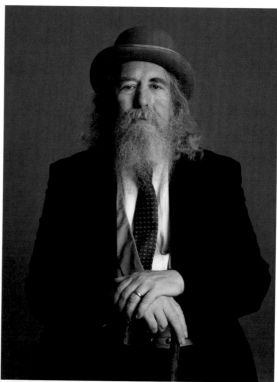

2.24

RELATIVE SIZE OF LIGHT

Relativity is a critical component of light. Perhaps the most considerable component of relativity is how it affects the hardness or softness of light. Relative size determines softness of light more than anything else (followed by diffusion). Consider the sun. It is a very large light source, but it is about 92 million miles (or nearly 150 million kilometers) away, and therefore relatively small to us. On a clear day, the sun creates hard light. You know this. Shadows from direct light are crisp, the highlights are so bright and the shadows are so dark. It is already like that with our eye, but the camera only exaggerates it.

However, that very same sun, on a cloudy day, produces incredibly soft light. Think of the sun as the bulb and the clouds as the baffle (the outer layer of diffusion) of a softbox. The cloudy atmosphere is relatively massive to us and produces

soft light. Diffusion produces a quick and easy way to soften light, but the size is the deciding factor. As the (relatively) small sun hits the clouds, it spreads out. Now the sunlight is filling light over the entire size of the clouds. The light is not the sun or the clouds individually—it is now one cohesive source that we need to think about as one. Hence, we have one very large light.

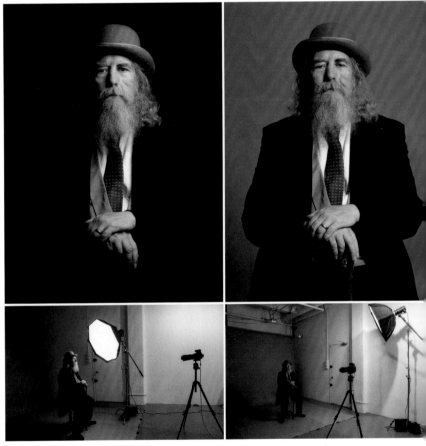

That same technique can be applied to moving a studio strobe or another artificial light source. Imagine a softbox one foot away from the subject. That light would be very soft. That same softbox 25 feet away would produce a harder light (although we would need to increase the power to maintain a similar exposure). By only changing the distance of the light to the subject, the properties of the light change completely, giving us a harder edge and less contrast overall (**Figure 2.25**). In other words, the larger the light is relative to the subject, the softer the light—and this applies to all the light, modifiers, and setups we will be discussing.

2.25 In the first image, the light is close, so the qualities are soft and contrasty. The unlit side of the face and the background are dark. In the second image the light has moved much farther away. The overall photo has less contrast, and it is more evenly lit even though we have the same shadow definition on the left side of the image.

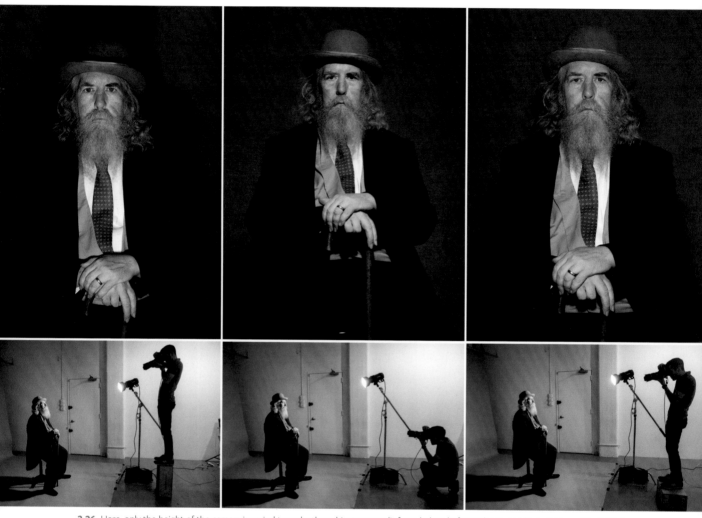

2.26 Here, only the height of the camera is varied to make the subject appear lit from below, lit from above, and lit straight on. The light does not change positions.

RELATIVE POSITION OF LIGHT

Remember, the position of the light is relative to the position of the camera *and* relative to which direction your subject is facing (**Figures 2.26** and **2.27**). Both are great ways to change the direction of light.

A light that is above the plane of the camera and pointed at a subject is perceived as downward light. If a light is positioned under the camera, it becomes upward light. A light that is fairly close to the camera mimics on-camera flash (and has a minimal shadow), whereas light to the side casts long shadows. Shadows create drama, which makes the position of the light a valuable tool.

Without moving the light, try rotating your subject to get your desired lighting pattern.

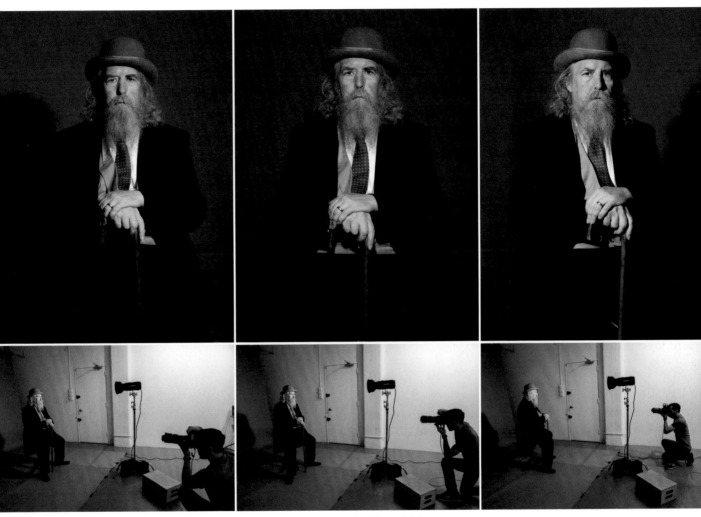

2.27 By only rotating our subject (and camera position), we can get multiple, different lighting patterns.

RELATIVE POSITION OF THE BACKGROUND

When shooting in studio, the position of the background has an effect on how dark or bright it shows up in the image. Consider the relative distance between objects casting a shadow and what that shadow falls upon. A person casting a shadow on a background one foot away will produce a harder shadow than on a background five feet away.

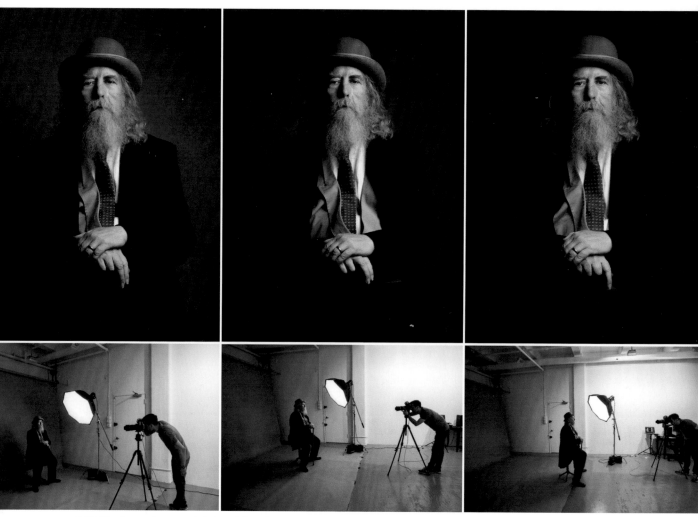

2.28 The distance between the light and the subject never changes, but the background gets farther away: two feet (left), five feet (center), and ten feet (right).

When the background is farther away, the shadow will be softer or it can potentially not be visible at all (**Figures** 2.28 and **2.29**). Of course, a background that is farther away may appear darker and that may need to be addressed with additional lighting.

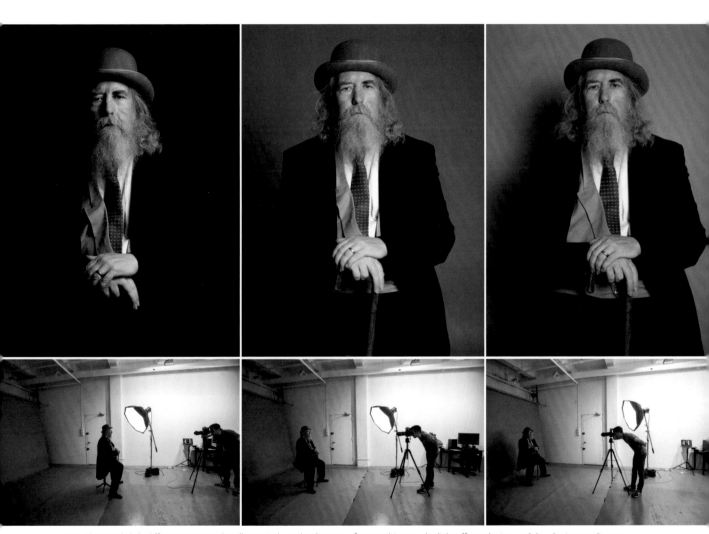

2.29 This is a slightly different concept that illustrates how the distance of your subject to the light affects the image (a.k.a. the Inverse Square Law, which is discussed later in the chapter). The light and background do not move, but the subject changes distances (two feet, five feet, and ten feet) from the source.

GIVING YOUR LIGHT A JOB

When lighting, it can be helpful to think about ways to break down things into a simpler language by giving each light something specific to do. This way, we can stack some relatively complex principles on some much more simple ideas—and then easily reproduce those ideas. Before delving into those more complex principles, we must first establish a few key terms. Almost any kind of light falls into these categories, and labeling lights this way helps to make sure that every light you use has a purpose:

- **KEY** The main light. The exposure is determined from this light (**Figure 2.30**).

- **FILL** The secondary light (**Figure 2.31**). This light (or reflector) determines how bright or dark the unlit side of your subject is. The second image shows the key + fill.

- **RIM** The behind (not *for* your behind, just behind) light (**Figure 2.32**). This light's job is to help create separation from your subject from the background. It can also add dimension. The second image shows the key + fill + rim.

- **BACKGROUND** This light brightens or adds color to the environment (**Figure 2.33**).

Figure 2.34 shows all of these lights combined.

It is also important to note that some lights can be dual, triple, or quadruple purpose. A rim light, for example, can also be used to light the background. But giving our lighting broad terminology at least helps us better home in on their intention.

TIP *Mixing light qualities—a hard key with a soft fill for instance—can yield incredibly interesting results.*

2.30 Key only

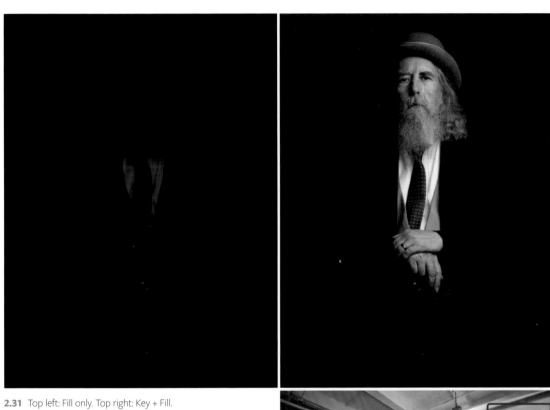

2.31 Top left: Fill only. Top right: Key + Fill.

2.32 Top left: Rim only. Top right: Key + Fill + Rim.

2.33 Background only

2.34 Key + Fill + Rim + Background

LIGHTING RATIOS TO CONTROL CONTRAST

Lighting ratios are a fantastic way to learn to light. They allow for a tremendous amount of control and repeatability. Imagine being able to get the exact light you want without having to even check once on the back of your camera—making the entire process accurate *and* efficient, without trial and error slowing you down. This is not to say that you cannot tweak the result once you see it (and you should), but it does make getting there that much faster, and it is not until using this technique regularly that you are able to see how much time and how many shots are wasted trying to get the light you want.

For lighting ratios to work, you will need a light meter. I use a Sekonic L-358, but any light meter that can measure the exposure of a flash will work (make sure your meter is *not* continuous light only). A light meter allows the user to set the ISO and shutter speed, then push a button, and it reads the correct f-stop for that point in space (correct exposure is based on rendering 50 percent gray accurately). The f-stop we are given is what we set our camera to. As we move the meter around, we are able to get different readings for the scene and are able to visualize how light moves through the space that we are lighting (**Figure 2.35**).

2.35 In this image, the face meters at f/14, but by the time the light reaches the hands, it is at f/7.1. This allows us to visualize falloff more accurately.

Looking at the image, we can see the overall exposure confirmed by recognizing that the face is noticeably brighter than the chest. The face (as it is the object we are lighting and the most important part of the image) is what we base our exposure on.

As we use the light meter for ratios moving forward, it is important to measure the components of light without interference from other lights. This may mean retracting the Lumisphere, using your hand, or turning off all other lights when needing to get an accurate reading from a single source in a multi-light setup.

Mastering both lighting ratios and the light meter are key to efficiently controlling dramatic light. From these building blocks, we can begin to explore how different ratios control contrast and shadow.

LIGHTING RATIO: 1:1

This lighting setup involves both a key and a fill. When creating a 1:1 ratio, the key and the fill are both metered to the same exposure, resulting in light that is even on both sides of the subject (**Figure 2.36**). Position of the fill is especially important (it is important in all ratio setups, but especially here as the unlit areas are particularly obvious).

TIP *I prefer to place a large fill directly behind camera, which is usually either a large bounce umbrella or scrim. This ensures that my fill light is unobtrusive and not especially noticeable. Placing the fill light too much to the side will result in sections of the face where the key or the fill fails to light, creating some particularly unusual shadows.*

2.36 Fill: f/11; Key: f/11; Camera: f/11, ISO 100, 1/125 sec.

LIGHTING RATIO: –1 STOP FILL

In this ratio, the fill has an exposure one stop less than the key (**Figure 2.37**). This results in a dominant key, but the fill is still rather bright. The fill has half the light of the key.

LIGHTING RATIO: –2 STOP FILL

Here, the fill is now two stops below the key, resulting in a more contrasty portrait overall (**Figure 2.38**). Detail is still clearly visible, but the darkness isn't overwhelming. The fill has 1/4 of the light of the key.

2.37 Fill: f/8; Key: f/11; Camera: f/11, ISO 100, 1/125 sec.

2.38 Fill: f/5.6; Key: f/11; Camera: f/11, ISO 100, 1/125 sec.

LIGHTING RATIO: −3 STOP FILL

A fill that is three stops below the key is on the threshold of losing detail (**Figure 2.39**). The shadow areas are quite dark, but still very adjustable on our shadow slider when we develop the image. Some clipping may be present. The fill has 1/8 of the light of the key.

LIGHTING RATIO: −4 STOP FILL

This ratio requires a significant amount of power from the key to establish enough of a difference to the fill (**Figure 2.40**). A four-stop difference is an incredibly contrasty portrait with a fair amount of potential clipping. Sometimes negative fill (such as a flag, which will be covered later in this chapter) is necessary to achieve this much black. The fill has 1/16th of the light of the key.

See **Figure 2.41** for all of these lighting ratios side by side.

 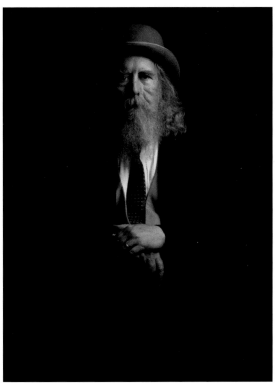

2.39 Fill: f/4; Key: f/11; Camera: f/11, ISO 100, 1/125 sec.

2.40 Fill: f/2.8; Key: f/11; Camera: f/11, ISO 100, 1/125 sec.

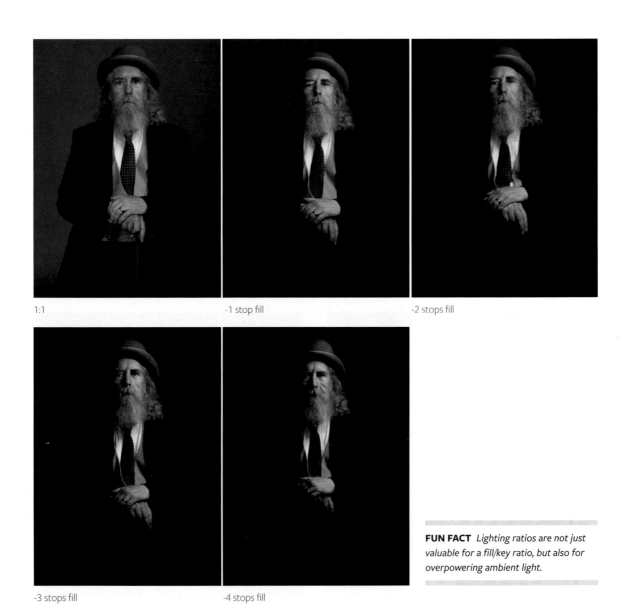

1:1 -1 stop fill -2 stops fill

-3 stops fill -4 stops fill

FUN FACT *Lighting ratios are not just valuable for a fill/key ratio, but also for overpowering ambient light.*

2.41 Side-by-side comparison: 1:1, -1 stop fill, -2 stops fill, -3 stops fill, -4 stops fill. Lack of fill also affects the brightness or darkness of the background.

WHY SIZE MATTERS

As was mentioned in the section "Relative Size of Light," the softness of light is determined by how big it is compared to the subject. This can be done by moving the light closer (to make it softer) or simply using a physically larger modifier. The caveat is that a larger light modifier (with few exceptions like a TeleZoom reflector) needs more power to produce the same exposure as a smaller modifier, due to a larger surface area that needs to be illuminated. This is usually remedied by increasing the power or moving the light closer to the subject. A larger modifier will generally produce softer light than a smaller one (**Figure 2.42**). The larger source will also light the subject more evenly. The smaller modifier will produce a more concentrated area of light.

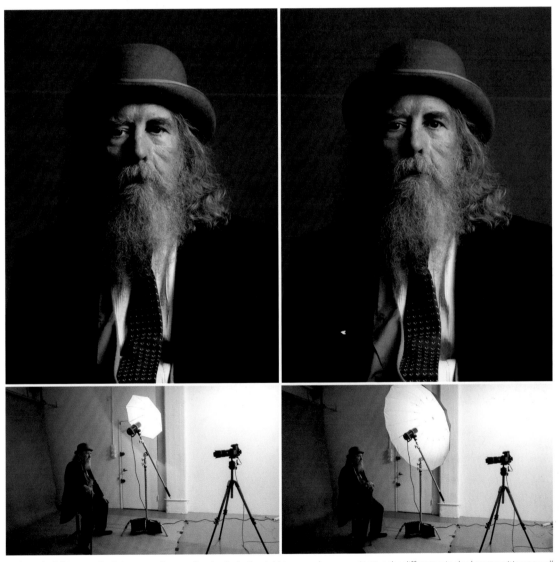

2.42 In the left image, the light source is a small umbrella; in the right image, a large one. Notice the difference in shadow transition as well as contrast.

The exception to this rule is using a scrim. A scrim is a large piece of diffusion mounted to some kind of a frame. It can act as a diffusor of artificial light, natural sun, or even act as a reflector.

A scrim allows you to change position of the actual light in relation to the modifier. When the source is close to the scrim, the light becomes harder (as the hotspot becomes more apparent), and as the light moves away, it becomes softer (the hotspot less apparent). See **Figure 2.43**.

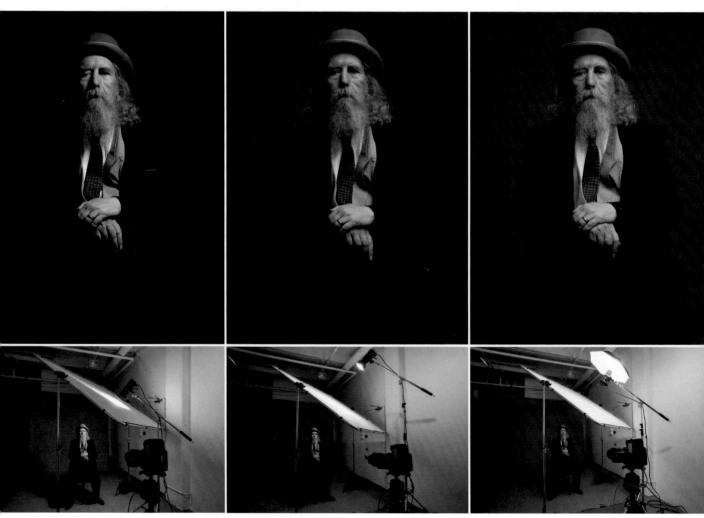

2.43 Left: Light is close to the scrim. Center: Light is as far as possible without bleeding onto the background. Right: Light is bounced through an umbrella first, resulting in even softer, broader light.

WHY SHAPE MATTERS

Although the shape of the modifier does have a minor effect on how the light emanates from the source, the result is mostly negligible, especially when considering modifiers of relatively similar size and shape, and when the modifiers are close to the subject. The bigger differences occur when comparing an octabox to a stripbox. Whereas the ocatabox will produce a broad light that has the ability to light much of your subject, a stripbox will produce a narrower beam. Strip boxes are incredibly effective at cre-

> ## WINDOW LIGHT
>
> The Dutch Masters, like Rembrandt, often used a window as a light source—something that was both directional and had the ability to fill a room if it suited their perception. A large scrim will give the characteristics of a window light, because it is: a) very soft light and relatively large, and b) it is shaped like a window.

ating soft rim lights for large (or all) areas of an object or person. The rationale for choosing your desired modifier may also be quite literal. Some photographers choose to mimic the look of window light, and as a window is often rectangular, they choose to use a rectangular-shaped modifier. Others prefer to mimic the roundness of the sun (or the shape of the subject's face) and use a round modifier such as an octabox or beauty dish.

There is one additional consideration when choosing the shape of the modifier—the *catchlight*. The catchlight is the reflection of the light source on the eyeball which creates a specular highlight (my grandmother called it a "sparkle"). A rectangular softbox will produce a rectangular shaped reflection on the eye and a round modifier produces a round shape. For some, a round catchlight within the eye (concentric circles) is most appealing to them and can feed a certain obsessive compulsiveness. The catchlight also becomes a way for the crafty photographer to study an image to help deduce how it was lit. See **Figures 2.44–2.48**.

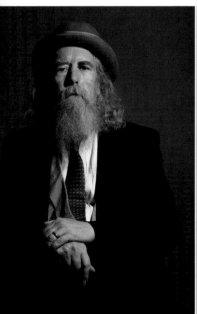
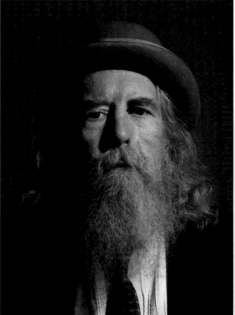
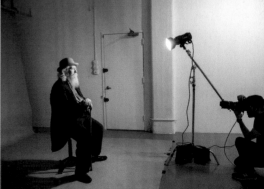

2.44 Zoom reflector

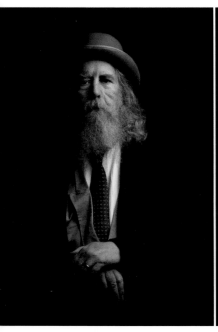
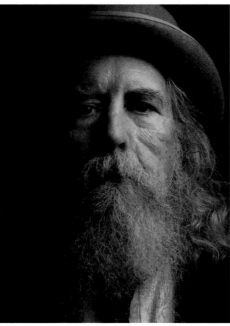
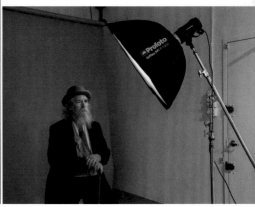

2.45 3' octabox

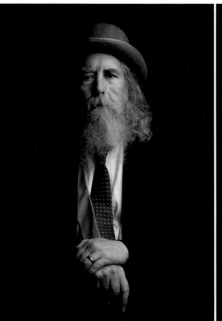
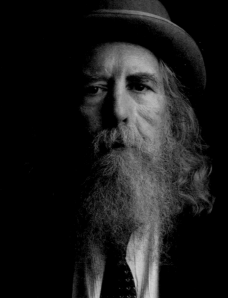

2.46 3'x4' softbox

2.47 4' stripbox

2.48 Beauty dish

HOW FALLOFF CONTROLS CONTRAST

As light emanates from the source, the camera's perception of that light changes based on how far the light travels. We have mentioned falloff earlier and that there is less light the farther away you are from the source (**Figure 2.49**). If we were to place a subject at various positions away from the light, we would need to compensate with our exposure to make sure our subject stays consistently visible. However, even though the subject's exposure is consistent, the light's visual properties drastically change.

The strength of the gradation depends on the distance of the light to the subject and the power of the flash. For example, a light on full power that is very close to the subject will have a falloff of light at a relatively short distance (in part due to a high f-stop) (**Figure 2.50**). The subject backed up ten feet, or the light (at the same power) backed up ten feet with a stationary subject, will have a much more gradual falloff (**Figure 2.51**). This is known as the inverse square law. Understanding the distance and falloff gives you the ability to darken down a background in a more enclosed space or control the contrast of the image, thereby adding drama.

2.49 Falloff happens much more quickly when the light is close. When falloff is quick, contrast is high. As distance and falloff increase, contrast decreases.

INVERSE SQUARE LAW EXPLAINED

The power of light doesn't correlate directly to distance; instead it's based on exponential power. As you move n times further away, your power gets n^2 times weaker. Twice as far means your power is 4x weaker. Three times as far is 9x weaker. The falloff is the strongest nearest to the light and much more gradual the farther from the light.

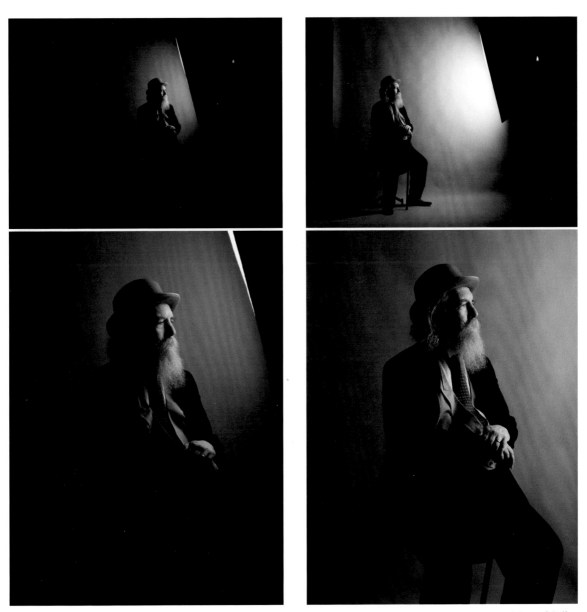

2.50 Close to the light, high contrast, and quick falloff.

2.51 Farther from the light, decreased contrast, and slower falloff.

PUTTING LIGHT WHERE YOU WANT IT...

So far we have covered shaping and modifying light by making it softer. Sometimes light needs to be tightly controlled, yet still be hard. For this, the three most common modifiers are: grids, snoots, and barn doors.

Grids allow for a (relatively) tight concentrated beam of light. They come in a variety of sizes called degrees, which describe the size of the honeycomb (or egg crate) pattern; a tighter grid pattern is indicated by a smaller degree number (like 10 degrees) (**Figure 2.52**). A larger number (like 40 degrees) will still produce a relatively tight beam, but will be significantly larger by comparison. Grids are useful for background or rim lights as well as a key (for creating a spotlight on the face). Grids are not exclusive to direct light, as grids are also made for many other modifiers such softboxes or beauty dishes (**Figure 2.53**).

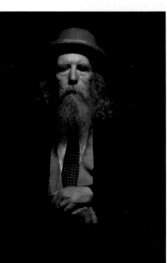

2.52 From left to right: No modifier, 5-degree grid, 10-degree grid, 20-degree grid.

2.53 Left: Beauty dish. Right: Beauty dish with grid.

Snoots are another way to create a tight beam of light. The difference between a grid and a snoot is that a snoot gives a more defined edge to the falloff compared to a grid as well as a tighter beam in general (due to the modifier being *slightly* farther away from the source). This does, however, result in a more aggressive hotspot in the middle. The position of the snoot on the light does change its qualities. Pushed as far back as possible, the snoot acts as a (relative) flood (**Figure 2.54**). Positioned at the end of the light, the snoot behaves more like a spot. I find the snoot as a spot to be too harsh on the face (as the light is already quite contrasty) and the flood produces a focused beam that is a little more even. Snoots can also be used in conjunction with a grid to make the beam even more focused.

Barn doors adjust the light from four sides with adjustable flaps that control the gradation in four directions. By moving the flap closer to the center, the spread decreases. Moving the flap outward increases the spread. Barn doors can be used to light one part of the image and easily block another. They can also be used to create a tight, focused beam of light (**Figure 2.55**).

The barn doors are closed down in the right image to eliminate spill onto the background, but the flexibility of the barn doors allows you to customize the shape. In this instance, we created a long vertical beam of light to allow more light onto the hands.

2.54 A snoot set to flood.

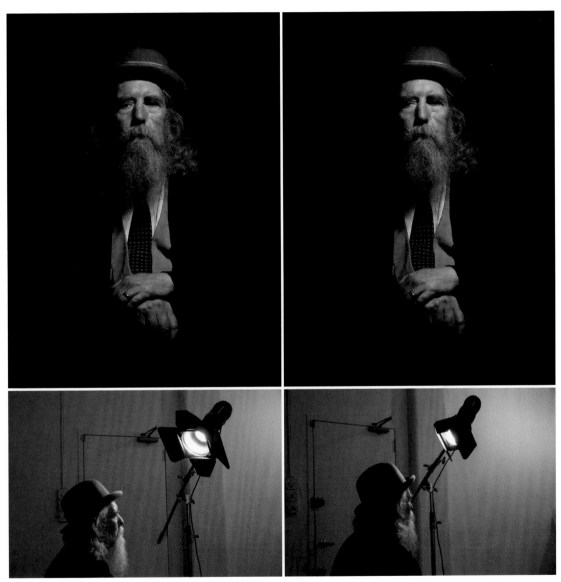

2.55 Left: Barn doors open (no effect). Right: Barn doors closed to create a beam.

Even though grids, snoots, and barn doors do slightly different things, it is best to experiment with all three to gauge what works best for you (**Figure 2.56**). I personally use grids more often, but it is a matter of personal preference.

2.56

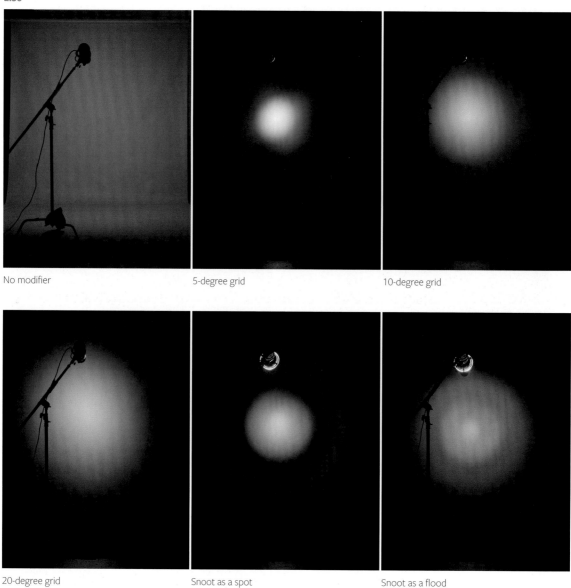

No modifier

5-degree grid

10-degree grid

20-degree grid

Snoot as a spot

Snoot as a flood

...BLOCKING IT WHERE YOU DON'T—THE FLAG

Perhaps the most underutilized modifier *in all the world* (possibly a hyperbole) may be the flag. The flag is a metal frame (in all sizes) wrapped in black fabric, meant to absorb or block light (**Figure 2.57**). The flag can be used to create *negative fill*, because the fabric absorbs light, making the unlit area darker, as a way to taper light (similar to barn doors, except not mounted to the light), or to create shadows on the subject.

The flag can be used to taper light. For example, we can light a subject from a certain angle (that may normally light the background) and use a flag to prevent the background from being lit by the same light (**Figure 2.58**). This can be used to block something completely from being lit as well as creating an in-camera gradient.

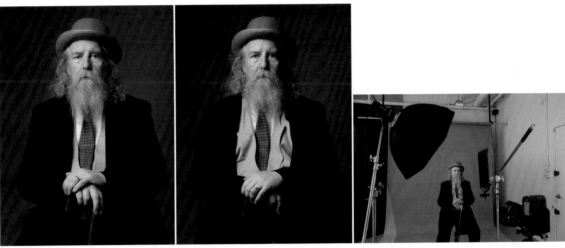

2.57 Left: No flag. Right: Negative fill. Notice how the shadow on the right side of the second image is noticeably darker. When using the flag to create negative fill, the effect is usually subtle, but it is a great way to add contrast to your image (by darkening the shadows) without having to change the power of the flash and exposure on the camera.

2.58 The flag is used to create a dark gradient on the background on the left side behind the subject.

Earlier, we looked at how a subject closer to a background produces a crisper shadow edge. The same concept is true for objects casting shadows on the subject. The closer the object is to the subject (or farther from the light source), the harder the shadow. The farther the object is from the subject (closer to the light source), the softer the shadow (**Figure 2.59**).

2.59 Here a flag is used to create a shadow on the face. In the first image, the flag is closer to the face. In the second, the flag is farther from the subject (closer to the light source). Notice how the defined edge of the shadow changes.

THE SPECIAL ORDER MENU

Sometimes the standard fare of light modification just will not do. For those instances, we have you covered. Without getting into every specialty modifier ever created, we will explore a couple of my favorite and most used—specifically bounce modifiers and the ring flash.

As mentioned earlier (in the section on specularity), bounce modifiers are descriptively named. They modify the light (obviously) by bouncing the light (diffused reflection). In addition, bounce modifiers often diffuse light as well (by using an outer baffle), although this is not necessarily always the case.

Inside this modifier is where the magic happens. Instead of the light facing outward, it faces inward—so the light emitted from the modifier is already soft and lacking a prominent hotspot. An excellent example of a bounce modifier at the high end is the Broncolor Para 88—a deep parabolic softbox. What makes this particular modifier so great is the added feature of a focusing rod, wherein the placement of the strobe within the modifier can be moved, turned, and rotated around, allowing for a more (or less) focused beam of light and making this modifier worth its weight in gold (which it probably costs more than).

At the medium end would be the Rotalux Deep Inverse Octa (**Figure 2.60**). This modifier is a little on the large size, but the design of it allows for the strobe to be mounted inward. It does not have a focusing rod mechanism. The cavernous shape of the Rotalux Deep Octas (like the Para 88) creates a more condensed spread of light compared to shallower octaboxes, ultimately allowing for more control. For those who find this modifier to be too substantial (59"), the reverse mount can be ordered directly from Elinchrom separately and is usable with the smaller-sized octaboxes (even though they are not sold with them).

At the inexpensive end is what I consider the "best bang for your buck" modifier, the umbrella with a diffuser (**Figure 2.61**). Available in a variety of sizes, this modifier is simply a bounce umbrella with a layer of diffusion on the outside. This is traditionally referred to as a *brolly box*. There is much less control over the spread of light (especially at the larger sizes), but whether you need to blanket a scene in very soft light, create a little shape on a face in an otherwise dark ambient scene, or add unobtrusive fill, the umbrella with diffuser is a valuable and versatile tool to have.

A dramatic departure from softer bounce modifiers, the ring flash is not a modifier, but a bright light to smite insufficient shadow light. Since shadow is relative to the position of the light source in relation to the camera, the ring flash (originally invented for dental photography) produces minimal shadow by surrounding the lens with the light, evenly illuminating the scene (**Figure 2.62**).

2.60 Rotalux Deep Octa with a reverse mount. The left image has diffusion on the outside, making the light quite soft. The right image has the diffusion removed and gives a punchier, more contrasty light.

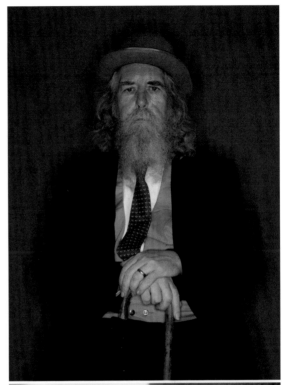

2.61 Umbrella with diffuser

2.62 RING FLASH!

Although its effect as a key light is oftentimes (but not always) gimmicky—the shadow halo is synonymous with the light—the ring flash is a tremendous tool for controlling fill (**Figure 2.63**). Except when diffusion is used, the ring flash produces a punchy, specular fill that accentuates highlights like skin, moisture, and shiny objects. The result can even give an illustrative feel to the image. Artists like Dave Hill, Dan Winters, Jill Greenberg, and others all effectively use the ring flash as fill.

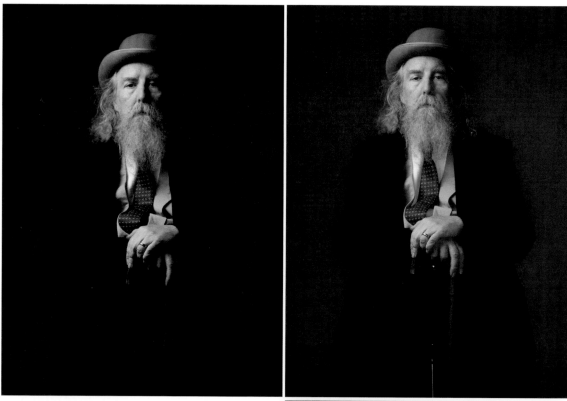

2.63 Left: Octabox key, no fill. Right: Octabox key, ring flash as fill (–2 stops under).

WRAP-UP

Although we may have touched on a fair amount of technique, you should know that there is always an infinite amount to learn on the subject of lighting. One of the most appealing parts of this medium is the bottomless vat of water that we often find that we have fallen into, and no matter how much we drink, there is always more. And either we feel like we are constantly trying to keep our head above water, or we become better swimmers. Hopefully, we become the latter.

Technique is only one part of the equation, and a mastery of one's tools is also important to becoming a better photographer. We must know when to implement them, know when to give more, and know when to pull back. Now that we have the tools in place, we can look at when, where, why, and how to apply them.

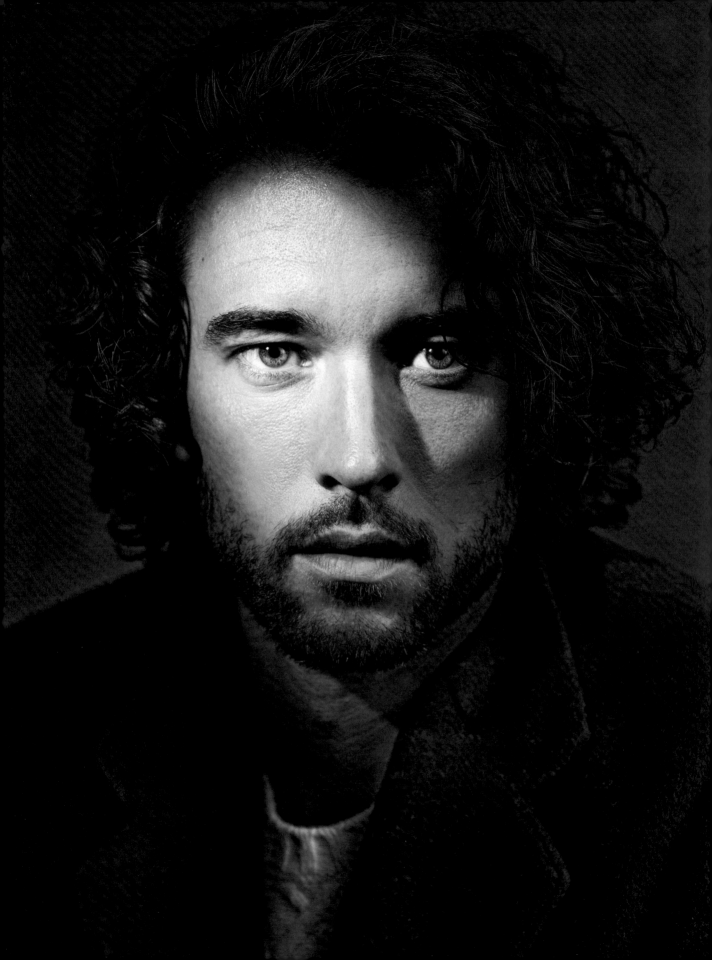

CHAPTER THREE
TAKING SHAPE

SHAPING THE LIGHT, MOOD, AND FACE

PARAMOUNT

The first lighting pattern is known as Paramount (**Figure 3.1**). Commonly used by old Hollywood portrait photographers (hence the name), this pattern is created by positioning the light to the front of the subject and above camera, creating light that defines the cheekbones and results in a shadow underneath the nose. Due to the shape of the shadow under the nose, this is also known as butterfly lighting.

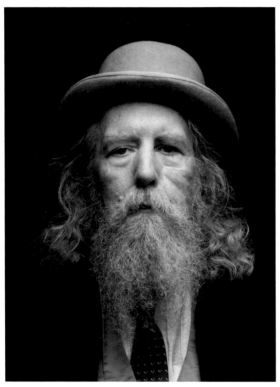

3.1 The Paramount light pattern.

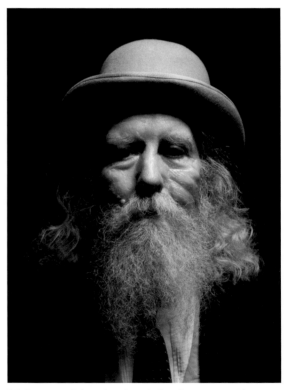

3.2 Paramount light is placed very high in this portrait. With no catchlights, the eyes look lifeless.

LOOP

As the light moves more off-center, the shadow under the nose begins to lengthen to one side. If it lengthens to the point where it meets the cheek shadow, we have gone too far into the next pattern (Rembrandt), but between there and Paramount, we are firmly in the lighting pattern known affectionately (and perhaps literally) as loop (**Figure 3.3**). Loop is characterized by the nose shadow creating a loop off to the side of the nose. This pattern also introduces more shadow to the unlit side of the face, resulting in more definition of the subject's bone structure.

REMBRANDT

Continuing the cranial orbit, the nose shadow becomes so long it merges with the cheek shadow, resulting in a triangle of light under the eye on the unlit side of the face. This is Rembrandt (**Figure 3.4**). This style of light was popularized by the Dutch Golden Age painter of the same name (see Chapter 1 for more on the artist). Rembrandt is often synonymous with dramatic light, and so this lighting pattern is as well. Moving the light more off-axis introduces more shadows, thereby introducing more drama and a more defined sculpting of the subject's features. The benefit of this particular pattern is that it produces the most shadow on the unlit side of the face while still keeping both eyes in the light. Ideally, both eyes retain the key's catchlight, which helps to brighten up and bring life to otherwise cold, dead eyes.

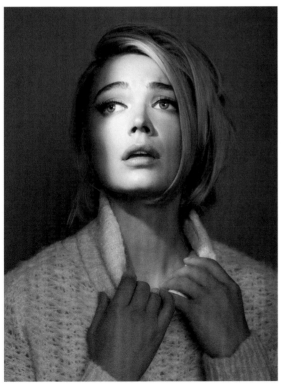

3.3 The loop light pattern.

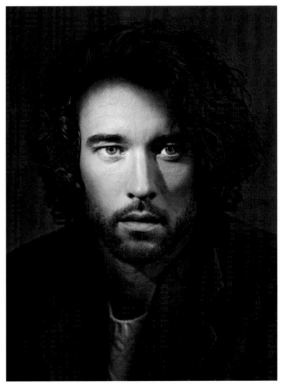

3.4 The Rembrandt light pattern.

As mentioned in Chapter 2, many softboxes, when used close to the subject, are similar in their quality of light. Why do photographers use certain ones over others? When should you use an octabox versus a rectangular softbox? The answer is often the catchlight—that tiny specular reflection of a light on the eye (**Figure 3.5**). Historically, soft light sources were windows. The reflection in the eye was a rectangle or square that matched the shape of the windows. In modern times, and especially as photographers are sometimes obsessed with details (rightly so), some prefer a round catchlight, because the shape is more aesthetically pleasing in a round eye (round pupil and iris, you get the picture). Other examples of round catchlights include: beauty dishes, bare heads, the sun, round reflectors, and snoots.

3.5 Catchlights produced from different sources (left to right): rectangular softbox, octabox, beauty dish, and zoom reflector.

SPLIT

As the light moves even more to the side, half the face is now hidden in shadow. This pattern is called split (**Figure 3.6**). Much like Batman, this light is seeped in drama, often feels brooding, and has no parents. The light almost always feels very dramatic. Notice how the eye that was lit in the Rembrandt pattern is now in shadow.

3.6 The split light pattern.

RELATIVE POSITION OF THE LIGHT

So far, all the lighting patterns have been shown with the face directly to the front. How does one apply the pattern when the face turns? No matter the position or rotation of the face, the pattern is what describes the light on the subject at that time. For example, the subject and light may be in the same position, but if the subject turns their head in either direction, the light pattern changes. This accounts for an easy way to get the exact lighting you want—if it is not quite there, just rotate the head a little (**Figure 3.7**). This is a much simpler system than moving the light every time. Remember, there is no definitive right or wrong position of light. The "right" position is completely subjective, taking into consideration the subject's face, what light looks best to you, or what mood you wish to create.

FULL FRONTAL
With a front-facing subject lit with Paramount, the light can be described as "flat"—especially when the light is not high enough to create deep shadows. Lighting from the front places as much of the subject as possible in even light. Also called "frontal lighting," this front-facing light has the least amount of overall shadow compared to the other methods, but that does not mean it cannot create lots of drama. Photographers like Platon are incredibly successful at using this light to produce brilliant results.

3.7 Rotate the subject without moving the lights to achieve different light patterns.

BROAD LIGHT VERSUS SHORT LIGHT

In addition to knowing the overall lighting pattern on the face, it helps to identify the ways in which the shadow or lit side is shown via the camera's perspective. The two terms used here are broad light and short light.

Broad light. When the lit side of the face is positioned to camera, this is known as broad light. Broad light can be communicated using loop, Rembrandt, and split, although it is typically most effective with Rembrandt and split. Using this method, the bright side is turned closest to camera, presenting a mood that is often a little brighter and less brooding. This method can create a greater tonal disparity between the lit subject and the unlit areas of the image (in this case the background), causing the subject to jump out a little more.

Short light. Conversely, when the unlit side faces camera, this is known as short light. Short light is typically a darker, moodier light (**Figure 3.8**). Loop has the nose shadow on the side of the face closest to camera, which can be distracting depending on the person. When used as a Rembrandt, the small triangle of light faces camera and the lit side acts as a rim light of sorts. With split, the face is mostly unlit except for the sliver of light on the side.

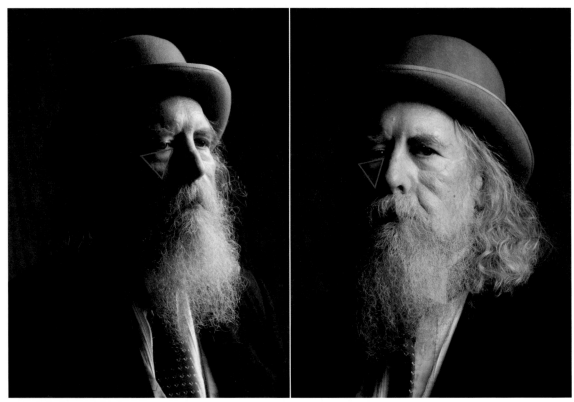

3.8 Left: Short light in Rembrandt. Right: Broad light in Rembrandt. Take note of how the triangle of light appears different in each image.

By rotating the subject and leaving the light in place, different lighting patterns (Paramount, loop, Rembrandt, and split) can be achieved, as was mentioned earlier in Figure 3.7. This can also be accomplished with a stationary subject and moving the light.

When the photographer rotates around the subject, the light changes from broad to short (**Figure 3.9**). This, too, can be achieved by moving the light around the subject.

<table>
<tr><td colspan="2">WAYS TO CHANGE THE LIGHT ON THE FACE</td></tr>
<tr><td colspan="2">

Move the light
Turn the subject's face (and/or body)
Change the angle of the shot
Any or all of the above

</td></tr>
</table>

3.9 Adjusting your angle and having the subject move with you helps to change the lighting pattern without having to adjust the position of the face drastically in camera.

WHEN TO USE BROAD VERSUS SHORT

The choice of broad or short light is entirely a personal preference. Sometimes how the photographer wishes to portray the shape of the subject's face can help dictate the use of broad versus short light. For example, when photographing a wide face, I may choose to narrow it by using short light; for a thin face I might widen it with broad light.

THE VERTICAL AXIS

In addition to moving the light around the subject (or rotating the subject), the vertical position of the light impacts the appearance of light on the face. When light is low (and closer to the height of the camera), the lighting is more flat, because fewer shadows are visible.

For example, Paramount light has fewer shadows visible compared to split light; however, when a light in Paramount is raised vertically, more shadows are introduced below the nose and jaw. The higher the light, the longer the shadows. The effect, in this pattern, is more defined cheekbones (**Figure 3.10**). When the light is too high, it can introduce dark eye sockets, which can potentially be undesirable.

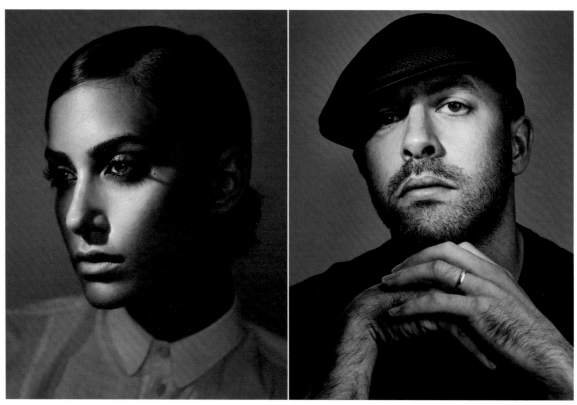

3.10 Left: A light raised higher will result in a longer shadow under the nose, chin, and eyelashes in this portrait. The cheekbones are also well defined. Right: A lower light produces relatively shorter shadows, as can be seen here with the nose.

Raising the light vertically for loop lighting points the shadow downward, as a nose shadow protruding into the cheek may not be wanted. In Rembrandt, raising the light creates a deeper triangle of light on the cheek, which can help close the nose shadow and eliminate distracting light near the mouth (**Figure 3.11**).

3.11 Unclosed Rembrandt light can create unflattering partial shadows near the mouth. Raise the light and put it at more of a side angle to fix this problem.

WHICH MOOD, WHICH LIGHT?

After exploring several ways in which the face can be lit, the next question may be, Which is the best? The easy answer is to say Rembrandt (because he's totes the best), but the more complicated answer is that the right lighting pattern is the one you want. If the desired goal is to achieve maximum drama, a pattern that presents lots of shadows is best. Short light introduces more shadows (which would seem to make it the default choice here), but that is not necessarily true. The placement of the light builds with the decision of how dark the shadows are (or are not) meant to be. This is the moment in which the techniques of lighting ratios would be applied. All of these elements are figured out, decided upon, balanced, and added up to help you achieve the mood, create the effect on the face, and direct the eye where you want the viewer to look.

WRAP-UP

Lighting patterns are not mandatory rules. In fact, you may discover that restricting yourself to a certain type of lighting pattern may be an exercise in frustration. Patterns work best when used to help pre-visualize light or if need be as a visual guide to position the subject's face. With that said, you do not need to *rely* on creating any of these patterns for a successful image. Be open to spontaneous movement as you work with a subject, and if you can coach that spontaneity into the light you want, then you just might have something special.

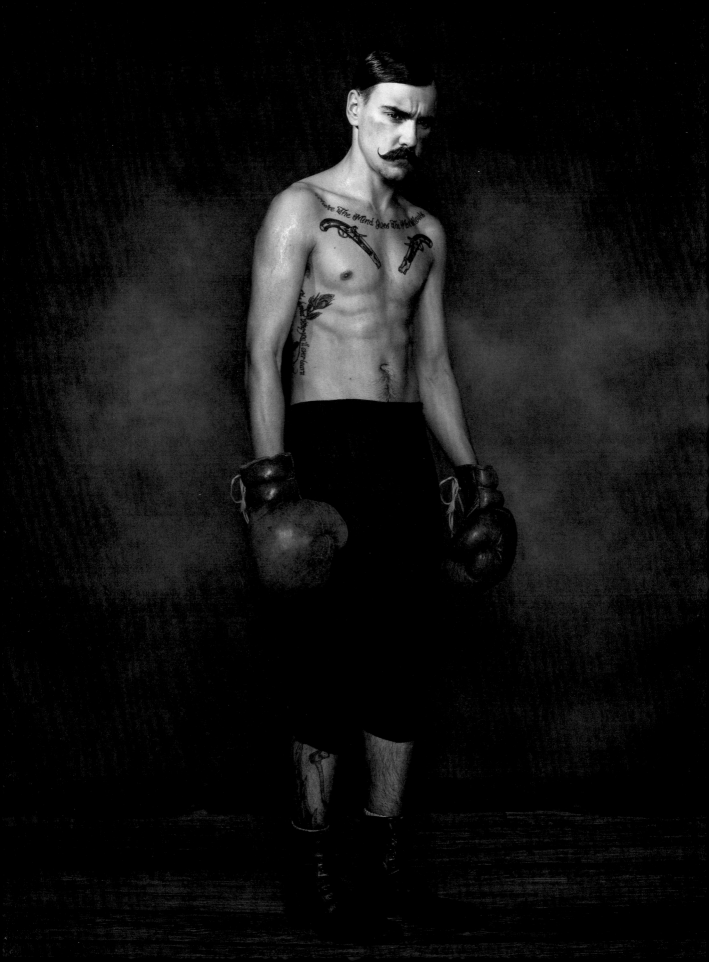

CHAPTER FOUR
HOW MANY LIGHTS

USING ONE, TWO, AND THREE LIGHTS TO FURTHER THE PURPOSE

When thinking about the lighting of a portrait, it is difficult sometimes to know where to start—there are simply endless places to begin. In Chapter 2, "Technical Lighting," we identified several of the tools and methods available, but here we will explore the creative application of those techniques and dig into the "whys" of light. In addition, we will compare the pros and cons of shooting in studio versus shooting on location, the single light versus the multi-light approach, and several case studies showing a variety of lighting setups. Although this is not the *definitive* listing of every way to light, the concepts covered here can be integrated into your own methods of crafting light and shadow.

THE PURPOSE-DRIVEN LIGHT

Learning how to use every piece of equipment we own (and many that we do not) is a noble pursuit for sure, but it does not account for much if the equipment is not used successfully. But what even constitutes "success" when creating an image? Isn't it entirely subjective? Yes and no. In the simplest of terms, is your image doing what it sets out to do? This requires the photographer to step back and consider what *exactly* the image is setting out to do, or more succinctly, the purpose of the shot. In portraiture alone, there can be a variety of different purposes. For example, the goal may be to simply capture the subject in a flattering way. It may be to make the subject appear compelling or make them appear the way the photographer sees them. The desired goal might even be political (i.e. the portrait is meant to please someone else entirely). This final decision does not always fall to the photographer or the sitter, especially in the case of commissioned and editorial portraiture.

Obviously these conditions are not the only ones a photographer will encounter, nor is any one condition the only condition that must be met, but having an idea going in will help in the decision-making process. If the photographer wishes to flatter the subject, he or she should choose flattering light. If the photographer wishes to show drama, the light should be dramatic. If one wishes to make the subject appear horrific, then horror lighting would be appropriate.

Lighting is not the only decision that contributes to making an image successful, but it may be one of the most important technically speaking, as it sets the overall tone and feeling of an image more so than virtually anything else.

STUDIO VERSUS LOCATION SHOOTING

I am predominantly a studio photographer. This is for a variety of reasons: I like the control of the studio, and New York is not always conducive to working outdoors or on location (for weather and logistics alone). But a strong, successful, dramatic image can come from a studio or a location shoot. There are several pros and cons for each setting. Here are some to consider:

STUDIO SHOOTING
PROS
▪ Full control of light and environment
▪ No fighting time of day, unpredictable light, or nature
▪ The ability to work with more delicacy (in the case of wardrobe)
▪ The crew has a more controlled space to work
▪ Air conditioning or heating
CONS
▪ Potentially simple backgrounds
▪ Potentially building sets, which can be expensive
▪ Any lighting, posing, or styling errors are more obvious
▪ Cost to maintain a studio space or rent one
▪ Upkeep of lighting equipment and backdrops

LOCATION SHOOTING
PROS
▪ Unique, dynamic backgrounds and environments
▪ Artificial lighting is not necessarily required
▪ Models can have elements to interact with
▪ More diversity of angles and movement
▪ Any lighting, posing or styling errors are less obvious
▪ Cost (except for location rentals)
CONS
▪ The environment and nature are unpredictable
▪ Challenging and inconsistent lighting scenarios—especially running out of light
▪ More difficult for crew to work
▪ Logistics of planning and permits (where applicable)
▪ Wardrobe is more likely to become damaged or dirty
▪ Temperature can affect subject (if outside)
▪ Risk of damaging property

These, of course, are not the only pros and cons to these situations, but it is worth pointing out the cons of one are remedied by the other and vice versa. Sometimes a location shoot is necessary, and sometimes there is a choice. Again, this goes back to the idea about what must be considered for a successful photo and what the given constraints are. If there *is* a choice, the decision becomes a creative one based on what matters to you. Remember, dramatic portraiture has successfully been portrayed through both scenarios for hundreds of years.

THE SINGLE VERSUS MULTI-SOURCE APPROACH

One of the biggest lighting decisions is perhaps not often an entirely conscious one. Some photographers root their visual style in the ways portraits have been made for centuries. Others prefer an approach that is entirely modern. Both are 100 percent correct. The line in the sand separating the two is creating an image that looks like it was lit with a single light versus creating an image that looks like it was lit with multiple lights.

This may seem like an inconsequential point. However, it is deeply entrenched in history. In the days before electricity, multiple light sources were uncommon, because the main source of light was often a window. For much of time most paintings were seemingly lit by a window (or singular source), and that simple detail has carried over to influence modern photographers. Even when painters inserted a subject into an environment, the subject was regularly painted in the studio (or indoors) separately. This is one of the big reasons why many photographers, without even realizing it, prefer a simpler light setup with a single light (**Figure 4.1**). However, once electricity arrived, multiple light sources were more common and they gradually made their way into photographs. The concept of multiple light sources in imagery (both in painting and photography) is mostly a modern convention, only common for less than the last 100 years. When creating portraits inspired by classical painting, choose an approach that *feels* like a singular light, even when it is not.

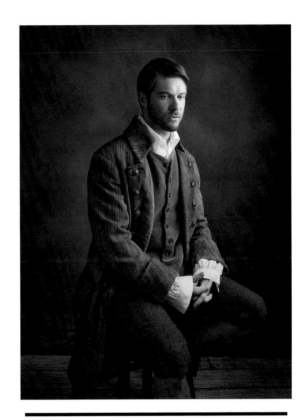

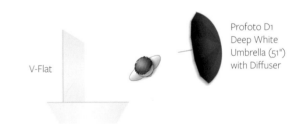

V-Flat

Profoto D1 Deep White Umbrella (51") with Diffuser

4.1 An effective single-light setup with a Large Profoto Deep Umbrella (51") with diffuser, casting beautifully soft light. Positioned to the left, a white v-flat fills in the shadows and preserves detail in the clothing. A printed texture/vignette on the background gives the appearance of a background light without needing one. ISO 100, f/4.5, 1/125 sec.

Because the process of lighting is completely personal, some photographers may prefer the (obvious) multi-light (**Figure 4.2**) instead of the "non-obvious" approach. Before continuing, it is important to address the distinction between the obvious and non- (okay, *less*) obvious, multi-light approach. In an obvious, multi-light setup, separate light sources are distinct, each light has a clearly defined purpose, and each can be positioned at vastly different positions or angles.

A SHORT VIGNETTE ON VIGNETTES

A vignette is a falloff of light, but the term can be used in multiple circumstances. Optical vignetting occurs in lenses, resulting in the corners of the frame becoming slightly dark. This varies from lens to lens and is usually a characteristic of less expensive ones. Accessory vignetting occurs when a lens hood, filter holder, filter, or other item is slightly visible in the frame.

A vignette can also be added for an artistic effect in post-production in Lightroom or Photoshop. A darkening of the edges can draw the eye toward the center of the frame, but a lightening vignette can also be created (dark is better). A printed vignette (mentioned elsewhere in this chapter) utilizes the concept of drawing the eye to the center of the image, but without needing an additional background light to create the effect.

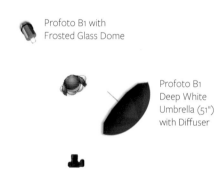

Profoto B1 with
Frosted Glass Dome

Profoto B1
Deep White
Umbrella (51")
with Diffuser

4.2 For this Active1st Sport shot, the key light is high and at camera right, which creates an aggressive shadow on the cheekbones and accentuates the muscle definition on the body. The rim light is high and at camera left and behind, which helps to separate the subject from the background but also illuminates the smoke and sweat. ISO 250, f/13, 1/125 sec.

In a non-obvious multi-light setup (**Figure 4.3**), the light appears to originate from the same place (the giveaway to prove otherwise is often the multiple catchlights). It may not, but the lights that are *not* the key (typically fills) work together to alter the characteristics of the main light and rarely create noticeable shadows of their own.

When is it best to choose one method over another? Begin with the question: Am I painting with a big brush or lighting with precision? Both methods have their advantages and disadvantages. While surgically precise light can yield incredible results, the byproduct is less room for movement from the subject and even less room for error on the photographer's part. For example, with precise lighting, the subject moving a few inches may ruin the shot by completely altering the way the light falls on him or her. This may be perfect to achieve a particular dramatic look, but impossible to shoot if the subject is moving around.

"Big brush" lighting, on the other hand, uses a single, large modifier to light the subject and often the background. This can be a large umbrella, large softbox (or octabox), or even a scrim. This method is more forgiving to movement, position of the subject, and skin texture. In the following examples, the single-light setups are variations on the "big brush" method. As more lights are added to the equation, the need for precision increases.

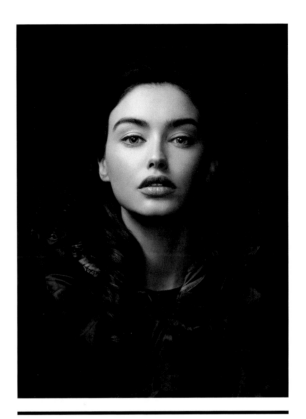

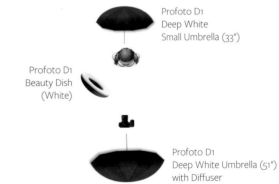

Profoto D1
Deep White
Small Umbrella (33")

Profoto D1
Beauty Dish
(White)

Profoto D1
Deep White Umbrella (51")
with Diffuser

4.3 The key light is a beauty dish (white) to camera left. The large umbrella behind camera controls the fill of the shadows. The small umbrella is on a boom arm high and behind the subject, creating a hair light and illuminating the background. It is angled specifically to create the subtle gradient of light on the background. ISO 100, f/11, 1/125 sec.

ONE LIGHT

It has been mentioned a couple times already, but it is important to reiterate here: beautiful results can be achieved with only a single light. However, careful attention to that light must be made to really take the single light to the next level. Remember, the single light can be, but is not necessarily, simple. In instances where speed, simplicity, and traveling light are clutch, the value of understanding impactful one-light setups cannot be stressed enough. The following examples are just some of the ways a single light can be used to create a dramatic portrait.

> The technical concepts covered here with single-light setups: shooting with low, ambient light, checkerboarding/feathering the light, flags/negative fill, and intentional lack of separation from the background.

The subject in **Figure 4.4** was shot on location in Morocco using a Profoto B2 and a white OCF Beauty Dish (both the light and the modifier were chosen for portability). The purpose was to capture the subject proudly and powerfully on top of a sand dune overlooking his camp just before sunrise. The light was hand held on a pole and positioned at camera right. The time of day was just before sunrise, so a slow shutter speed was used to increase the exposure of the environment.

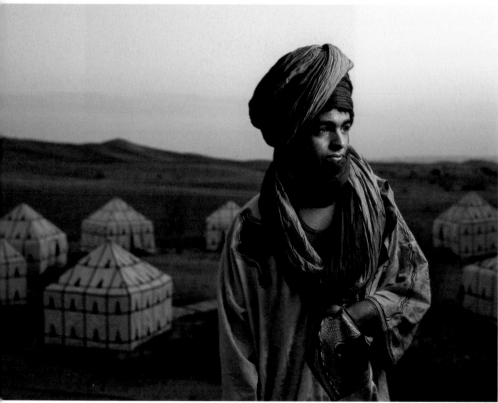

Profoto B2
OCF Beauty Dish
(White)

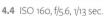
4.4 ISO 160, f/5.6, 1/13 sec.

In **Figure 4.5**, only a single light was used. The purpose was to create an elegant beauty portrait, showcasing the model, makeup, and hair. The key was a Large Profoto Deep Umbrella (51") with a diffuser. The body was turned away, putting her chest in shadow (and minimizing attention to the area), but the face was turned slightly to camera. A broad, loop (almost Rembrandt) light rendered the face lit on both sides, but the camera-left side still utilized significant shadow. The light was soft and even on the camera-right side and the shadow on the left accentuated cheekbone definition. The key light was positioned to partially light the background with a "checkerboard" effect, which created depth. (The effect of alternating dark and light tones is called checkerboarding the light.)

Feathering (see Chapter 2) was an invaluable tool to make a single light appear more complex (checkerboarding, in this case). The light was turned so the edge of illumination was visible on the background. Starting from the right side of the image (the origin of the light) and moving left, the light appears dark (on the background), light (on the camera right side of the face), dark (camera left side of the face), and then light (on the left side of the background). The light appears to travel in two opposite directions (or may even seem to be two lights), but it was actually a single light creating both effects. The gradient was positioned behind the subject's head.

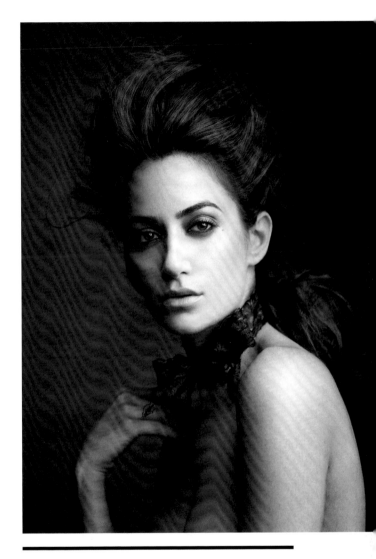

 Profoto B1
Deep White
Umbrella (51")
with Diffuser

 4.5 ISO 160, f/4.5, 1/125 sec.

In **Figure 4.6**, the purpose was to capture the subject as strong and mysterious. The key light was placed very close and at camera right, utilizing full-frontal, Rembrandt light. On camera left, a black flag was used to create negative fill and enhance the shadows (and thereby increase overall contrast) on the dark side of the face, making the subject appear to emerge from the darkness. The subject was approximately three feet from the background, but a lack of separation fails to inform the viewer of the space, adding to the drama and the mystery.

Whether this is the only light used, or you continue adding more, crafting the single light is one of the foundational elements of lighting. This light shapes, contours, and establishes the mood of a photograph.

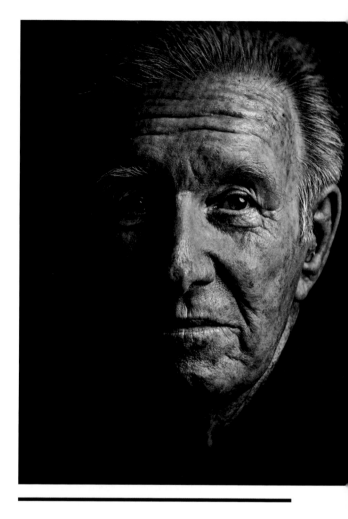

Flag

Profoto B1
Elinchrom 39"
Rotalux Deep
OctaBox with
Reverse Mount,
Interior and
Exterior Diffuser

4.6 ISO 100, f/8, 1/160 sec.

TWO LIGHTS

Adding a second light can have a range of effects, depending on what the purpose of the second light is meant to be. With the purpose of the light being the primary consideration here, we must think about what a second light adds to the image—shadow, control, or separation. Typically, a second light either controls the shadows (increasing brightness via fill, manipulating the hardness or softness, etc.) or separates the subject from the background (rim light, hair light, background light). In the following images, we look at some of the ways two lights can be used to help fulfill the goals of an image.

The purpose of the image in **Figure 4.7** was to create a dramatic portrait inspired directly by the painter Rembrandt. The subject turns away from camera and his face is lit in a broad, Rembrandt light by a Profoto White Softlight Reflector (Beauty Dish) with a grid at camera right. High power from the strobe was utilized to create a strong shadow on the camera-left side of the body without using a flag. The subject was wearing dark wardrobe and was standing against a dark gray background. In order to create separation, a second light (with Beauty Dish) was placed behind the subject to cast light onto the background and create a subtle vignette.

> The technical concepts covered here in two-light setups: the practical use of the background light, mixing qualities of light, the ring flash as fill, multiple ways to utilize shadows on the face, and using strobes and the sun together.

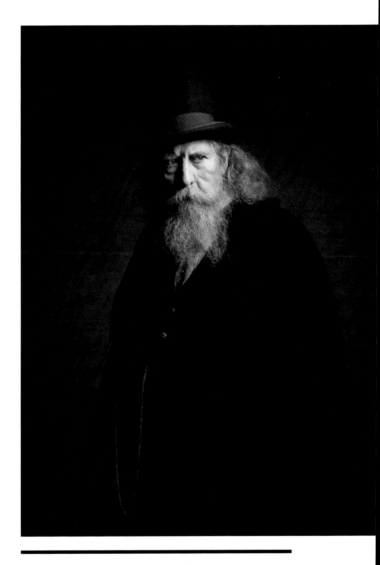

Profoto D1
Beauty Dish (White)

Profoto D1
Beauty Dish (White)
with Grid

4.7 ISO 100, f/13, 1/125 sec.

THREE LIGHTS

Lighting with three lights is not all that different from lighting with many more. Understanding how to use three lights will open the door to a nearly infinite number of options—fill, background, creative effects, and more. A single light (key) sets the scene. A second light modifies that scene or that light. With three lights, you can do anything your heart desires. Lighting with three lights is not that different than lighting with 10. Except 10 is probably brighter. The following are examples of three lights used for different visual goals.

The three-light setup shown in **Figure 4.10** was straightforward—each light had a clear purpose. The key light was a White Softlight Reflector (Beauty Dish) with diffuser at camera right, creating full-frontal Rembrandt light. A small, strip softbox was used at camera left to add light (and highlights) to the fabric of the dress. The purpose was to show the subject as regal and powerful (shooting from a low vantage point relative to the subject presents an upward camera angle, which helps here) in the style of Flemish painter Anthony van Dyck.

As the subject's dress was very elaborate and decorated with embellishments, the details were important to showcase. In van Dyck's paintings, satin fabrics were rendered with shine, and even though the light was dramatic, the fabric still was shown with lots of detail. The third light was a softbox on a boom arm set high and directly behind the subject. As she had dark hair (and the background was dark) a subtle hair light helped to define the elaborate hairstyle (it would have been a waste not to show it). The hair light was positioned overhead to not appear far away from the key light—giving the illusion that it may be a single, large source, even though it was not. On the camera left side, a white v-flat was used to fill in overall shadow. The fabric itself was reflective—resulting in the small bit of fill under the jaw on the camera-left side.

The technical concepts covered here in three-light setups include: accentuating textures and details, lighting practical effects in the environment, and crafting the complex, "single" light.

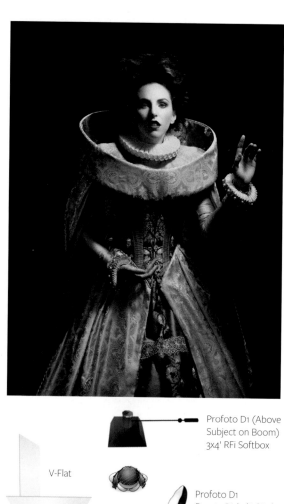

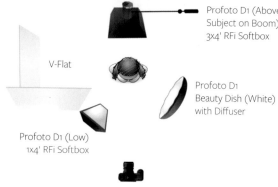

V-Flat

Profoto D1 (Above Subject on Boom) 3x4' RFi Softbox

Profoto D1 Beauty Dish (White) with Diffuser

Profoto D1 (Low) 1x4' RFi Softbox

4.10 ISO 100, f/5, 1/125 sec.

The image in **Figure 4.11** was created for the handbag designer Cela New York. The concept centered around fire, so the purpose was to implement that as effectively (and safely) as possible. Actual fire was not used (I disappointingly was not allowed), but to create a realistic fire effect in the scene (before the fire was composited in) gelled lights and a smoke machine were used. The key light was a large octabox on a boom above the subject, creating Rembrandt light based on her position lying down. The fill light (camera left) had an orange gel and was meant to mimic the orange glow of the flames. The light originated from the direction (and angle) where the flames would be added in the final image, helping to sell the illusion once the flames were in place. This light highlighted the underside of the handbag, making it stand out more in the image. The background light (low, camera left and behind) also had an orange gel to mimic the glow of fire and light the smoke from behind. Lighting smoke from behind helped to make it more visible.

Profoto Acute 2 Head with Orange Gel

Profoto Acute 2 Head with Orange Gel

Profoto Acute 2 Head on Boom, Pointed Down, 5' RFi Octa Softbox

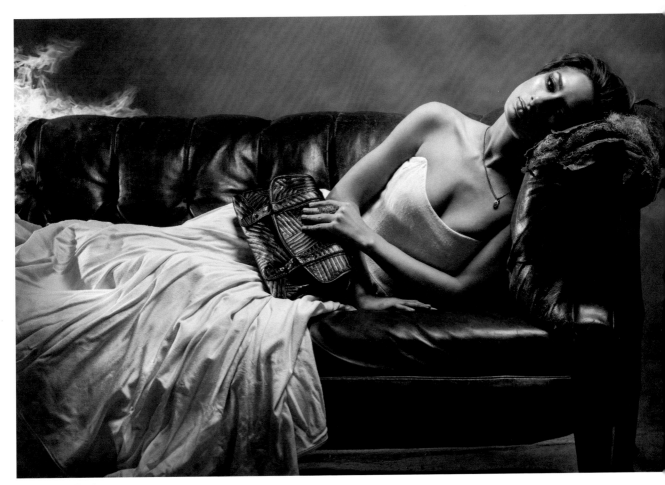

4.11 ISO 250, f/9, 1/200 sec.

Trying to pay homage to an old photograph, the purpose in **Figure 4.12** was to create a photo that felt "of the period," but I also wanted to emphasize an illustrative and painterly aesthetic. To accomplish this, the "complex" single light was utilized. At first glance, the image appears to only have a single source (and no obvious catchlights are found in the eyes to help), but there are three lights.

Pointed at the face was the key light (camera left)—a Profoto D1 with a 10-degree grid and a snoot. This produced a very narrow (but soft edged) beam of light. The light pattern was a broad loop light (although the makeup on the camera-right cheek may make it difficult to tell). The fill light was a Profoto Deep Umbrella (51") with a diffuser positioned directly behind the camera at approximately a stop of power below the key light. This makes the face brighter, but only by a little. By the time the light reached the subject's feet, the falloff was more apparent. The third light was a ring flash mounted to the camera as fill. The purpose of this light was to give the illustrative feel of

the light and accentuate the sweat, muscles, and leathery objects (gloves and shoes) with subtle highlights. Since these two fill lights do not create their own noticeable shadows, they only slightly influence the look of the overall image and they do not decide it directly. There was no light on the background—the vignette was printed.

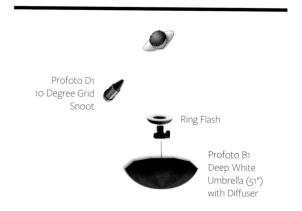

Profoto D1
10 Degree Grid
Snoot

Ring Flash

Profoto B1
Deep White
Umbrella (51")
with Diffuser

WRAP-UP

Lighting can be used in an endless number of ways—it only needs to be successful in serving the purpose of the image. That purpose, of course, is a decision made by you. Photography is wonderful in that it is both a creative and technical medium. Within the atmosphere of photography, lighting captures that essence better than any other part of the process.

Be as creative as you want to be. With only one light, creativity is certainly possible, but if you get to the point of using three lights, the sheer number of creative combinations and controls opens to you. Whether it is a mix of ambient light, strobes, speedlights, hardware store work lights, or a lamp from IKEA—light is light. It is your call how to shape it, control it, move it around, modify it, fill it, feather it, flag it, or anything you want—as long as the light serves the purpose of the shot.

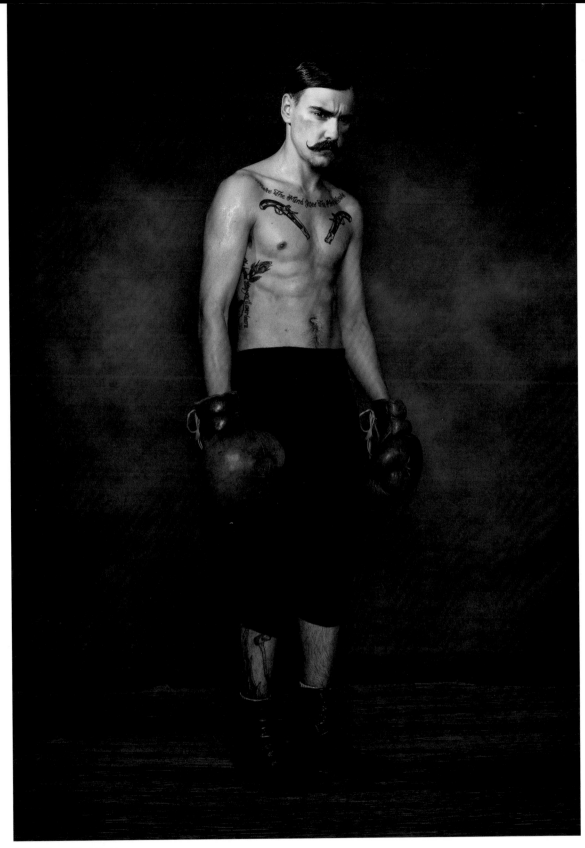

4.12 ISO 100, f/8, 1/125 sec.

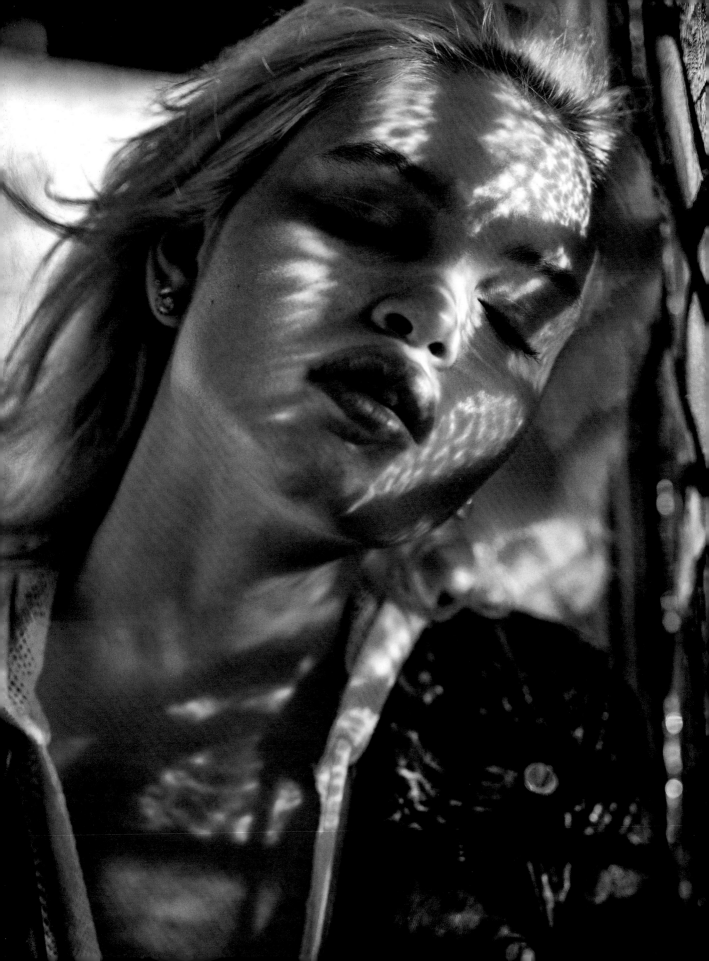

CHAPTER FIVE
COLOR

DIRECTING THE EYE AND INFLUENCING PEOPLE

"It's easier to make color look good, but harder to make it service the story."

—Roger Deakins, cinematographer

Color inhabits the world around us in countless ways. It has the power to affect us psychologically and emotionally. Certain shades of blue are used to help treat headaches. A shade of pink known as "Baker-Miller Pink" is used in some jail holding cells to reduce violent behavior. Color even helps facilitate organization in our daily lives—from stoplights to notifications on our phones.

For image-makers, color is the foundation of emotional response. Filmmakers can use color as a motif that reinforces or subtly adds to narrative elements, helping to tell the story (or add clues to one). Photographers use a single frame to make a statement with color. Focusing only on making colors aesthetically pleasing is not an incorrect approach to color theory—there is no right or wrong way to use them. However, by studying the color wheel and color relationships as well as examples of applied color theory in images, we can analyze the methods in which color can be used to help articulate the final vision of our image.

It is impossible to know everything about color (even the term *master* may be overstated in every conceivable use). It simply encompasses too many elements of life and culture for us to truly know everything (or even mostly everything) about it. Hopefully, this chapter becomes a launch pad to explore color within your own work, because understanding the ways in which colors can manipulate the viewer's response to an image is an endlessly powerful tool that will only make your work stronger and more effective.

A strong and purposeful use of color helps to reinforce the overall purpose of the shot and influence the mood. Color is one stylistic decision (amongst many) that helps move the big idea (the greater concept) further down the river. A smooth flowing river often results in a more successful image. This is how colors "service the story."

HOW COLOR MANIPULATES

Color is something we encounter in our lives every day. It may not be something we *consciously* think about, but as photographers (and visual creatives), it should be. The physiological effects of color have been studied since the Middle Ages, and there are many theories that set out to explain which emotional responses are tied to certain colors. A single color can encompass a wide range of emotions or have many associations affiliated with it; this can be affected by mood, emotion, time, or culture.

Chemist Michel Eugène Chevreul (1786–1889) came up with the core concept of the color wheel that we know today (**Figure 5.1**). The most revolutionary component of this idea was visually representing how colors interact with one another—also known as simultaneous contrast—and articulating the idea that a single color can appear different based on the color it is near. This was used earlier by Baroque painters via chiaroscuro and later by impressionists such as Monet and Cézanne and abstract expressionists like Rothko.

5.1 Michel Eugène Chevreul's color wheel (1839). These 72 color divisions were an early attempt to systematically organize color.

Yellow

Yellow (**Figure 5.3**) is warm and optimistic. It can strongly affect the emotional state, signifying confidence, self-esteem, wealth, enthusiasm, emotional strength, and friendliness. It is a color commonly used for children (especially when choosing a color that is gender neutral). It can, unfortunately, also be over-emotional, fearful, depressed, and cowardly. Yellow is the color of rubber duckies, pencils, hyperbolic journalism, construction equipment, and the meth suits from the television series *Breaking Bad*. Fun fact: during the Medieval and Renaissance periods, prostitutes were recognized by wearing yellow (Mary Magdalene is often depicted wearing yellow). The first Chinese emperor was known as "The Yellow Emperor" helping to establish the prominence of yellow in Chinese culture, where it is seen as the most significant color as it has the capability to bring balance to the others. Some cultures have chosen far more nefarious purposes for yellow—for example, the choice of hair color by Guy Fieri.

5.3 Yellow is an emotional color, giving lots of feels.

Blue

Blue (**Figure 5.4**) is intellectual. The color represents serenity, coolness, calm, authority, honesty, and trust (banks and businesses use blue in their logos). It can also mean coldness, unfriendliness, and a lack of emotion. Blue is a first-place ribbon and blueberry pie. It is also sadness. Blue is worn by police officers and Bruce Springsteen (via a Canadian tuxedo). The duality of blue is especially interesting as it can represent affluence ("blue bloods" were called this because of the veiny, translucent paleness of their skin) as well as the working class ("blue collar").

Historically blue represented a lover's fidelity, a marriageable woman, servitude, and chastity (the other color besides red in Mary's robes). Blue was one of the last colors to be given a name in languages around the world, due to its infrequency in nature. Another theory is that earlier humans did not see color the way humans do today, because their eyes were not developed to perceive certain hues. In Homer's *Iliad*, for example, the sea is described as "wine-colored." The ancient Greeks had no word for blue (but they did have one for sodomy...so priorities). By the Renaissance, blue was still uncommon as a color choice for painters as the ingredient used to create the pigment, lapis lazuli, was rare and more expensive by weight than really good cocaine. It was not until the 18th century that a cheaper alternative became available and the usage and popularity of blue increased.

5.4 Blue can send a shiver up the spine. It *feels* cold, especially those blues closer to purple.

Green

Green (**Figure 5.5**) is balance. It shows harmony, environmental awareness, and equilibrium. Hippies and Jill Stein supporters (usually mutually exclusive) are green. Conversely, it is also the color of money and wealth. A world of green makes us feel good, as it alludes to a fertile earth. Negatively, it can be bland, bored, or envious. Muslims use green extensively and it is a color associated with paradise. Mohammed is described as wearing green, white, or both. Green has been donned by figures from Robin Hood to Peter Pan, Tinker Bell to the Hulk. The Statue of Liberty is inadvertently green, aged by time. Absinthe introduced the world to "green fairies." Surgeons wear green, because it is the opposite of red (blood), making the results of the performed activities less distracting in the moment (red on white is a bold fashion statement) and less menacing when confronting the family in the waiting room afterwards.

5.5 Green is the color of a healthy earth (pictured) but an unhealthy face (not pictured).

Beyond the primary colors, many other colors make the viewer feel more specific and nuanced emotions. Let's look at some examples.

Pink

Pink (**Figure 5.6**) conveys love, sexuality, femininity, youth, desire, innocence, and romance. It is less excitable than red. It soothes, rather than arouses. Negatively, it elicits inhibition, emasculation, and even sometimes weakness.

Violet

Violet (purple) (**Figure 5.7**) is spiritual and royal. Purple and violet are visually similar, but violet exists in the spectrum of light (shorthand: ROYGBIV; longhand: red, orange, yellow, green, blue, indigo, violet), whereas purple is created from mixing red and blue pigments. It represents awareness, higher truth, and luxury. The luxury can also be interpreted as decadence and can make the viewer feel inferior. Historically it was the color of kings (to dye clothing purple was time-consuming and costly), the Medici family, and the depictions of Christ during the Middle Ages. Purple was also worn by knights, pharaohs, and Prince (see *Purple Rain*). However, the color virtually disappeared during the Renaissance, because of the near extinction of a particular snail used in the pigment, but the color made a resurgence in the mid-1800s when a synthetic alternative was found.

Orange

Orange (**Figure 5.8**) is a warm color (like fire), situated near yellow in its lighter shades and brown in its darker versions. Like yellow, it is comforting, but the color is seen as more optimistic, playful, energetic, and uplifting (especially in its more vibrant incarnations). In languages around the world, orange (previously called red-yellow) was one of the last named colors—only gaining its own namesake when the fruit it shares a name with became more popular in the western world. Orange represents Halloween and Cheetos and is considered sacred in certain religions and cultures. Buddhists use orange for their robes. Brighter, more vibrant shades are used as a warning color and are meant to be attention grabbing, especially from a distance

5.6 Pink, similarly to red, seduces but in a less aggressive way, staying just far enough outside the friend zone and providing the occasional wink and nod.

5.7 Purple never means to cause you any trouble...never means to cause you any pain. (Photo by Michael Ochs Archives/Getty Images)

and against a blue sky or body of water—traffic cones, construction barricades, life vests, and most things used during emergency purposes. The color adds an exciting element to a photograph without overpowering it. Negative emotions associated with orange are frustration, impulsiveness, cheapness, and immaturity.

Brown

Going deeper and darker, brown (**Figure 5.9**) is still warm, but more serious. Brown is orange all grown up, dreams abandoned and a little dead on the inside. It represents earth, nature, reliability, and stability. Brown can also be perceived as boring, unfunny, and dull. It borrows certain characteristics from red and yellow and has the gravity of black but with a lack of sophistication and less severity.

5.8 Orange helps separate the subject from a cool background, but does not pop out so much that it is distracting to the subject.

5.9 Brown is the color of old leather and whiskey. Use responsibly.

White, Gray, and Black

When saturation goes to zero, the color becomes white, gray, or black. These colors also have their own responses.

White (**Figure 5.10**) is clean, sterile, and pure (chaste). It is simple, efficient, meditative, and pious (holy). Sterility, of course, can also have a negative connotation, as can coldness and elitism. As a neutral color, white works well with almost any other color. Sometimes a bold white can overpower the image, so an off-white, or cream can sometimes work better.

5.10 White weddings make for more expensive dry cleanings.

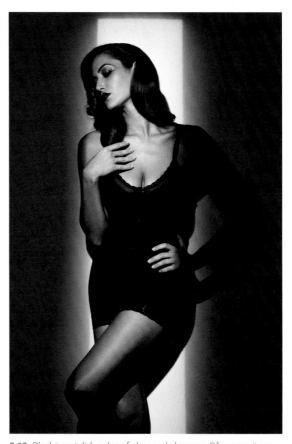

5.11 Gray isn't exciting, but it's not meant to be. It is the purgatory of colors.

5.12 Black is a stylish color of class and elegance. Of course, it can also denote the villain.

Gray (**Figure 5.11**) is, by its very essence, neutral. This limits the color's emotional responsiveness. Gray can feel professional, but it can also feel gloomy. This depends on the intensity of the shade. As gray is closer to white, it inherits the characteristics of white (and can work well if a pure white is too strong). A dark gray, on the other hand, can alleviate the heaviness that comes with a true black. Historically, gray has represented poverty and modesty.

Black (**Figure 5.12**) is luxury, sleekness, and sophistication. It is power. When all colors are combined, black is the result. Because of this, black is a heavy, weighty color. This can be construed negatively too, as black can also mean oppression and evil. Black can be worn to a funeral or a cocktail party. During the Middle Ages in certain countries (like Italy), black denoted wealth (as using black dye was time-consuming and expensive), but in others (like England), wearing black was indicative of the lower class.

We may not know exactly how colors affect us at a psychological level, but they do. Films use color to influence the viewer's reaction to a scene or character to further the (usually emotional) story in subtle (or even obvious) ways. *La La Land*'s colors are vibrant, exuberant, and dreamlike in the beginning, only to give way to a more subdued palette later on in the film as the characters face reality, struggle, and a compromise of those dreams. Colors can even, for instance, aid the viewer without contextual help to discern the good guy from the bad—like in *Star Wars*, where Luke wears white and Darth Vader wears black. Other filmmakers will sometimes break with traditional uses of color to trick the viewer or lead them subconsciously toward a twist ending (Alfred Hitchcock utilized this technique).

MAKING COLORS PLAY NICE

There are numerous ways in which color combinations can work with each other successfully. Controlling color is not just a way to communicate more effectively; it can also be a cornerstone to personal style. When colors work well together, they provide balance to the image. This is also known as harmony. There are many different harmonies that have been used and studied over the years, but in this book, we will concentrate on four: monochrome, complementary, analogous, and triadic.

MONOCHROME

When colors share the same hue (but have varying saturations and luminosities), they are monochromatic (**Figure 5.13**). A monochrome image is often thought to be only black and white. While this is *technically* correct, a monochrome image only actually needs one color (whatever that color may be). Since white, gray, and black are visible in any hue, they do not count as a separate color.

NOTE *Many people struggle with whether an image looks best in black and white or color. Obviously, this depends largely on the person, but I find there are two main considerations when deciding. First, do the colors of the image add to the image or not? If so (typically when they fall into any of the mentioned color schemes), the image should be in color. If the colors in the image are distracting (or do not add anything to the image), the image may look better in black and white. Second, is there a strong contrast between the tones or textures in the image? A high-contrast image (based on subject matter, not necessarily post-production) typically works better in black and white than a low-contrast image.*

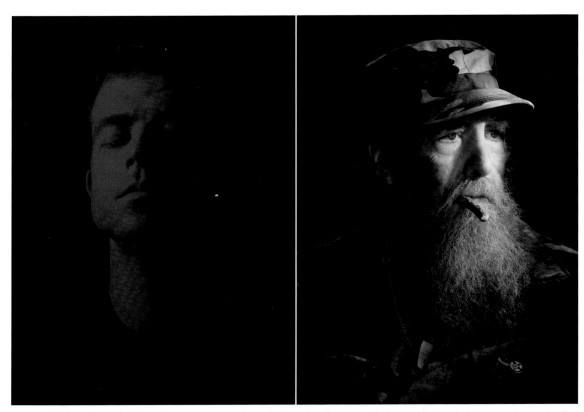

5.13 In the left image, a red gel is used to create a monochromatic image in color. In the right image, a black-and-white conversion creates the monochrome in post-production.

COMPLEMENTARY

Colors have opposites, and much like Paula Abdul and MC Skat Kat, opposites do attract. These are colors directly across from each other on the color wheel (**Figure 5.14**). Every warm color has a cool counterpart (and vice-versa). Using complementary colors is also a way to create contrast in an image (white and black are opposite colors as well). The most commonly used pair in movies is blue and orange (**Figure 5.15**). The leading theory behind this is that since skin tones are mostly in the orange family and blue is the perfect complement, the use of blue during both production and post-production helps make the actors pop out more. Other examples of complementary colors are red/green and yellow/purple (**Figure 5.16**).

5.14 The color wheel helps to visualize color relationships. Brighter hues (traditionally mixed with white) are known as tints. Middle hues (mixed with gray) are known as tones. Darker hues (mixed with black) are known as shades.

5.15 Blue and orange work together to create contrast. Without the blue clothing, the image would be almost monochromatic. The blue helps to separate the subject from the background more clearly. The combination is also pretty.

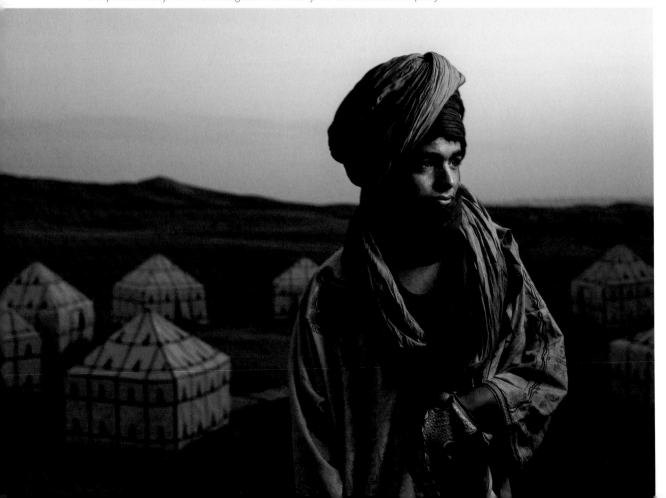

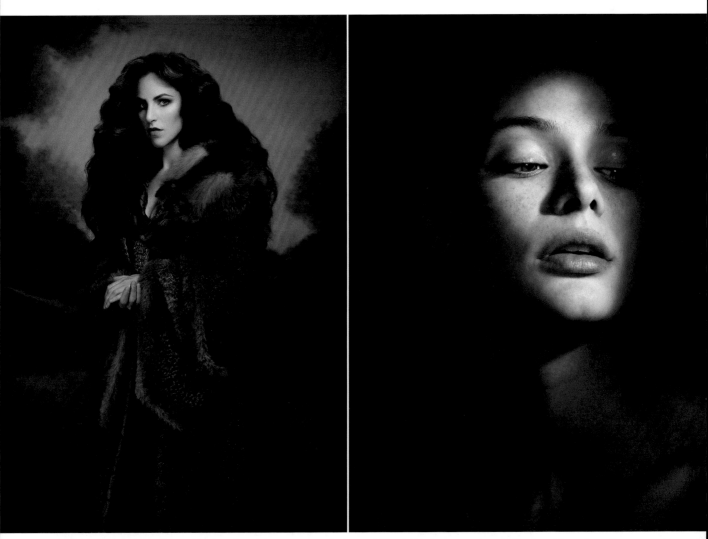

5.16 The left image uses the combination of a red dress on a green background. The right image uses post-production to create cool, purple shadows and a warm, yellow light on the face.

ANALOGOUS

Any group of three to four colors, side by side on the color wheel, is known as analogous. These schemes are very harmonious and often serene. Think of it as an expanded monochromatic scheme, which can be more helpful (and realistic) in a photograph (as opposed to a drawing or painting). Examples are orange/yellow/yellow-green (**Figure 5.17**) or blue/purple/crimson. Adding in a complementary color to an analogous scheme can also be an effective way to add visual interest.

TRIADIC

Sometimes at first glance, a scene can appear to not have a color scheme and the colors appear erratic. This is sometimes a triadic scheme. A triadic color scheme is made of three colors evenly spaced around the color wheel (making a triangle) (**Figure 5.18**). These schemes are usually very bright and vibrant and are often used as a palette for children.

Color harmonies can be an effective tool when using color to create a sense of visual balance in the work. These, of course, are only some ways to achieve balance and harmony. There is also the opportunity to use discordance, wherein colors purposefully do not belong and purposefully create contrast. A red dress in an otherwise monochrome image is an example of discordance.

5.17 Here, an analogous scheme creates a color harmony of warm tones from orange to yellow to yellow-green.

5.18 Although the colors may, at first, seem haphazard, the combination of red, blue, and yellow creates a balanced and colorful palette.

MEMORY COLORS

Certain colors in our mind are tied to certain objects or memories. Although color is one of the most difficult things for the human brain to have perfect recall of, we recognize when familiar colors are shown incorrectly. This is the very definition of a memory color. Green is strongly associated with our memory of grass and blue with the sky. This works with flags, logos, skin tones, and food. Memory colors are cultural and obviously certain colors are more tied to where the person grew up.

Neutral colors should also be rendered neutral if the idea is to establish a subtle grade. When the sky or skin color, for example, is noticeably changed, the viewer automatically expects a visual fantasy. However, when memory colors are retained, the "look" can be pushed much further, more successfully (**Figure 5.19**).

5.19 In the first image, the color is neutral and no color adjustments have been made. In the second image, a blue hue is applied to the image, but the skin color no longer looks realistic. In the third image, the skin is masked out to reveal the original color, making the final treatment more pleasing to the eye.

WRAP-UP

Having seen some of the ways in which color has the capability to manipulate the viewer, we can now use these tools to help express our visual stories; I dive deeper into my own personal choices and approach to color in both Chapters 6 and 7. Color as a symbol has evolved significantly over time, but many historical remnants are still found all around us today. Knowing how they have been used not only helps us to comprehend more meaning from historical imagery, but it can also add deeper context and meaning to our own.

CHAPTER SIX
STYLING

MAKING GOOD VISUAL CHOICES

Lighting and post-production are often the two components of an image believed to dictate the "style," but a successful image has considerably more invested than just these two elements. All visual choices are the preliminary building blocks that contribute to the styling of the over-all image and help define the voice of the artist. The choices covered in this chapter include wardrobe, background (or environments), hair, makeup, and props.

Good styling levels up an image that is *competent* and makes it *strong*. Your styling choices help you create intent. Stronger visuals are more dynamic, and by putting something in front of you that is exciting, you will be more excited with the images created from them. But remember, these things need to be planned ahead; they don't happen by accident.

STRENGTHENING THE PURPOSE

All styling choices need strength of purpose. That is to say, every visual component in the frame *should* be considered. This is *not* saying to ignore spontaneity; it is quite the contrary. Having styling elements in place first allows for more creative spontaneity without stressing over small details that could be sorted out before you click the shutter. Whether you choose sleekness or grit, low or high key, a stronger image is one with cohesion—stronger together. This cohesion does not happen by accident. It occurs through deliberation and (often) collaboration.

By now I may seem like a broken record, but I cannot stress this enough: know the purpose of the shot. In a dramatic portrait, we are portraying the subject in a dramatic way. This can be accomplished through strong shadows, bold colors, and emotion. Wardrobe, environment, hair, and makeup together contribute to the end goal—whatever that goal may be. If any one of these choices does not further the purpose, change it to an option that does. Is the subject wearing pastels in an image where a bold red would be more dramatic? Switch the wardrobe. This is true for backgrounds and makeup as well. When the detailed elements do not supplement the final image, they detract from it. An image's polish originates in the thoughtfulness of its details.

WARDROBE

One of the biggest decisions regarding styling is what the subject is wearing (or in some cases, not wearing). People in charge of clothes are even called "stylists." Traditional portraits are stridently more lenient than fashion portraits in terms of the timeliness of wardrobe selections. A traditional portrait does not need to adhere to the trends of the fashion industry, whereas an expectation of fashionable style is likely when creating portraits with a fashion purpose.

This can mean different things to photographers working in different markets too—no matter the size of the market. New York style, for instance, is going to look different than Los Angeles, Paris, or Milan style. If fashion portraits are your thing, be aware of the fashion in your area (or the area you want to shoot for). Do not think this limits your choices of styling, just that trends should be thought through when deciding on clothing. Wardrobe stylists are a highly beneficial addition to your team but can be a struggle to find. Be creative! Options like Rent the Runway are solid resources for clothes and they ship anywhere in the United States.

The subjects in traditional portraits have a larger range of options for wardrobe as the clothing does not have to be timely. For a portrait, a businessman may photograph great in a suit he owns so long as it fits well (or can be made to look that way). Another option is creating a character for the subject (**Figure 6.1**). Styling (especially with costumes) can be used to create a character that plays up elements of a subject's personality. Ask yourself, are the clothes meant to be an idealized version of the subject—meant to *amplify* parts of the subject's personality? Do they help *create* an entirely unique character or visual fantasy, or are they meant to *recede,* so the subject's personality comes to the forefront of the image?

6.1 This image creates a character around certain parts of the subject's personality. He spoke very fondly of his *British-ness.* He is also a mounted park ranger and lover of horses. The jacket is his and something regularly worn while riding. The hat, bow tie, monocle, and pocket watch were chosen as playful elements of his personality.

Styling is another way for color to be used. Historically, wardrobe was one way in which the subjects reminded the viewer of their wealth and importance, as if the ability to commission a portrait in the first place was not enough of a way to show it. Depending on the time period and where they existed in the world, the colors and ostentation varied (**Figure 6.2**). Napoleon adorned himself like a Fabergé egg. Rembrandt's subjects often wore clothing that was far more subdued even if it was expensive. Oftentimes, dark colors (specifically blacks) were a way to show wealth as the dyeing process of clothing was time consuming and required many steps, which made the garments more expensive and fancy.

6.2 Left: *Napoléon I on His Imperial Throne*, 1806, by Jean-Auguste-Dominique Ingres. Napoleon wears a Christmas-tree skirt and the most impractical boots. Right: *Bust of an Old Man*, 1631, by Rembrandt. Although this man's eyes suggest that he was clearly a gangster, his all-black clothes do not leap to the forefront of the painting. This was not always the case for Rembrandt's work, but the Calvinist sensibilities of the time often found their way into his work.

The color of the wardrobe can be a way to create contrast from the environment (through complementary colors, for example) or blend in (using monochromatic or analogous color schemes). The use of bold colors like red is dramatic, and using different colors elicits different reactions (see Chapter 5). Using colors that show strength or provocation (reds, purples, whites, and blacks) creates drama while other colors (especially in lighter iterations)...not so much. In successful dramatic images, color is a part of the conversation beforehand. It may not be the focus, but it is at least discussed and purposefully decided.

STYLING CHECKLIST

Here are a few things to consider when picking wardrobe:

- **Color:** Does the color of the clothing complement or contribute to the image in some way?

- **Fit:** Are the clothes flattering to the subject? Avoid having seams and buttons noticeably pull. Use clips and pins when needed to make a loose piece more form-fitting. Know what kinds of clothing complement certain body types.

- **Movement:** Does the fit allow for movement? Depending on the wardrobe, some clothes are best portrayed with motion and others allow for very little. Think about the ideal way to position the particular wardrobe piece. Does the subject need to sit or stand? Where is the best place for the hands?

- **Texture:** What is the tactile feel of the image? Is it rough or smooth? Is the time period modern or period?

WHERE TO FIND COSTUMES

Costume and theater rentals are great resources for wardrobe, and they are found all over the world. Some are willing to ship, but don't be afraid to check locally.

- Oregon Shakespeare Festival (www.osfcostumerentals.org)
- Rent the Runway (www.renttherunway.com)
- Etsy shops (www.etsy.com)
- eBay (www.ebay.com)
- Local costume rentals
- Local community theatre

BACKGROUNDS

Whether one is shooting in a studio or on location, the space behind the subject cannot be ignored. Without getting too heavy on composition here, the main touchstone is the concept of "figure/ground" (see Chapter 2), with the main goal of separating the subject from the background. In a two-dimensional image, this is a way to create depth and help with visual organization. This can be done through depth of field, contrast, framing of the subject within the environment (also usually through contrast), and lighting (**Figure 6.3**).

DEPTH OF FIELD

Through depth of field, the subject is in focus and the background lacks focus by varying degrees. This can work particularly well when the background has no relation to the subject, does not add any additional context, or is too distracting. Another by-product of very wide apertures is the soft edges of the subject, which can be reminiscent of paintings, where the detail decreases away from the face and large brush strokes are more apparent, making the edges of the subject appear "fuzzy."

6.3 In the first image, the background is busy and is in a similar color palette, so a shallow depth of field is used to help separate the subject from the background. In the second image, the subject is much lighter than the dark background. The clothes are subtly darker than the background, creating a separation, but the combination of low-key tones from the wardrobe and background help reinforce the focus on the subject's face. The last image utilizes a rim light (high and behind the subject) to separate the subject in an otherwise dark scene.

CONTRAST

Using contrast, bright subjects pop out from dark backgrounds (or dark parts of the background) and dark subjects do the same on a bright background. Using this method utilizes a more refined compositional eye than simply throwing the background out of focus and, when the background adds meaning to the subject, results in a stronger image than simply using a wide aperture. This can be done using a studio background or an environment, but the concept remains the same—dark subject on light, light subject on dark.

LIGHTING

A third option is lighting. A rim or background light helps to create separation of the subject from the background. Either light (or both at once) can be utilized, but they will have the same overall result—creating separation. Of course, an obvious separation is not even entirely necessary. Using very little tonal differences between the subject and background was a common device used by painters through the centuries. Dark clothes on dark backgrounds (with little to no separation) was often a way to instruct the viewer where to look—the face. This approach requires more control over low-key tones and obliges the viewer to pay closer attention to the image to absorb what the artist set out to show. When utilizing no separation, the subject emerges from the shadows with no clear definition to his edges. No method is more correct than another, and through enough testing, you can decide your preferred method. But pick one and make it on purpose.

ENVIRONMENT VERSUS STUDIO

Using an environment creates its own share of opportunities and challenges. First, there is ample possibility for a visual feast. Environments are dynamic and add dimension to a portrait. They are also sometimes difficult and unpredictable to work in for many other reasons (see Chapter 4). When shooting portraits in an environment, it is crucial to remember that the subject is the most important part of the image and the environment should not overwhelm him or her. A strong portrait has a clearly defined subject. The environment helps to frame the subject, add context, or both. It may also require additional lighting (but it may not).

In the studio, some may think that backgrounds are simple and boring. This is not the case at all. It is true that in the studio there is nowhere to hide (you control nearly every component of the visual image and failures and successes are on full display), but there are still many options available for interesting backgrounds. The most common (and inexpensive) method is a roll of seamless paper (**Figure 6.4**). These come in a variety of colors and widths and are relatively cost-effective. As the name suggests, there is no seam—meaning it is meant to appear as a void behind the subject. Lights and gels can be used to modify the paper's appearance. Seamless backdrops can make for a bold, graphic background behind the subject. Similar to seamless (but at the other end of the cost spectrum) is the cyclorama (or "cyc"). This looks close to seamless in a photo, but is constructed out of plywood (which makes it heavy and hard to move) and painted the desired color. A cyc does not get wrinkled or creased like paper and the subject can utilize it as an interactive element if needed.

6.4 Seamless paper creates a clean, minimal background.

A step up from seamless paper—and easier to maneuver than a cyc—is the printed backdrop (**Figure 6.5**). Like rolls of paper, they come in a variety of sizes, and unlike paper, they are available in a much wider range of colors, textures, and materials. They come in an assortment of styles and even scenes (both painted and photo) to fulfill any need. In addition to backgrounds, roll up mats with different floor textures can be used to easily and cheaply change out floors. Both are viable options to maintain different, interchangeable sets.

Lastly, there is the painted canvas backdrop (**Figure 6.6**). This option is more expensive than the printed option, because these backgrounds are not mass produced but are created by hand. Backgrounds like these are seen in the work of Annie Leibovitz, Norman Jean Roy, and Patrick Demarchelier. A printed background is typically used one way (as a background), but a canvas backdrop is more versatile and is regularly used as a compositional device within the greater image for added effect and depth.

When there is the option of shooting in studio or with an environment, consider that sometimes stripping away context (the environment) adds more focus and meaning to the individual, but other times, the environment adds more to the overall narrative.

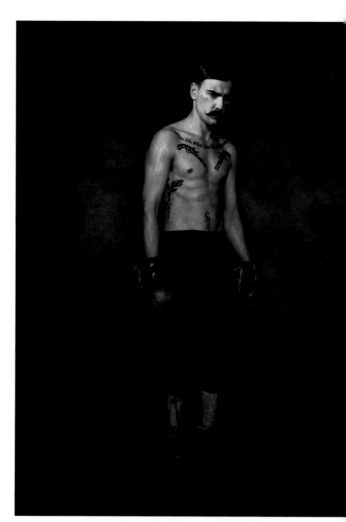

6.5 The background (a wrinkle-free polyester that can be put in a washing machine) and floor (a neoprene rubber mat) are both printed. Courtesy of Denny Manufacturing.

WHERE TO FIND BACKGROUNDS

Seamless paper, printed backdrops, and floors are available from:

- Savage (www.savageuniversal.com)
- Denny Manufacturing (www.dennymfg.com)
- Silverlake Photo Accessories (www.silverlakephoto.com)

Painted canvas backdrops are available from:

- Gravity Backdrops (www.gravitybackdrops.com)
- Oliphant Studios (www.oliphantstudio.com)
- Broderson Backdrops (www.brodersonbackdrops.net)

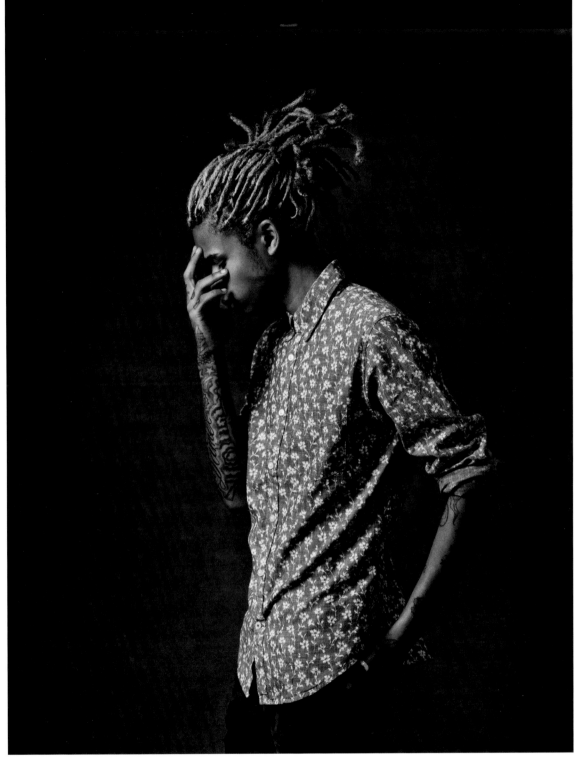

6.6 A canvas backdrop creates a unique, textured background for the subject.

TEXTURES

In addition to tones and colors, textures can create added visual interest in an image. And if you want a cleaner overall aesthetic, perhaps a *lack* of textures would be a better direction. Textures can affect your image via many different routes: in clothes, skin, backgrounds, and props. Clothes are the obvious starting point—the range of possibilities is staggering—from tweed to mesh, metal to silk, and furs (faux or otherwise) to (p)leather or lace. Clothing textures can suit any genre or mood.

Skin can have wonderful textures from the head to the hands and everything in between (hair, wrinkles, freckles, and scars, for example). On the face, makeup can create texture—sometimes through a purposeful, heavy textural application—and other times just a simple highlight on the collarbone.

Textures can be found on props and backgrounds. I regularly prefer a textured background to a clean seamless. While some photographers prefer smooth, clean surfaces, others celebrate the irregularities—and some like both. All of these elements boil down to personal choice; just be sure to decide which route your image is taking.

MOOD BOARD

A mood board is a collection of images or ideas that can be easily shared with the team involved in the shoot. This can include images of the model, hair and makeup inspiration, wardrobe, color palettes, etc. Pinterest, Behance, and Tumblr are all great places to find inspiration. Pinterest has a built-in system to create and share mood boards.

HAIR AND MAKEUP

The degree to which hair and makeup are used is dependent upon the goal of the image. A fashion portrait may have considerably more makeup than a non-fashion-inspired one. It may also have absolutely none at all. The goal of a portrait is different than that of fashion or beauty. With a portrait, it is particularly important for the subject to wear the hair and makeup—not the other way around. Overly elaborate eyes, for example, can take away from the subject. In a fashion image, "overwhelming" can be the point. In a portrait, hair and makeup should typically contribute to the subject as the focal point and not the other way around.

When working with hair and makeup artists, a mood board made in advance can be helpful to ensure that everyone is on the same page (**Figure 6.7**). If the goal is to create a character, hair and makeup is a great way to get the subject more invested in who they are meant to become and often makes it easier for them to "perform." Hair and makeup artists can quickly become indispensible members of your team. Working with skilled artists makes a difference. They know what can flatter a particular individual while not taking away from the concept. Collaborating with experts with their own ideas and contributions can greatly improve your own visual sensibilities, not to mention increasing your subject's self-esteem. Looking great leads to feeling great, which ultimately makes the job easier.

WHERE TO FIND STYLISTS AND HAIR AND MAKEUP ARTISTS

- Modelmayhem.com
- Local salons
- Store makeup counters

6.7 Use mood boards to have wardrobe and backgrounds planned in advance. This keeps the production more organized and helps the team work with a cohesive vision.

PROPS

Although not a mandatory addition to an image, props offer a great way to give the subject something to do. When a subject is in front of the camera, they sometimes forget how to use their hands or at least what to do with them. Sometimes uncomfortable or stiff subjects may have difficulty at first, but using a chair, table, or prop can give them something to lean on, interact with, or help get them into character.

Rembrandt kept a collection of props in his studio and utilized them in many paintings (**Figure 6.8**). Historically, in commissioned portraits, adding a prop was a way to describe the subject or inject hidden meaning. For instance, a book represented learning, a skull could represent death or mortality, and mirrors and reflections represented vanity. Props offer a great way to say something in your image without hitting your viewer over the head. Giving them something to discover can add to the appreciation of the image.

6.8 Rembrandt was an avid collector. This room in Rembrandt's house is filled with his collectables—some of which made their way into his paintings as props.

WRAP-UP

Wishy-washy decisions are the bane of visual style. Commit to decisions and have strong opinions on the elements in your image. When you plan your styling ahead of time, you have more tools at your disposal to communicate more effectively *and* be inspired in the moment. A subject in a t-shirt with no hair and makeup on a white background *can* work, but it can be more difficult to express your idea or be inspired to create. Build the scene that inspires you. Put something in front of your lens that *you* want to shoot. Epic clothing, hair, makeup, and props give you more to work with and more elements to layer, which all add up to helping you tell your visual story.

CHAPTER SEVEN
POST-PRODUCTION

ADDING THE POLISH

It can be easy to dismiss an image with exceptional post-processing as one that is too heavily reliant on tweaks and techniques to achieve its quality. In today's world—where most images have an expectation of some degree of work after the fact (whether it be darkroom, Lightroom, Photoshop, or others)—it is worth reiterating the importance of *quality* post work. The adage of quality over quantity reigns especially true here.

Early in the learning process, wanting to do as much as possible (or correct *everything* to attain perfection) can overwhelm our approach, and often early attempts at retouching can seem caked-on or may clobber the image. Just because you can, doesn't mean you should. Taste and restraint are key even when doing large amounts of retouching.

Often, good retouching is more about what the retoucher chooses to *keep* rather than remove. Although not uncommon for photographers to outsource retouching (either to save time or due to a lack of ability), some photographers choose to do their own. This can allow the photographer to be in total control of the image from start to finish, crafting it exactly in line with his or her original vision, but again, as has been noted before, the key is to know what you want.

HOW THE IMAGE SAUSAGE IS MADE

In the beginning, there was the bit. And it was good. Imaging or post-production is a complicated process that involves a near–Rube Goldbergian set of components working together to display your picture of a kitten grasping adorably to a clothesline. Before digging into developing raw files and jumping right into Photoshop, let us address some key components of how the computer processes colors and how they translate across different substrates (screen, print, etc.). These components are: color gamut, bit depth, and resolution.

The color gamut, or range of all possible colors, must be considered (**Figure 7.1**). A specific color gamut, or *portion* of all possible colors in the universe, can be referred to as a "color space." The *translator* of that space (what allows it to be communicated across devices) is called a "color profile." The terms color space and color profile are regularly used interchangeably, but technically speaking, the profile is the mathematical (computer language) description of that space. Any particular printer and paper combination will commonly have its own color profile that ensures the colors and contrast are printed to the paper as accurately as possible to how they appear on a screen. This is the translation of colors across devices and is applied in the printing module.

When working in Photoshop there are various working profiles or editing color spaces, which allow for an image's colors to be consistent across a variety of devices and provide a reliable space to edit images within. This is the profile an image stays in unless it needs to be converted for another purpose like printing or displaying for the web. These spaces are gray balanced, meaning that any changes made to the image will affect all colors (red, green, and blue) equally, which makes it reliable.

> **NOTE** In this chapter, we will go over *my* workflow from start to finish. This is not the only way to handle editing and developing, but I like it. Also, this chapter does not cover everything that I do in post-production, step by step—that is simply beyond the scope of this book. We are, however, covering the *ideas* behind the process (and in some places, going into more detail than in others). Consider this a peek—albeit a very thorough peek—but not software training.

7.1 A color gamut is like a box of colored pencils. The more pencils, the more colors that can be produced.

Examples of editing spaces are ProPhoto RGB, Adobe RGB (1998), and sRGB (**Figure 7.2**). A larger gamut editing space like ProPhoto RGB or Adobe RGB allows for a bigger sandbox to play in. ProPhoto RGB is the largest, most commonly used editing space. The range of colors it can use is relatively comparable to the entire visible spectrum that we as human beings can see with our eyes. Slightly smaller is Adobe RGB, which has a color space similar to high-end printers and monitors (like EIZO or NEC; the better of these options can display 99 percent of Adobe RGB). Many users find that this space is perfectly acceptable for working with images (even when planning to print), because the gamut is similar to a printer and no monitor can display more colors than this anyway.

The opposing argument to this view is that ProPhoto RGB is just a little bit larger, and if even some of the colors cannot be displayed, why not have the flexibility within the files just in case? As someone who regularly does a substantial amount of post-production, I use ProPhoto RGB.

sRGB is an editing space commonly used for web images. It is smaller (resulting in smaller files) and easily read by internet browsers. When an image is uploaded to a social media site like Facebook, the image is automatically compressed and converted to sRGB. Converting an image to this space before uploading at least allows for the user to have more control over the image's color. sRGB conversion happens automatically in the Save for Web dialog box within Photoshop or can be set manually using Export As or even Quick Export. sRGB images can be printed, but Adobe RGB and ProPhoto RGB will yield more vibrant and dynamic results.

Color profiles exist whenever the computer needs to talk to a specific display device (e.g. monitor, printer, scanner, digital camera, etc.). Making sure the screen is displaying colors correctly is integral for color management and post-production. Unfortunately, most screens do not come calibrated and need regular recalibration (ideally once a month) to maintain color accuracy. This is done with the use of a colorimeter or spectrophotometer, the latter being the more powerful in that it also has the ability to

COLOR SPACES

Color gamut, a.k.a. color range, describes the variety of colors that can be used in a specific device. This can also be referred to as a color space.

Color profile is the translator of a particular color space so it can be read correctly by various devices.

7.2 This graphic represents the color range of various editing spaces. The largest irregular shape represents the range of all colors. The largest triangle is the ProPhoto RGB space. The second largest triangle is Adobe RGB. The smallest triangle represents sRGB.

build color profiles for printer/paper combinations. X-Rite and Datacolor are great systems. These devices sit over the screen and measure the value of certain colors when they are displayed (**Figure 7.3**). At the end of the calibration process, a custom color profile is created for that specific monitor, and colors are displayed accurately.

Bit depth is the second component of understanding color. Bit depth is the number of possible colors that can be represented in a color space. Whereas the gamut or range establishes the variety of colors possible, the bit depth is the device's ability to articulate an amount of colors within that gamut (color space). Imagine color space as the dictionary of all possible words in a language. Bit depth is the lexicon, or the known vocabulary, of that language. The larger the lexicon, the more that can be expressed within that language. Images are commonly 8-bit or 16-bit (although technically they can be higher or lower). A size of a 16-bit file is much larger than an 8-bit file.

Important practical point: the human eye is estimated to have the ability to distinguish around 10 million colors at the high end. Why then do we even need anything more than 8 bit (at 16.8 million)? The real answer is not that simple, but if it could be simplified into one word, it would be "flexibility." Just having the *option* for more colors is exponentially more helpful (even if those colors are never used). The only real cost of a 16-bit image over an 8-bit image is storage space and possible computer performance losses. Imagine this scenario that may or may not have happened to me. As a bridesmaid, I purchased a certain size dress months prior to a wedding that I thought I would need. By the time the wedding came around, I realized the dress was too big in some places and too small in others. If I had a dress that was just a little bit larger, I could have tailored it down to fit me perfectly, but because it was just about exactly what I needed, there was no flexibility in the design. This made fitting into it more difficult than it needed to be. I made it work, but I was not happy about it. That dress is 8 bit and a dress one size up is 16 bit. (Note: this did not happen to me.)

7.3 An X-Rite i1Display Pro colorimeter calibrates a monitor.

SON OF A BIT!

Bit, short for binary digit, is the smallest unit of data in a computer. One bit is expressed as either "on" or "off," which in computer language means "0" or "1." An 8-bit image describes a specific amount of color able to be articulated in a gamut. As one bit gives the option of two choices (0 or 1), an 8-bit image is 28 (or 2 x 2 x 2 x 2 x 2 x 2 x 2 x 2), which equals 256. This is a number that will show up often in imaging. An 8 bit refers to a single channel, and as a digital system has three (red, green, and blue) for a total of 24 bits, the *actual* number of colors possible is 256 x 256 x 256, which equals roughly 16.8 million possible colors. A 16 bit is 216, or 65,536 possible colors per channel (red, green, and blue), giving the possibility of 281 trillion colors overall.

To further complicate the understanding of bit depth, devices have trouble recording or displaying anything more than 14 bits. The raw, uncompressed data from a camera sensor on most cameras is 12 bits, with higher-end cameras able to capture 14 bits. A professional-grade monitor, such as EIZO, can display 10 to 12 bits. However, even though a camera may only be able to capture 12 bits, converting the image to 8 bit automatically discards a lot of useable information.

The noticeable differences between 8-bit and 16-bit images appear when doing substantial post-production and/or dealing with gradients with little detail (like skies). As a rule of thumb, an 8-bit image can be okay if there is not much post-production, but a 16-bit image is a much safer option if there is. I always err on the side of safety. Establishing if an image is going to be 16-bit must occur in the raw conversion process either in Lightroom preferences or in Adobe Camera Raw (ACR) (**Figures 7.4** and **7.5**). Converting an image after it has been processed from 8-bit to 16-bit has no benefits; however, when saving for the web, an 8-bit conversion is recommended.

When printing, some printers give the option to use 8-bit or 16-bit information. A 16-bit image will give notably smoother gradients in areas of little detail (like skies). Printers also have a much higher resolution compared to a screen.

Screens come in a variety of resolutions and pixel densities, and the sharpness of a screen is expressed as dpi (dots per inch) or sometimes ppi (pixels per inch) when the resolution is not adjustable (phones for example). Dpi considers both the screen size and the resolution it has been set to. Monitors were regularly manufactured at 72 dpi since the mid 1980s, which remained the industry standard for decades. In truth, monitors today are significantly better (higher dpi) than 72.

Most desktop computers have a dpi that ranges between 100–110. A 4k monitor typically has a dpi of around 200, depending on the size of the monitor. A laptop retina screen touts 220 dpi, retina iPads are 264 dpi, and iPhones (over 400 dpi) are much higher. Other phones are reaching 576 dpi. There is no industry standard anymore and using 72 dpi may be displaying images at far below what they have the ability to be seen as. A printer, long viewed as the unattainable bar of resolution and quality compared to a digital screen, prints at a resolution between 300 dpi and 600 dpi (depending on the printer). Printers are still higher than screens, but some screens are bridging the gap remarkably well. Of course, it is worth noting the size. A print has the ability to be much larger compared to a phone's screen, but the technological implications are impressive nonetheless.

7.4 Raw conversion preferences in Lightroom are located in Lightroom Preferences > External Editing.

7.5 Raw conversion preferences in Photoshop are located at the bottom of the ACR window.

THE PIXEL

A pixel (short for picture element) is a small dot on your screen, and it is the basic unit of programmable color. Each pixel is made up of some combination of red, green, and blue. Many pixels together form the visual image. The physical size of a pixel depends on the resolution set by the computer. The smallest possible size of the pixel (which comes from setting the highest resolution) is called the "dot pitch." The dot pitch determines the possible dpi of a screen.

RGB VERSUS CMYK

There are two primary color systems that photographers deal with—additive and subtractive. These are also known as RGB and CMYK and are integral to how the computer (and us for that matter) handles and manipulates color (**Figure 7.6**). The spectrum of color (as we use it digitally) is laid out in a very logical way, but it is slightly different than the art school color wheels. That said, the systems share a lot in common, so any previous knowledge of the color wheel is still helpful.

7.6 R + G + B = White and C + M + Y = Black (K).

ADDITIVE

The primary system that photographers shooting and manipulating digitally use is known as additive color. This system is made up of the colors red, green, and blue (RGB) and begins with a dark, lightness space and adds light (in the form of those colors) to achieve the image. When red, green, and blue combine at full strength, the color is white (imagine something being "white hot"). Any electronic screen is an additive system. A DSLR uses an additive system. A cell phone, television, or Jumbotron is an additive system. Start with black (no light), add colored light to get colors, and at full power is white.

SUBTRACTIVE

The subtractive system, on the other hand, is used for printing. The colors that make up the subtractive system are cyan, magenta, yellow, and key (black). They are also known as CMYK. In a subtractive system, we begin with white (or relative white determined by how white the paper is) and add ink until we reach black. Cyan, magenta, and yellow combine to make a very dark brown, but printers use a separate black ink to achieve a truer black. Many modern inkjet printers use multiple versions of each color for more vibrant prints.

RENDERING INTENTS

Found in the Print dialog box (**Figure 7.7**), the rendering intent determines how the translation from an RGB to a CMYK occurs. Some translations work better than others, depending on the image content. The two recommended intents are *Perceptual* and *Relative Colorimetric* (my personal preference). In Perceptual, the relationships between colors are preserved, shifting all the color together to prevent out-of-gamut colors. The shift will be more natural to the human eye. In Relative Colorimetric, only out-of-gamut colors are shifted to the closest reproducible color, and the other colors remain the same. Results differ for everyone (since it depends on the edit and color profile), so experimentation is key.

7.7 Rendering Intents are found in the Print dialog box in Photoshop.

When printing, the conversion from additive to subtractive happens automatically. This is aided by the use of custom profiles for the particular printer and paper combination (those profiles are usually found on the paper manufacturer's website and must be installed on the computer). There are, however, certain components of the conversion that must be addressed. First, something displayed electronically is backlit, meaning it will appear brighter than that same image in print (the considerations for this are addressed later in this chapter, where I discuss developing for the print). Secondly, colors on a screen can exist in the gamut used for editing, but do not appear in print (usually because some papers can have comparatively small gamuts). These are known as "out of gamut" and changing rendering intents can correct this.

In the post-production process, all these colors (RGB, CMYK) are fundamentally related to each other. As additive is the opposite of subtractive, the colors within the systems are opposites as well. Red is the opposite of cyan. Green is the opposite of magenta. Blue is the opposite of yellow. And white, as we already know, is the opposite of black. In a subtractive system, the print is developed in a darkroom. In an additive system, the image is (or can be) developed in *Lightroom*.

These opposing systems of colors can be illustrated when using a Curves adjustment layer within Photoshop. **Figure 7.8** shows a 50 percent gray color square. By bringing the entire RGB curve upward, it makes the image brighter, adding light (**Figure 7.8a**). When the curve is pulled down, the image is darker, subtracting light (**Figure 7.8b**). Within the individual channels, raising red increases the amount of red and makes the image brighter (**Figure 7.8c**); lowering the red curve adds the opposite of red (cyan) and makes the image darker (**Figure 7.8d**). Raising the green curve adds green and makes the image brighter (**Figure 7.8e**); lowering adds magenta and makes the image darker (**Figure 7.8f**). Raising the blue curve adds blue and makes the image brighter (**Figure 7.8g**); lowering adds yellow and makes the image darker (**Figure 7.8h**).

7.8 50 percent gray

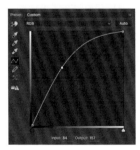

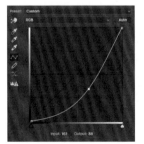

7.8a The RGB curve is raised. The image is brighter and all colors are affected evenly.

7.8b The RGB curve is lowered. The image is darker and all colors are affected evenly.

It is worth noting that certain colors can have similar hues but different results when added to an image. For example, red and magenta are similar, but red lightens the image while adding magenta darkens. Additional comparable pairs are green/yellow and blue/cyan.

Knowing how colors relate to each other is integral in removing colorcasts or adding them intentionally. To remove a colorcast, simply add its opposite. For example, a yellow colorcast will be neutralized by blue, a green colorcast by magenta and a red by cyan (and vice versa for each pair).

7.8c The Red curve is raised. The image has a red cast and is brighter.

7.8d The Red curve is lowered. The image has a cyan cast and is darker.

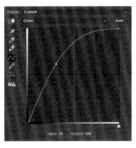

7.8e The Green curve is raised. The image has a green cast and is brighter.

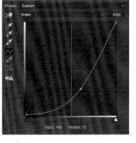

7.8f The Green curve is lowered. The image has a magenta cast and is darker.

7.8g The Blue curve is raised. The image has a blue cast and is brighter.

7.8h The Blue curve is lowered. The image has a yellow cast and is darker.

THE COMPONENTS OF COLOR

Color (within the RGB system) is made up of three individual elements: hue, saturation, and brightness (also referred to as luminance). Using the color picker within Photoshop (**Figure 7.9**), click on the button next to "H" which brings up this particular method of navigating and selecting colors. I find it to be quite helpful:

- **Hue (H)** is the degree that a particular color exists around the color wheel. The range is 0–359, and it moves on this vertical bar. Counting 0 as a number, 360 possible values make this a linear representation of the color wheel. Notice the same red at the top and the bottom of the bar.

- **Saturation (S)** is the purity of a color. 0% saturation of a particular hue is black, white, or gray. 100% saturation is as much of that particular hue that can be utilized. Moving the value horizontally from left to right controls saturation.

- **Brightness (B)** is the luminance (brightness or darkness) of that particular color. At 0% is black and 100% is either white or colored depending on the saturation value. Moving the value vertically up and down controls brightness.

7.9 Photoshop's Color Picker

THE RAW FILE

One of the most commonly overlooked elements of post-production is proper development of the raw file in Lightroom (**Figure 7.10**) or ACR. Many photographers either do not process the raw at all before bringing it into Photoshop or do so incorrectly. "Correctness" is a relative term, however, and what works for some, will not work for others. Relative helpfulness may be the better term, but its lack of succinctness makes for a wordier description. For that reason, correctness is how we will describe it, despite its very definition being inherently misleading to our purpose. Forgive me.

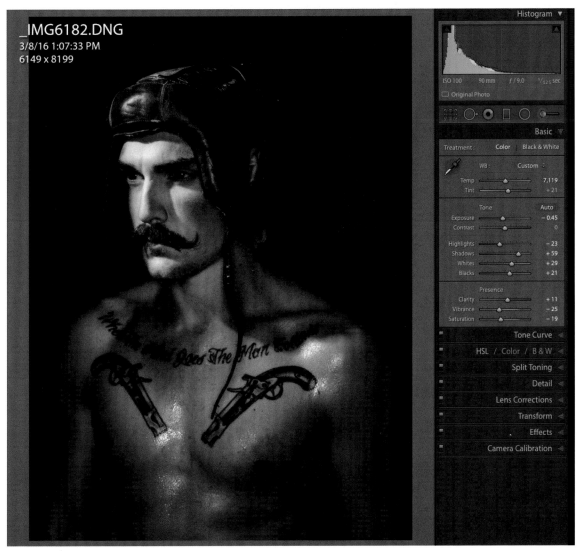

7.10 The Develop module in Lightroom is where the magic happens.

As there are several approaches, I am of the belief that photography is primarily a print medium and images should be developed for such. Even if one does not plan to print the image, simply developing for the print will result in a higher quality of processing. This is because a quality print requires processing for more information than does an image for the web, and while an image destined for print can work for the web, an image developed for the web does not necessarily work for print. More on this later (see "What It Means to Develop for the Print").

Modern DSLRs have the capability to shoot in the raw or jpeg format (with some also having the ability to work with tiff). Working with a raw file, as opposed to a jpeg, captures the complete, uncompressed data from the camera's sensor. Shooting jpeg may seem easier because the images may look closer to the desired end image from the start, but the raw allows for much more flexibility and ability to correct more mistakes in exposure. The tiff format gives substantially better files compared to the jpeg, but still not as powerful as a raw.

THE HISTOGRAM

To begin, the histogram must be understood and utilized. Our eyes are not always the most dependable devices for accurately reading exposure and contrast since they can adjust automatically. The histogram only changes when it is on purpose. Similar to a line graph found in elementary school math, the histogram plots the information of the image as changes occur. In ACR or Lightroom, the histogram is in the top right corner of the screen. As the image is developed, the histogram changes accordingly. The histogram is more easily understood if it is divided up into sections (**Figure 7.11**).

7.11 The histogram divided, denoting blacks, shadows, midtones, highlights, and whites. This histogram shows mostly shadow information.

Each of these sections in the histogram corresponds to a slider in Lightroom's Basic panel (within the Develop module). The only slider that does not share an obvious name is midtones, which corresponds to the Exposure slider. All sliders within this module manipulate the histogram in a specific way.

Decoding the histogram is actually quite simple. Let's look at some examples. First, is the image high, medium, or low contrast? Keep in mind that this is all relative to the image itself.

The images in **Figures 7.12–7.14** have been processed three different ways. The first image is low contrast. More of the information exists in the midtones. The second image is medium contrast. There is a more relatively even amount of information in the shadows, midtones, and highlights. The third image is high contrast. More of the information is located in the shadows and highlights with less information in the midtones. Depending on the image and its subject matter, the changes to the histogram may be drastic or subtle—even when the overall visual change is substantial. In this particular image, a medium gray background takes up so much of the image's real estate that a peek at the histogram's midtones will not change much as the overall contrast is affected. Instead, notice how the information in the shadows and highlights changes.

None of these processes are more correct than the other. They only illustrate various ways to process contrast within the same image.

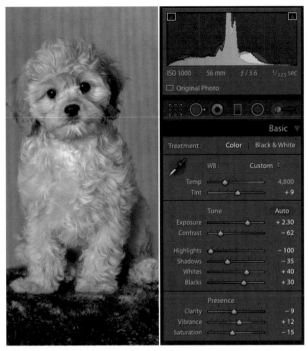

7.12 Low contrast

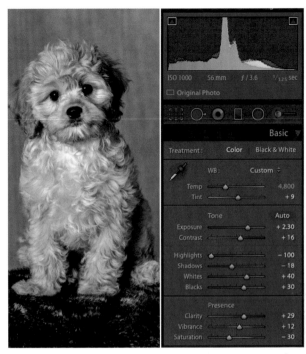

7.13 Medium contrast

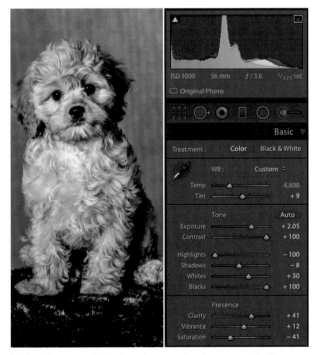

7.14 High contrast. Notice how the saturation decreases gradually while contrast increases. This helps to maintain a similar degree of saturation throughout.

Second, is the image high key, medium key, or low key?

This image has again been processed three more ways (**Figures 7.15–7.17**). The first image is low key, with most of the information to the left of center in the histogram. Notice there is significant information in the shadow range (done by increasing the Shadows slider). The medium key center-weights the image information in the histogram. The high-key image has most of the information to the right of center. Notice how there is significant information in the highlights (done by decreasing the Highlights slider).

Not every image will work well as a high, medium, or low key, but in general, images are much more flexible than they may seem. Of course, personal taste plays a large role in decision-making.

An image that is high, medium, or low key can be high, medium, or low contrast, which makes the combination of "correct" ways to process quite numerous. Experimentation and deciding what you want is the only way to find out what works for you.

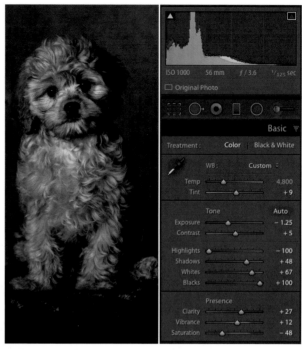

7.15 Low key

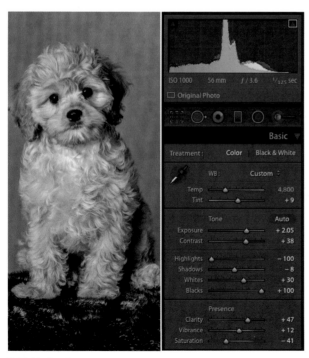

7.16 Medium key

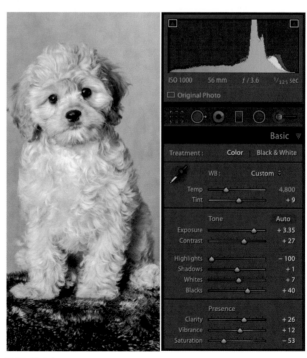

7.17 High key

DEVELOPING THE RAW FILE

Now that we have established several options as to what the general outcome of a developed image may be, let us look at the specifics of how we get there. For that, we take a journey through Lightroom's Develop module (**Figure 7.18**). Developing an image within your chosen software can be a lengthy and in-depth process. This is not a Lightroom book, so much of the concentration will be on "why" things are processed the way they are with some "hows" peppered in for seasoning.

There is, however, a general structure to how I approach the development of an image:

1. **White Balance.** As I regularly shoot in the studio, my white balance is usually close to the Flash preset. My aim is usually to represent colors close (or relatively close) to reality. I occasionally make small adjustments here by eye or using the Eyedropper tool if I have a neutral background. This can be done at virtually any time during the process without a drastic change to the overall tonality.

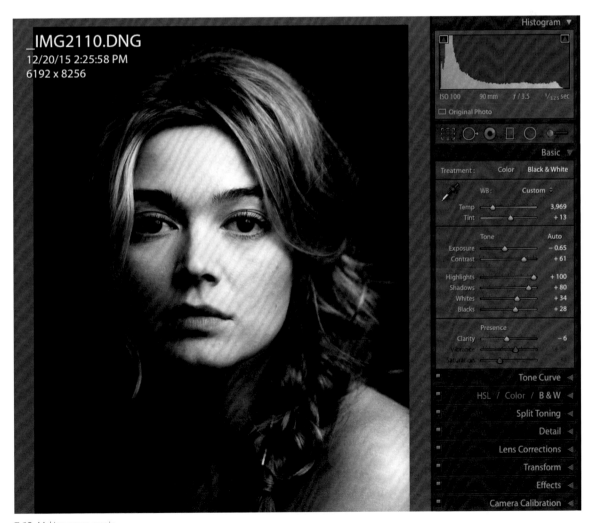

7.18 Making more magic.

2. **Exposure**. I like to start big and work to the smaller parts of the histogram. The Exposure slider moves all the information from a center anchor point. Here, I establish the general lightness or darkness of the scene.

3. **Whites and Blacks**. Using the Whites and Blacks sliders, I stretch the ends of the histogram. Start with turning on the clipping guides (the triangles in the upper corners of the histogram). Pure black (an absolute loss of shadow information) is shown blue, and pure white (an absolute loss of highlight information) is shown red. Generally, I like to have the tiniest amount of black clipping. White clipping depends on the image and where the clipping occurs. White clipping on a specular highlight? Could be fine. White clipping on skin when the lighting is soft? Probably not. Again, this is dependent on the image. Stretching the histogram has a couple of different implications. First, when printing it is a good idea to maximize the amount of information that can be mapped to the paper's gamut (which is usually slightly smaller than the electronic medium and is significantly smaller when printing on matte paper). Second, printers often utilize black point compensation, which maps the darkest point of your image to the darkest black of the paper gamut. Establishing this early allows for more control over the image output.

4. **Highlights and Shadows**. Once the blacks and whites have been established, the shadow and highlight information is expanded or contracted depending on the desired effect. By lowering the slider for the shadows, information in the shadows is compressed, removing details and making those tones darker. By increasing the Shadows slider, information in the shadows is stretched out, making details more visible and the tones lighter. The Highlights slider works similarly but in reverse. Lowering the highlights stretches out the tonal range, increasing detail. Increasing the highlights compresses the tones, making them brighter and decreasing detail. There is no right or wrong method here; however, an increase of shadow detail is generally a good idea when considering the print.

5. **Contrast and Clarity**. Both of these sliders control similar aspects of the image. Contrast affects the entire image, whereas the Clarity slider predominantly affects the midtones. Increasing the overall contrast displaces information from the midtones outward to the shadows and highlights (much like putting a fist in the middle of a glass of water). If the information has already been stretched out via the Whites and Blacks sliders, minimal contrast adjustment may be necessary at this point. Clarity has a similar effect, but it tapers as it reaches shadows and highlights, resulting in an effect that looks more "detailed" (with the slider increased) or "softer" (with a decrease). With the Clarity slider, the limits of the image (blacks and whites) stay mostly intact, as opposed to the Contrast slider. Too much clarity (or too little) is relative; however, a lowering of clarity generally looks much worse more quickly than an increase does. High clarity can have a negative effect on skin.

6. **Saturation and Vibrance**. The Saturation and Vibrance sliders do similar things, but with one key difference. Saturation makes changes to all colors equally, increasing or decreasing the purity of all colors. Considering what the brain finds palatable, it is usually best to imagine a seesaw. If the contrast is higher, saturation typically looks best lower, and the opposite is true (lower contrast, higher saturation). Vibrance gives the colorful pop associated with saturation when increased, but the key difference is vibrance does a better job at not affecting skin tones as heavily. An increase in saturation, for example, can often leave skin tones oversaturated in orange. Generally, I find myself decreasing the saturation more than increasing it.

There are many components to the development process. I encourage you to explore as much as possible. As there is never more flexibility in the file than in the raw process, it makes sense to develop the image as close *tonally* as possible to the final product right from the beginning, with one key exception, which we will talk about next.

WHAT IT MEANS TO DEVELOP FOR THE PRINT

As mentioned above, I believe that photography is still a print medium first and foremost. Of course, most images today are seen on screens, but it is difficult to argue that the print still has many benefits over the screen (size, resolution, color rendition, etc.). The technical specs do not even account for the personal element of satisfaction, the permanence, or the tactile beauty of a crafted print. *But* most images are seen on screens so it is important to make sure they look the best they can on those devices too. We as photographers in the modern age should be able to display images with proficiency in both realms. Fortunately, there are enough crossovers to handle both methods easily, but the approach must be a deliberate one.

First, the image should be developed for the print and at the end converted for the web. Developing for the screen first, then trying to print, yields less successful results. This occurs because the print produces a greater range of colors but sometimes smaller tonal ranges. Maximizing the information sent to the printer (to fit into a smaller range) will look better than an already diminished tonal range translated into one even smaller. For example, the popular post-processing technique of raising the black value and lowering the whites (lowering the contrast and giving the appearance of scanned, matte paper) does not translate well to print. Therefore, one does not have to avoid this method, but can apply it at the end of the workflow just before an export for web (this is the tonal exception mentioned in the previous section).

The second component of developing for the print is monitor brightness. This is more of a tip and not an absolute rule. The common solution for printing is to brighten an image up before sending the file to the printer. However, anytime these adjustments are made, some quality of the image is potentially lost. As an image for the web requires far less information, why not process darker then brighten the image for web instead of the other way around? This is especially beneficial when dealing with low-key images and wanting to show enough tonal range in the shadows.

The monitor brightness issue can be addressed in a couple of ways. Through experimentation, the user can set monitor brightness manually so that it corresponds with the print as closely as possible. This requires printing, testing, and comparison. Although not a scientific approach, this can get close enough results. Another option is to use two monitors (this is my personal approach). Setting each monitor to a different brightness setting allows for the image to be tested on each screen quickly without switching settings. Some NEC monitors, for example, have a print setting on the monitor itself that lowers contrast and brightness, and since the monitor does not have a gloss finish, it is even more representative of the print.

WORKFLOW

As mentioned in the beginning of this chapter, what follows is my overall approach to post-production. There are many workflows, but this one is mine. Remember no one method is necessarily more correct than the other.

CULLING AND EDITING

The term "editing" gets tossed around rather liberally these days when referring to post-production. Its real meaning is rooted in this step. Photoshop is not editing; at least not in the traditional sense. Editing derives from selecting the best images from any set. This is what a *photo editor* does. Over time, editing has come to encompass a wide range of post-production activities, so perhaps it is better to refer to this process by its other name, "culling." To cull means to thin out, as in "cull the herd." This very specific definition is perhaps a better label for this process of narrowing down images to the pre-ferred choices. Either term is correct, but one requires less time repeating proper definitions of a commonly used word, so perhaps "culling" is the easier choice here. Otherwise, continue fighting for moral victories in a world that has plenty already.

During this process, which in this case takes place in Lightroom's Library module (**Figure 7.19**), images can be flagged, rated, or labeled. Everyone has their own preferred method of selecting and there are multiple options for doing so. My method of culling: in the first pass, I do a quick run through and select images with a flag (the tilde key [~]). On the second pass, I filter those selects with a star rating (using the numbers 0–5). If I have images for different purposes, I will sometimes refine the selections with colors as well.

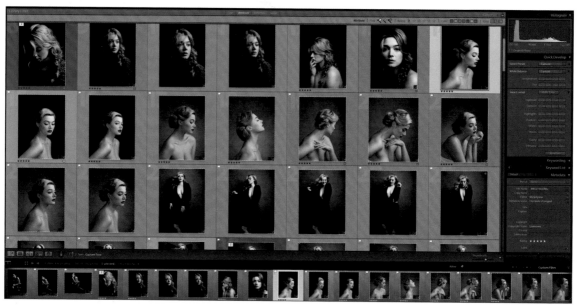

7.19 Lightroom's Library module.

DEVELOPING

Using the techniques mentioned in the "Developing the Raw File" section, here is where a single image is processed or developed to maximize information for the move to Photoshop and generally capture the look and feel of how the image is going to be. This, of course, represents a near infinite range of possible outcomes (several of which were discussed earlier), so the focus here will be on three different images (**Figures 7.20–7.22**).

Another benefit of developing in Lightroom (as opposed to ACR) is the develop settings can be copied or synched to many other images quickly and easily. This allows all selects to have a develop setting relatively close to the final look, giving clients a better idea of the final image without having to bring every potential photo into Photoshop to adjust.

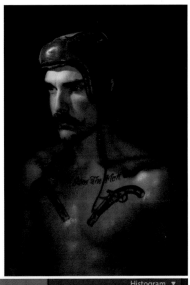

7.20 White balance has been adjusted, highlights have been darkened, and shadows brightened. Saturation has decreased and clarity has increased. Most of the information is to the left of center, making this a low-key image.

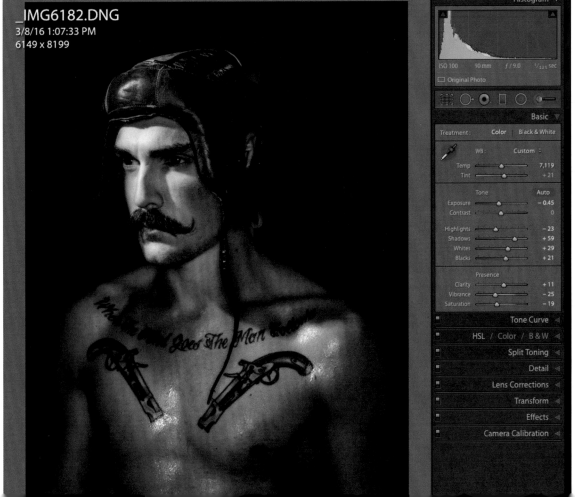

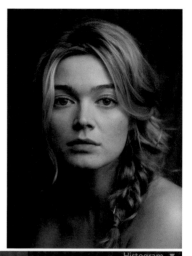

7.21 The image has been converted to black and white. The white balance is cooler (changing the tonality of the image). Contrast has been increased greatly. Highlights and whites are up considerably as are shadows and blacks. The overall effect makes the image brighter, but each section of tones (blacks, shadows, midtones, highlights, and whites) do so at different increments. Notice how it is a high-contrast image, but there is still considerable detail in the shadows and highlights. This would be a medium/low key image.

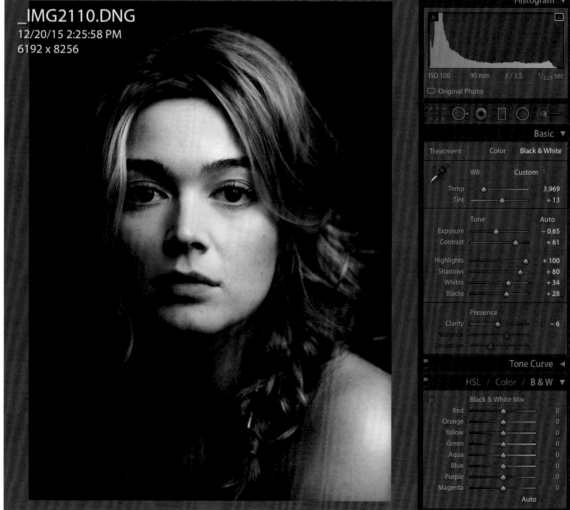

7.22 White balance has been adjusted so that it is slightly warmer than neutral. Contrast has increased. Highlights, shadows, and blacks are brighter. Vibrance and saturation have decreased, allowing for less variation in the overall colors. The lips and hair, for example, are much closer in color now.

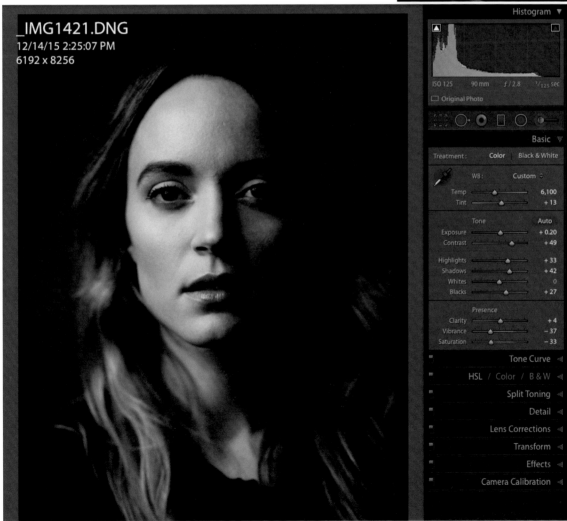

_IMG1421.DNG
12/14/15 2:25:07 PM
6192 x 8256

Histogram ▼

ISO 125 90 mm f / 2.8 ¹⁄₁₂₅ sec
☐ Original Photo

Basic ▼

Treatment : **Color** Black & White

WB : Custom ⇕
 Temp 6,100
 Tint + 13

 Tone Auto
Exposure + 0.20
Contrast + 49

Highlights + 33
Shadows + 42
Whites 0
Blacks + 27

 Presence
Clarity + 4
Vibrance − 37
Saturation − 33

Tone Curve ◁

HSL / Color / B & W ◁

Split Toning ◁

Detail ◁

Lens Corrections ◁

Transform ◁

Effects ◁

Camera Calibration ◁

RETOUCHING

Once the image has been developed to serve its purpose, it is exported to your retouching software of choice, in this case Photoshop. Here, things can be removed easily, manipulated more thoroughly, refined and polished to your desired finish. With a proper start in the develop process, retouching is the final step, albeit a very large one.

Of course, one must still consider the level at which the retouch is performed. This balancing act of the subject's vanity, how small distractions impact our perception of core beauty, current societal expectations, and just the fact that there are a lot of real *uggos* out there (just kidding!) can be an incredibly precarious minefield to navigate. But the threshold of how much one chooses to eliminate or alter is going to be an ongoing element of the work that mostly tempers with time. The amount of post-production becomes less about doing a large amount of changes and more about doing the *right* changes.

TIP *Although a tablet and stylus is not required for retouching work, it is highly recommended. Wacom makes great systems, especially the Intuos line. All retouching for this book was done on a Wacom Intuos Pro Medium.*

Cleanup

Lightroom and ACR have a healing tool, but unfortunately, it is not tremendously intuitive or ideal for many small issues (like fine skin work). For this, using Photoshop is quicker and allows for more to be done without slowing down the computer. Some people recommend automatically duplicating the background layer before beginning any work and doing cleanup on that duplicated layer. This step is completely unnecessary with recent versions of Photoshop. Simply creating a new, blank layer and making sure the cleanup tools used (Healing Brush, Spot Healing Brush, Clone Stamp, or Patch) are set to sample either "All Layers" or "Current & Below" (**Figure 7.23**) will make the necessary corrections without adding nearly as much bulk to the file, ultimately saving space and letting Photoshop run smoother. Even if there is more skin work to be done beyond basic retouching, the focus of this step is still only to remove textural distractions (bumps, blemishes, stray hairs, objects that need to be removed from the frame, or extended backgrounds) (**Figures 7.24–7.26**). The skin does not receive the full treatment here, as that occurs in the next section.

7.23 Set the sample method to "Current & Below" or "All Layers" when cleaning up on an empty layer.

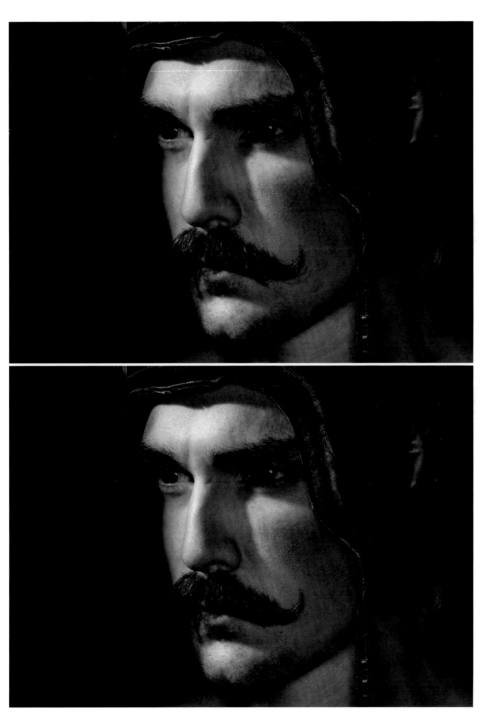

7.24 A lot of the cleanup often occurs on the subject's face. Here an unruly mustache has been fixed and a couple of minor blemishes have been removed.

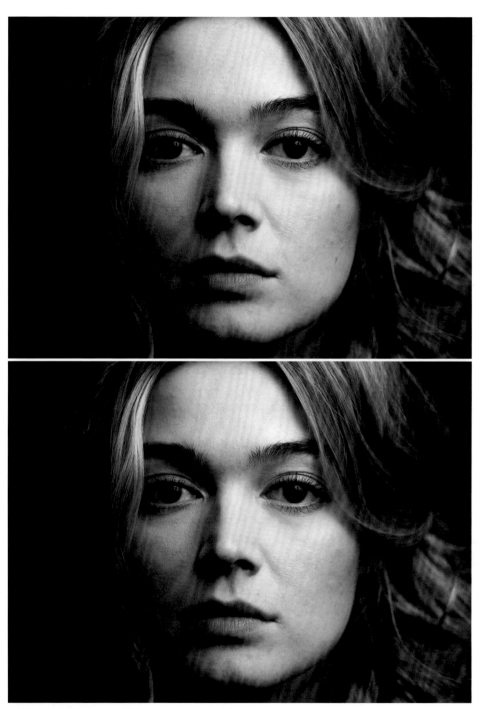

7.25 Some stray hairs, minor blemishes, and distracting freckles have been removed in this image.

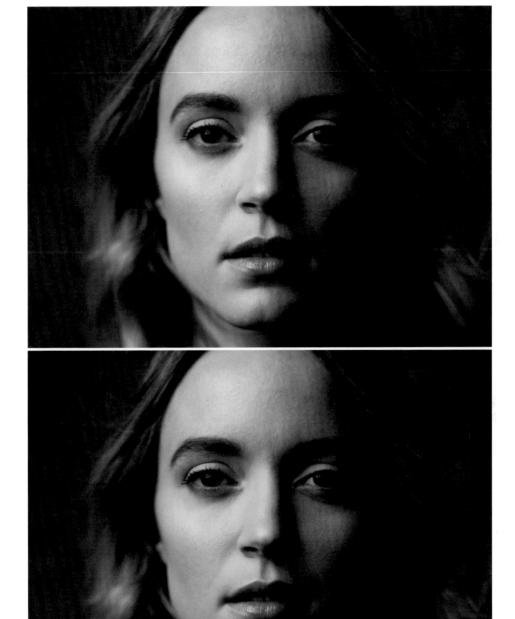

7.26 This image has a more complicated cleanup step. The original shot was slightly out of focus, so in-focus features (eyes, nose, and mouth) from a similar image were composited in. This shot was chosen over the other image due to hair position and general composition of the image. Once this was done, small blemishes were removed.

Dodge and Burn

Dodging and burning are photography techniques that predate Photoshop. In the darkroom, an enlarger projects the negative onto the emulsion (paper), developing the image. (I understand this is a gross oversimplification of the steps, and I apologize. Pitchforks down, please.) The longer the image is exposed, the darker it would be. And the less it is exposed, the lighter it would be (because it is closer to the white of the paper). When burning, a mask or hand is used (often making a not-quite-closed fist), wherein slightly more exposure would be on certain parts of the image. To dodge, one would use a tool regularly made from wire and cardboard to block certain parts of the image from exposure thereby "dodging" the light.

Intentional movement done by the tool or hand would feather the edges and make the shifting of brightness and darkness less noticeable. That's why today's Dodge and Burn tools in Photoshop look like a hand and a lollypop. Although there are Dodge and Burn tools, there are other methods (like using adjustment layers) that facilitate the same goal—which is to say lightening or darkening parts of the image. Therefore, dodging and burning can be done with a variety of different techniques.

There are two main approaches to using dodging and burning: global and local. Global dodging and burning shapes the overall lightness and darkness of an image. It can add or remove contour and depth, bring up the shadows in the dark part of an image, or add highlights to hair—the options are limitless. By enhancing shadows and highlights, the contrast is also being affected, thereby adding or subtracting drama to the image. As highlight and shadow are also what define depth, adding shadows and highlights make something stand out more, and removing those tones makes the object "flatten."

To complete a global dodge and burn, one can use the tools directly on the image layer. This is not recommended, as it is a destructive way to work. This means it affects the image's pixels without a safety net. Also, the information can be too aggressively altered too easily. Another method is to use a layer filled with 50% gray and set the blending mode of that layer to soft light or overlay. Overlay will produce stronger effects than "soft light" but they effectively do the same thing. In both these blending modes, 50% gray is invisible, so anything not 50% gray, specifically the tonal changes from using dodge and burn, are the only things that show. I recommend using the Dodge and Burn tools at around 5–15% opacity on midtones. Although the tools can target shadows and highlights specifically (and there is certainly a place for this), the effect will be more noticeable on midtones at this step, as 50% gray is kind of exactly a midtone. See **Figures 7.27–29**.

7.27 Highlights on the skin and the helmet were brightened. Shadows under the jaw and at the hairline were darkened. Muscles were contoured to increase dimension.

Local dodging and burning, or corrective dodging and burning, is considerably more involved. As previously mentioned, dodging and burning techniques have the ability to control the depth of an object or how much it is perceived to stand out. What if this object is a pore? Local dodging and burning takes the idea of dodging and burning and applies it to the pores of skin. The method of using a 50% gray layer to dodge and burn can be effective here; however, the method I use is different. By using two Curves adjustment layers (one to lighten and one to darken) and a brush (set to 100% opacity and 1–3% flow), the user has an extra degree of control beyond traditional Dodge and Burn tools (where exposure is the only way to adjust strength). The brush works best with 0% hardness and a round shape and is typically very small for most of the work. This work can be done with a mouse; however, a tablet and stylus is of great advantage here, both for speed and accuracy.

7.28 Dodging and burning here is relatively minor. There is some contouring at the jawline as well as the bridge of the nose. Highlights are also on the hair, and eyes are brightened.

7.29 Contour is added to the hair. Eyebrows and eye lines are darkened. Highlights are added to the lit side of the nose and the less lit cheek.

Take this closeup section of skin zoomed in to 100 percent (**Figure 7.30**). The light on the face makes each pore have a noticeable texture, which can sometimes be too distracting or inconsistent. By dodging the shadows and burning the highlights, the appearance of bumpy and inconsistent skin can be reduced or softened without the removal of any actual texture.

7.30 Before and after, local dodging and burning results.

This may seem tedious and time consuming. *It is tedious and time consuming*. It is also one of the steps within the workflow that is very much a *technique*. Many steps in the post-production workflow can rely on the same actions over and over or similar steps with slight modifications. Local dodging and burning is different every time, and *it takes practice*. Very few are good at it the first few tries, so stick with it and don't give up (**Figures 7.31–7.33**).

In my personal workflow, I perform local dodging and burning before global. My general approach is to clean up the image before shaping and toning the entire shot. As this step is also the most time consuming part of any retouch, I like to get it out of the way early.

NOTE *For more in-depth information on local dodging and burning, check out my YouTube channel (youtube.com/c/ChrisKnightPhoto).*

7.31 Most of the effort is concentrated on the unlit side of the face, with extra attention paid to the hard shadow created by the nose, softening that transition. The dodging is represented as red and the burning as blue.

7.32 More attention has been paid to the lit side of the face, mostly dodging. The area between the eyes has been lightened, as has the crease between the nose and cheek. Any area located in the transition between light and shadow normally needs extra focus, as can be seen by the bottom right jaw and the left side of the face.

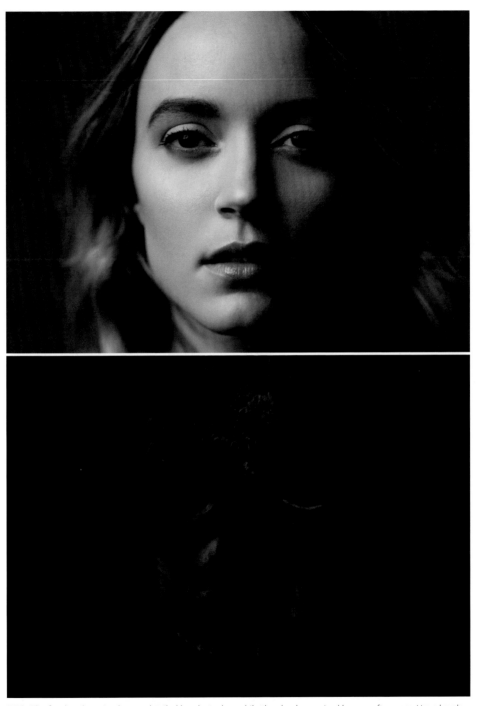

7.33 The forehead received more detailed brush strokes, while the cheeks received larger, softer ones. Use a brush size appropriate to the area you are working on. Many common issues with local dodging and burning are from using a brush that is either too large or too small.

Liquify

Not a contributing factor of adding drama, the Liquify filter is important nonetheless and can drastically change the impact of an image. Liquify is found under the Filter menu within Photoshop. It works by overlaying a mesh onto the image, and the user can shift, warp, and transform that mesh, thereby affecting the image. The mesh is disabled by default (but can be turned on), so the manipulation is usually done simply by looking at the image itself. Common liquify tools are: forward warp tool (the finger pushes the image around), reconstruct (this effectively brushes an "undo" over any changes made in liquify), pucker (sucks in), bloat (bulges out) and freeze mask (prevents whatever is brushed from being affected by liquify). Newer versions of Photoshop have a Face-Aware Liquify feature that allows for easier manipulation of individual facial features. I like to use the Liquify filter as the last step before color and tonal adjustments. This allows the shifting of the image as a cohesive whole, so all cleanup and small adjustments can be done before this step.

Liquify must be done on a pixel-based layer; therefore, everything visible must be on one layer. This can be done by flattening the image, but then all prior steps are lost. A recommended solution is to "stamp visible on a new layer." This step merges all visible layers onto a new layer above the layer that is currently selected. Unfortunately, this does not have a menu command and must be performed via a somewhat lengthy shortcut: Shift+Ctrl+Alt+E (Windows) or Shift+Command+Option+E (Mac).

Note: this shortcut will not work if the current selected layer is turned off (invisible), so a new, blank layer must be created first. Stamping visible on a new layer does add considerable size to a file (especially if this is done multiple times), so be cautious of using it too often. This step will be on top of all work that has previously been done, but the work is not lost, just underneath.

Once the stamp visible on a new layer has been applied, one can use the Liquify filter with wild abandon. Remember though, just because something can be moved and adjusted, does not mean it should. Just like restraint and personal choices must be considered during the skin and retouching process, one must also have similar considerations when using the Liquify filter. The personal choice must be made: *Am I contributing to the best version of the person I'm photographing? Is this how they see themselves? Or am I drastically changing the individual to fulfill my own version of what I think the image should look like?* This is something every retoucher grapples with and must decide for him or herself. I believe that post-production should aid in removing distractions and that the subject should appear compelling and still look like him or herself. Otherwise is it really a portrait?

Liquify allows for the ability to not just change body shape, but to make clothes fit better, make hair more perfect, and even change expression. But the changes made are more realistic when they are grounded in reality. Therefore, paying close attention to how someone could pose or move as well as general anatomical structure is helpful here. Much like working with skin, using the Liquify filter does take a little practice as it is different each time. See **Figures 7.34–7.36.**

TIP *Personally, the vast majority of my liquify work is done with the forward warp tool (the finger). Try using a higher brush density (around 70%) and a lower brush pressure (around 25%) when using liquify—these settings can be changed by checking "advanced mode" on the right side of the window. A high density uses a greater area of the brush at once and a low pressure makes the shift or change more gradual—both of which help the liquify adjustments appear more subtle and believable. Also, use a brush slightly larger than what you think you may need. This allows for the movements to be larger and more gradual and ultimately less noticeable. When using this step in environmental portraits, be aware of background elements that have straight lines or repeating patterns. Using the Liquify slider too carelessly can result in a noticeable warp to background objects that should not have it.*

7.34 The top of the head/helmet straps are pushed down. The mustache is shaped, and the muscles are bulged a little.

7.35 The hair is reshaped, making the curves more elegant. The shoulders are lowered (elongating the neck) and the jaw is slightly raised.

7.36 The hair is reshaped to make it look more windblown. The neckline is lowered to elongate the neck. The left eyebrow is shaped and more defined. The left side of the top lip is raised to be even with the right. The right eye is opened.

Color and Tone

As was discussed in Chapter 5, color and tonal adjustments can aid in creating drama and even provoke an emotional response (**Figure 7.37**). Color can be added in *many* ways, but the most important decision is which colors to add and how much. The method in which color is added is mostly irrelevant, as most can achieve basically the same result. In this section, we will look at four methods: curves, selective color, luminance masks, and plugins.

7.37 Before and after a Curves adjustment. A slight red cast is removed and the skin tone appears more natural.

When set to its default option, the Curves adjustment affects all channels of color at once. This will make overall changes to the tone of the image, increasing or decreasing contrast (with an "s-curve" or "inverted s-curve") and/or making the image brighter or darker (raising the curve or lowering it). Sometimes this adjustment can also affect color unintentionally. To avoid this, set the blending mode of the curve layer to luminosity.

NOTE *Curves are maybe the most versatile of all the adjustment layers, as a Curves adjustment layer can do what many other adjustment layers can do—in one place. Generally, although many are similar, their interfaces are different and the decision to use one over another is mostly personal preference. So, even though color balance is not covered here, it is still a perfectly acceptable method of achieving a similar result.*

Curves can also change color through selecting the channel specifically (changing RGB to Red, Green, or Blue). As mentioned in "RGB vs. CMYK," colors have opposites. Therefore, the Red channel adds red and magenta (raising the Red channel adds red, lowering it adds cyan), the Green channel adds green or magenta, and the Blue channel adds blue or yellow. Each individual channel can add any of these tones to the black point, shadows, midtones, highlights, and white point (**Figure 7.38**).

TIP *A good starting place if you have trouble deciding on colors: use complementary colors or opposites (RGB/CMY). For example, blue to the black point and yellow to the white point.*

Selective Color adjustment layers (**Figure 7.39**) are another great way to adjust the color within an image. These can be used to color correct (making the colors as they appear to be in real life) or change the colors more drastically. Selective Color adjustment layers allow the user to go into each color (RGB, CMY, blacks, midtones, and whites) to adjust colors and brightness. Each adjustment works in opposite colors (just like curves), but they are listed as cyan, magenta, and yellow—as opposed to red, green, and blue with curves. A helpful approach can be to select the slider, concentrate on the image and slide it to both extremes of any given color. Once you believe that specific color is neutralized, move on to the next one, but do not be afraid to revisit a color that was previously adjusted.

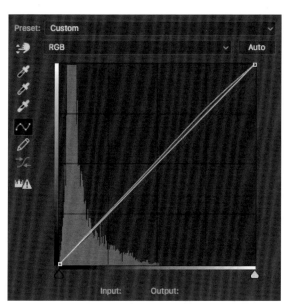

7.38 A minor Curves adjustment adding green, red, and yellow (negative blue).

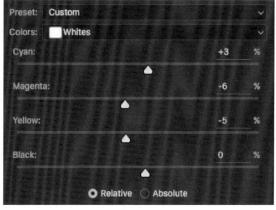

7.39 Selective Color adjustments allow tremendous control over the colors in an image. Here, the whites of an image add cyan, green (negative magenta), and blue (negative yellow).

Adjusting blacks, midtones, and whites is a great way to aggressively change the color of the image (as the adjustments can be quite strong). This is especially true when increasing the strength of the blacks as well as the whites. Adding white, however, can add a nice highlight to your image. Again, changing the blending mode of this layer to luminosity or color may be helpful here.

Luminance masks are slightly more involved and do not *directly* alter the color or tone of an image. Instead, they allow for the color or tone adjustment to affect certain *tones* of the image (i.e. shadows or highlights). Channel masks can do this as well, and a Red channel (**Figure 7.40**) is sometimes more effective, as it can separate skin tones from the rest of the image more successfully. Either way, the concept is mostly the same: bright tones or dark tones

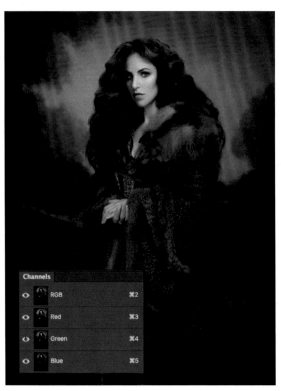

7.40 Channels can be viewed and selected in the Channels tab. This Red channel displays a bright face, slightly less bright sky, and relatively dark most everything else.

are selected. A channel mask makes the selection based on color, but a luminance mask bases its selection on tone. This difference gives it a slight edge, as sometimes we may want to add a color to the shadows or highlights evenly.

There are multiple ways to make a luminance mask. My preferred method is using Apply Image (**Figure 7.41**). Begin by creating the adjustment layer that will be used to add color to the image.

1. Select the mask of the adjustment layer that will target the highlights.

2. Go to Image > Apply Image and select the following:

 - Source: current file

 - Layer: Merged

 - Channel: RGB (this combines all color channels)

 - Invert: not checked

 - Blending: Multiply (the original mask must be a reveal all, white mask)

 - Opacity: 100%

 - Preserve Transparency and Mask: not checked

3. Press OK.

The new mask that has been created is a luminance mask that targets highlights. To view only the mask, Alt+Click (Windows) or Option+Click (Mac) on the mask thumbnail. Although this step is not required, it helps to visualize exactly what is being affected; the brighter the area, the more color is applied. To refine this mask, one option is to use levels (Ctrl+L (Windows) or Command+L (Mac)). This levels is not an adjustment layer. By changing contrast, one can change the mask to select more or less of the shadows or highlights (**Figure 7.42**). Simply clicking back on the layer's normal thumbnail will exit the mask preview.

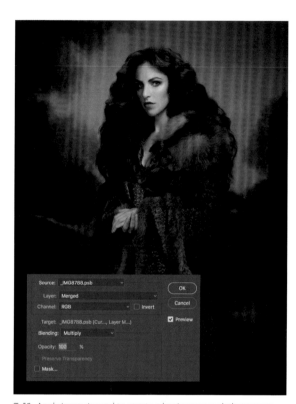

7.41 Apply Image is used to create a luminance mask that targets highlights.

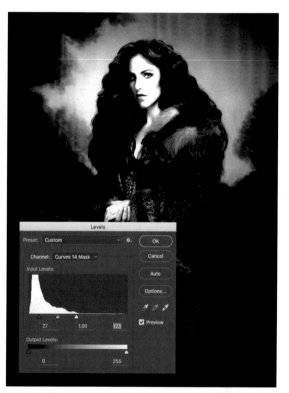

7.42 Use levels to affect the contrast of the luminance mask. By increasing the contrast of this mask, more highlights and fewer shadows are selected, allowing targeted adjustments to the tones of the image.

To select the shadows, the steps are nearly identical with one key difference. In this case, select the mask to target the shadows (**Figure 7.43**).

1. Go to Image > Apply Image and select the following:

 - Source: current file

 - Layer: Merged

 - Channel: RGB (this combines all color channels)

 - Invert: checked

 - Blending: Multiply (the original mask must be a reveal all, white mask)

 - Opacity: 100%

 - Preserve Transparency and Mask: not checked

2. Press OK.

7.43 Apply Image with Invert checked to target shadows.

View the mask using Alt+Click (Windows) or Option+Click (Mac) on the mask thumbnail. Use levels to fine-tune the adjustment (**Figure 7.44**).

The intensity of the colors, the specific color itself, the opacity, and the density can all be changed to refine the color added. Luminance masks can also be used to make part of the image brighter to darker (popping the highlights or darkening the shadows for example). For more information on this technique, check out my YouTube Channel (youtube.com/c/ChrisKnightPhoto).

In addition to what Photoshop has built into the software, there are some plugins that do a great job with color and tone. Some recommendations:

- Alien Skin Exposure X
- ALCE (Advanced Local Contrast Enhancer)
- Google Nik Collection

NOTE *Rarely do I use any preset or plugin at 100% opacity. Adjust any canned look to taste and don't be afraid to use it very subtly.*

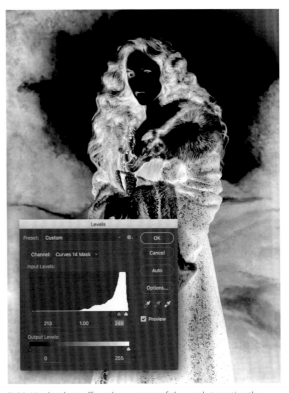

7.44 Use levels to affect the contrast of the mask, targeting the shadows more accurately.

FINAL STEPS

The image at this stage is basically complete. These final steps are more or less the "clear coat" and largely a matter of personal preference. These steps are sharpening, adding noise, and final adjustments for the web. There are many different variations of each of these steps—a couple of them are referenced here. What's most important here are the concepts rather than the exact chosen method.

First, the image is sharpened. Several methods require a stamped visible layer, so do not forget that step if needed. Some people prefer Smart Sharpen, and others prefer Unsharp Mask. When using them subtly, the differences are mostly negligible. Use whichever method is preferred, and avoid over-sharpening and the appearance or artifacts (**Figure 7.45**). If necessary, mask out the hair to remove the added fine detail, as it can be distracting.

Second, add noise. The noise is applied after the sharpen step, because sharpening noise can introduce artifacting and looks a bit artificial. This step is entirely a personal preference, but a small amount of fine noise adds a consistent finish across the whole image. If texture has been lost due to over-processing the skin, this can add some back. This is more noticeable in print than on the web, but the desired effect is to slightly reduce what can be considered the sterility of a digital image. That said, some people prefer a perfectly noiseless image, and this step is unnecessary. Programs like Alien Skin Exposure have a fantastic grain algorithm, but I apply noise to a 50% gray layer set to the overlay blending mode (**Figure 7.46**).

The noise varies in amount (5–15% depending on the image), but I recommend Gaussian and Monochromatic, as this makes the noise slightly larger and does not have added color.

7.45 An over-sharpened image. Digital artifacting is very noticeable.

7.46 Added 8% Noise, Gaussian, Monochromatic on a 50% gray layer set to the overlay blending mode.

Finally, the image is adjusted for the web. This process will be different, depending on the user (and the processing), but my rule of thumb is to slightly lower overall contrast and slightly darken the image (**Figure 7.47**). I find this is especially helpful when the image is low key, because many uncalibrated monitors arrive from the manufacturer with the contrast set too high. Slightly lowering the contrast means a low-key image that uses the entire spectrum of the histogram will not appear too dark.

7.47 A final Levels adjustment to make the image web ready. The overall contrast is lowered and the image is slightly brightened to compensate for the darker monitor.

WORKFLOW QUICK REFERENCE

1. Cull images
2. Develop selected images
3. Retouch
 - *Cleanup:* New blank layer, healing tool, spot healing tool, clone stamp. Make sure the tool is set to sample "Current & Below" or "All Layers."
 - *Skin:* Local Dodge and Burn, make the skin pretty.
 - *Global Dodge and Burn:* Shape and contour the image.
 - *Liquify:* Be sure to "stamp visible on a new layer," using the shortcut Ctrl+Alt+Shift+E (Windows) or Command+Option+Shift+E (Mac).
 - *Adjust Tone and Contrast:* This is a good place to use plugins if desired.
 - *Adjust Color*
 - *Final Steps:* Sharpen, noise, and web levels.

WRAP-UP

Remember, there is no one workflow that is right for everybody. The only real solution here is experimentation and trial and error. When new techniques come along, do not be afraid to replace the way things were previously done with something better. Post-production does not exist in a vacuum apart from all other skills you have. The more you pore over your images, the more you will develop as a photographer. You will see mistakes and things to adjust for the future. This process is an evolving one. Be open to change.

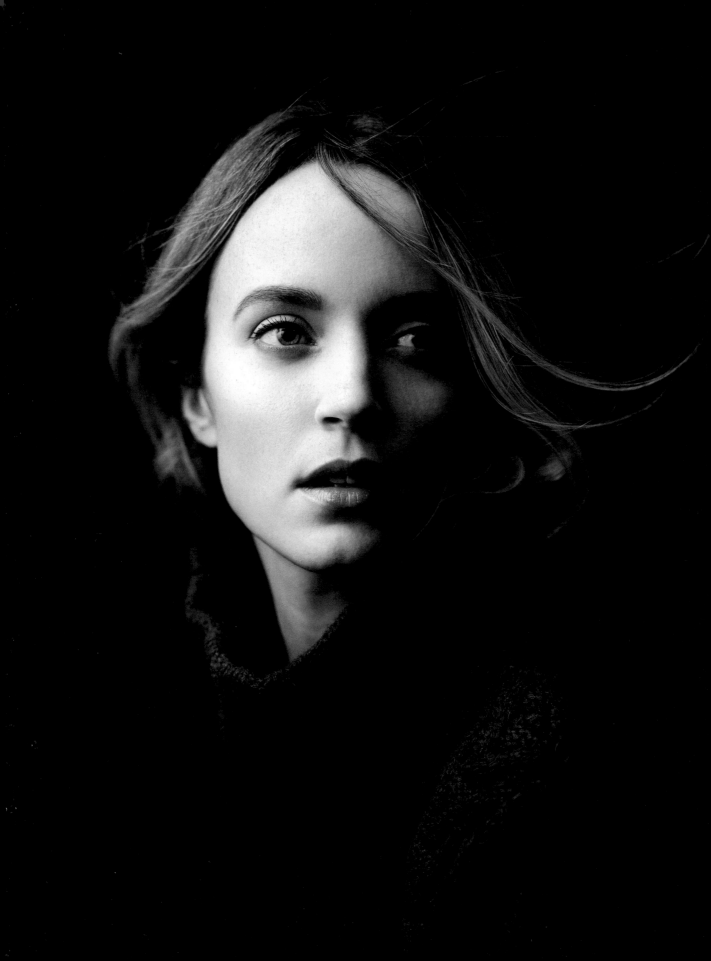

CHAPTER EIGHT
PERSONAL STYLE

YOU DO YOU

Technique can be taught. And many photographers exist on similar planes of skill level and technical knowledge. The main differences between them are their decision-making skills. These decisions are sometimes technical (Chapters 2 and 7), creative application of the technical (Chapter 4), stylistic (Chapter 6), or personal. Together they are what make up personal vision. Do not expect a full vision to show up in a puff of smoke at once—this is a lengthy and gradual process with missteps and wrong turns along the way. That's okay. The more work you create, the louder your personal voice becomes—eventually becoming so loud it is all you hear. The deafening loudness becomes your subconscious decisions. Just like endlessly hearing, "Sit up straight," from your mother except it actually works (sorry, Mom!).

DEVELOPING YOUR PERSONAL STYLE

Personal style means having something to say. In today's competitive market, competency is a dime a dozen. Having a personal vision that is threaded through an overall body of work is integral to standing out from the crowd. What do you want people to think that you bring to the table? Even if your capabilities expand far beyond your niche, your value is *your* experience and knowledge funneled through your particular voice to create whatever you create within a frame. Shoot what you love and you will fill your portfolio with work you are passionate about. This will allow you to create work that is better, stronger, and ultimately more fulfilling.

In this chapter, the plan comes together. Here we will focus on how to find and refine your voice and apply it to your overall body of work, examine how gear contributes to style (or doesn't), think about a narrative, and finally, review case studies where images are broken down into all of these components.

Shooting only what you think people want is a path of futility. Although sometimes it is necessary to make images to pay the bills, it is important to set aside time to create work that fulfills you creatively. The more work you create like this, the more you will find your own personal style. Shoot the work you want to get hired for. The caveat to this: sometimes the work you want to shoot is not work people will pay for. There is a balance, but creating unique, dynamic portraiture (no matter what that looks like) will lead to people hiring you for that work.

Do not feel the need to show everyone all your work. No one hits it out of the park 100 percent of the time. It's okay to try something and strike out—just don't parade it around.

When it comes to inspiration, recognize the difference between things you admire and things you want to create. I fawn over Sebastião Salgado, but recognize his work is nothing like mine. Self-awareness and introspection are key components in your quest to develop personal style.

Everything in this book so far has been meant to break down the visual process. The culmination of all these individual elements together is something the French call *mise-en-scène*, or "placing on stage." It describes the ways we tell visual stories. Think of it as setting the scene, but through visual poetry. Typically, this is a term used in cinema, but it is just as effective here when referring to creating visual narratives through photography.

How is a story told in one image? Doesn't working in a single frame make telling a narrative difficult? Remember, a picture is worth a thousand words. As cliché as that phrase may be, it is not wrong. Just like an effective film narrative, the narrative in an image does three things: establish a time and space, set a mood, and suggest what the character is feeling. Although this section is located at the end of the book, narrative is usually one of the earliest decisions in the creative process (and sometimes it is even done subconsciously). Sometimes it can be difficult to see the big picture without clearing the littler things out of the way first. That is why this chapter comes toward the end of the book.

Begin by asking yourself, what am I trying to say? This may not be an easy question to answer. It may take time and a lot of introspection to figure it out. Of course, it may also be quite easy. The journey to get there is different for everyone. But once you do, the clouds open up and everything becomes much clearer. This is the genesis of an image's purpose.

BUILDING A COHESIVE BODY OF WORK

Once the idea of giving an image visual cohesion sets in, the next stage is making multiple images feel like each other to create a body of work. Within a more finite chasm, visual cohesion is necessary when a set of similar images is meant to tell a single narrative—an editorial or photo essay for example—but what is being addressed here is an over-arching "feel" to the images in a portfolio. In the current market of photography, clients (especially higher-end clients) seek out a distinct voice more than general technical competency. They want to like what you do and then hire you to do it for them. This is not to say all photos should be lit and edited in the same way (certain similarities are not bad, but do not feel the need to pigeonhole yourself into a specific process), just that they should not appear jarring when seen next to each other.

I am of the belief that when I am looking at an overview of an artist's work, I should be able to gauge an overall feel for how they wish their work to be perceived. This feel (or narrative style) may be driven by their use of color, light, post-production, styling, or emotion. It may be one more than the others, or it may be many of these components working together. If your overall body of work does not convey your style to the viewer (without you being there to explain it), how can they know what they would hire you for, or what they could expect from the images you would create for them?

Explore the work of artists like Ellen von Unwerth, Mario Testino, Irving Penn, Peter Lindbergh, Tim Walker, David LaChapelle, Dan Winters, Eugenio Recuenco, and Gregory Crewdson. Each of these photographers has a visually cohesive body of work that is almost instantly recognizable.

A lighting style is not about repeating the same one or two lighting setups—it is about having an overall idea about what the light is meant to feel like. Lights can be configured in a wide variety of ways to achieve relatively similar outcomes. The details change, but the big picture is the vision in your head. Think about the ways you might describe your favorite artists. You probably have a clear idea about what those things are. Now, think about your own work. Can you describe your own work in a few words? Do those words thread through your overall portfolio? Now, think of the way you want others to view your work. That is the long-term and often perpetually just-out-of-reach goal. Know how you want your work to be—all you need is to shoot enough until it gets there.

GEAR DOES NOT MATTER (BUT IT KIND OF DOES)

Photographers can be notorious gearheads. I am no exception. There are valid arguments on both sides about just how important equipment is. Here is the truth: gear does not matter, but it does. The abridged version of this discussion mentions that a knowledgeable photographer can create with practically any tool. Here's the catch: with enough knowledge (and practice), you recognize the tools that help you to most effectively communicate your idea. Gear does not make an image better in the same way that complexity (or length of time invested) *automatically* makes an image better. Just because someone buys a scalpel, that does not make that person a qualified surgeon. I wrote in Chapter 2, "Light is light." It doesn't matter what it is created with. This is true, but certain *kinds* of lighting gear can make the job easier, allow for more creatively, or just make the images look more consistent.

Cameras are another area that receive probably more attention than necessary. Although not the case for every photographer, for many setting out to purchase a camera for the first time, there is a wide range of cameras that would be perfectly fine. Once a system is selected, it is often easier to stay within the ecosystem as more lenses or gear is added—but remember, there are great photographers shooting will all kinds of cameras. Some are better for certain jobs than others, obviously, but most will do the trick. To put it into perspective, if someone learned on a camera 10–20 years ago (or more), whether it was film or digital, he or she would be blown away by what most cameras created in the last five years are now capable of doing.

GEAR HANG-UPS

Hang-ups about gear are usually the result of one or two causes: overcompensation and overlearning. Sometimes, when our *creativity* is small, we can overcompensate technically, getting lost in the details and forgetting that the images may not have much substance. Most people do not look at an image and marvel at how many lights were required to make it; they only care if it is "good." Second, overlearning can get in the way. Oscar Wilde said, "You can never be overdressed or overeducated." While that may be good advice (and typically untrue on airplanes), sometimes learning too much, without actually *doing*, can be problematic. As important as learning is, the principles must be applied and practiced for it to be truly understood. This same mentality holds true for gearheads. We spend too much time fussing over minute technical differences when we should be out there pushing our gear to the limits.

WHY GEAR MATTERS

Now that we have discussed the ways in which gear doesn't matter, let us consider some examples when it might. Throughout the development process, there will be key gear acquisitions that dramatically propel your work forward. The result of this is twofold. First, in the learning stages, developmental jumps are exponentially larger and more noticeable, so any significant addition to the way you work can have obvious consequences—gear is no exception. Second, sometimes there are certain kinds of tools that create something unique or allow you to work in a new, creative way.

For example, the battery-powered strobe today is very different from those of only a few years ago. I am an avid user of the Profoto B1 and B2 lights. Both have similar capabilities—one is more powerful and the other is lighter and more portable. These systems were revolutionary for many photographers shooting on location or just not wanting to deal with too many wires. Previously, most outdoor lighting options were incredibly expensive (and often cumbersome) or small and not particularly powerful. Profoto's system works within their ecosystem of lighting modifiers and has the added benefit of High Speed Sync and TTL modes. Having a solid, practical, portable option that plays nice with a great existing system allows for the gear to get in the way less, so I can focus on creating more.

Another example is camera choice. Most cameras are just fine for many photographers. For some, there are other needs that actually help improve the work. As a photographer using mostly dark tones, I need a camera that can capture as much shadow detail as possible and that offers significant elasticity of files for post-production. The Pentax 645Z is my camera of choice—the medium-format sensor captures a beautiful shadow range and can be *reasonably* manipulated from four to five stops in post (depending upon the starting point of the ISO). I make large prints and a 51MP sensor is more than enough. This is not a camera to shoot sporting events (medium-format cameras are significantly slower than 35mm DSLRs), but since I shoot at a slower pace it is the right camera for me.

These are only two examples of gear that help my work. You may find similar examples with lighting modifiers and computer equipment. (I find it is nearly impossible to retouch without a Wacom tablet.) The point is this: don't get needlessly wrapped up in the gear. You can still create without the best of the best. But know that shooting with the best can sometimes help you create—it just takes knowing what's out there (and using as much as possible) to get there.

THE NARRATIVE OF THE IMAGE

We have talked about the "big picture" of one's career and style. Now we move to the "big picture" of the image. By another name, the narrative is storytelling—but it does not necessarily mean a *literal* creation of a story. It is about strength of purpose, and in some instances, the purpose may be purely visual (a dramatic, graphic use of color and texture for example), but it could be emotional or character driven. All of these things drive the narrative to be more than the face value of the image. When the idea of what is happening in the photo extends in the mind's eye, far beyond the image itself, the image becomes stronger, more compelling and, hopefully, lasting.

Consider the idea of the "decisive moment," the defining greatness of photographer Henri Cartier-Bresson. He wrote, "...photography is the simultaneous recognition, in a fraction of a second, of the significance of an event...which give[s] that event its proper expression." Photography is the frozen, split-second revelation that shows a greater truth about the subject. In portraiture—whether it's specific to the individual or the individual's character—the decisive moment augments them beyond the frame and the confined space within it, compelling the viewer to build the story of the subject in their own mind. This is the power of suggestion at its most effective.

So what is the story? More succinctly, why take the picture? That depends on you and where you are coming from creatively. For me, I love art history and painting; both inspire me more than anything else. My love and

knowledge of that is channeled into the way I tell a story. My most successful portraits often have the greatest amount of planning. Starting by developing the character with the subject, wardrobe is selected based off the type of character (a strong, bold personality may be portrayed as a queen). From there, hair and makeup inspiration is decided and the result is a collaboration with the artists on the day of the shoot. Backgrounds and lighting help to facilitate the idea—when creating a portrait of a queen that looks like a dramatic painting, the light should be obvious and mostly singular—but often choices must be made to accentuate details like wardrobe and hair. Having set the scene (placed the stage), the subject can be posed "regally" and "strongly."

During post-production, colors and tone can be manipulated to achieve the desired final product. This final step—if the actual shooting is well planned—is far less of an elephantine process than it may seem. The final image becomes something greater than the sum of its parts. Your purpose may be driven by the subject, the goals of the client, and the inspiration that drives you. The visual pieces together tell the story. The narrative does not need a "beginning, middle, and end," but it does need a purpose, which can be driven by you, a client, or both. This ultimately comes down to knowing your goals. Next we'll explore some examples where I clearly define my goals for the projects.

CASE STUDIES

Considering what has been covered throughout this book, we are now going to break down three images from concept to execution, including pre-production, styling, posing, lighting, and post-production. The core of each image is the goal or concept (the purpose of the shot). To strengthen that core, and the image's cohesion, many elements need to work together. For me, I find it helpful to go through a mental checklist of things like goals/concept, inspiration, color choices, etc., where I can think through the details of the shoot. This does not have to be a literal checklist (but it can be if that helps), and some of the decisions are even made subconsciously. Just breaking everything down can be a great exercise to make sure separate elements are working together to further the purpose.

PORTRAIT OF LINDA

Not every image needs a grand, highly thought-out concept. This can be true when creating a dramatic portrait focused more on the presence of that subject. Let's take a look at the motivations and goals behind the creative decisions made for a more subtle, yet dramatic portrait.

GOALS/CONCEPT In this image (**Figure 8.1**), the goal was to create a beautiful, compelling image of the model, Linda Holm, with dramatic light that felt soft and painterly.

INSPIRATION The inspiration for this image was drawn from the dramatic, studio lighting of Irving Penn and the mood, expression, and movement of Peter Lindbergh's work.

COLOR CHOICES The primary colors in the image exist in a muted, desaturated palette. No color is meant to appear significantly stronger than the rest, and consistent levels of saturation reinforce this. The prevailing colors are green (the sweater), yellow and beige (hair and skin), and red (the lips).

The yellow-to-green hues create a mostly analogous scheme to the image. The red is a subtle complement to the green (note that the subtle red does not overpower the rest of the image). This combination of colors creates visual interest as well as balance (green's emotional response is balance). In addition, there is a minor warm tone to the whole image (helping with color cohesion).

WARDROBE A textured turtleneck from an inexpensive, dual-lettered clothing store adds texture and color to an otherwise soft and muted scene. The tone is dark, so it blends into the background, but has enough separation via its color and texture to make the image more three-dimensional and help with the figure and background separation.

BACKGROUND The backdrop is a hand-painted canvas from Oliphant Studios in New York. The subtle, gray texture is difficult to see, but painted canvas absorbs and reflects light in a unique way, which gives the background more depth, because it is not flat and even. The neutral color does not detract from other colors in the image.

HAIR AND MAKEUP The hair and makeup artist created a natural makeup look with copper and earthy tones around the eyes. Red was added to the lips, but not a bold enough color to overpower the rest of the makeup. Most of the hair was tucked into the back of the turtleneck, but pieces were strategically removed to catch the wind created by a fan.

LIGHTING The image was lit with a Large Profoto Deep White Umbrella with diffuser. The single-light source illuminates the subject in broad Rembrandt light but was very close to the subject, feathering the light on her and casting light on the background for separation.

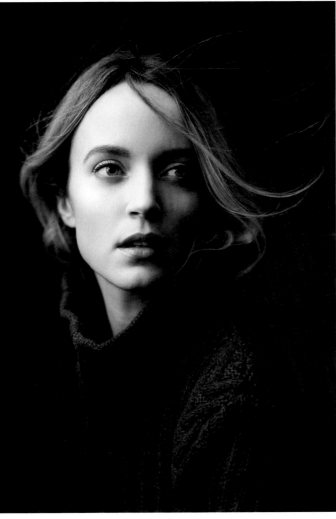

GEAR LIST

- **Camera**: Pentax 645Z with a 90mm lens
- **Lighting**: One Profoto B1
- **Modifier**: Large Profoto Deep White Umbrella (51") with a diffuser

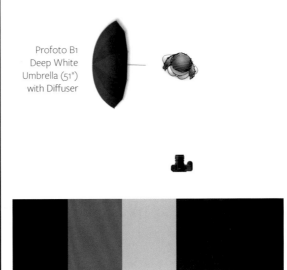

Profoto B1
Deep White
Umbrella (51")
with Diffuser

8.1 ISO 100, f/2.8, 1/125th sec.

TEXTURES The two prevailing textures are the sweater and hair. Both create a visual tension in what would be an otherwise smooth image. The light on the skin is soft (retouching contributes to this) and the background is too out-of-focus to show its texture. The edge of the subject is soft because of a wide aperture, helping to create a "painterly edge" (see Chapter 6, Figure 6.3).

POSING Linda is turned away from camera with her body toward the light, so the light can pick up more detail on the sweater (for separation). Her face is turned the opposite—away from the body—in the direction the wind is blowing her hair, creating a more dynamic pose and gesture.

CAMERA AND LENS Shot on the Pentax 645Z with a 90mm lens (71mm equivalent in a 35mm format), to capture enough low-key information.

The focal length of this lens, at this distance, creates no noticeable distortion to the subject.

DEPTH OF FIELD An aperture of f/2.8 created an extremely narrow depth of field, giving a softness to the overall image and helping to place focus directly on the face.

CAMERA ANGLE A slight up angle of the camera emboldens the subject to look out and beyond the frame. Looking off (a passive gesture) from a higher camera angle would make the subject appear weaker.

FRAMING Her body and frame are positioned to the center of the image, but the lean forward creates a strong diagonal line to add more dynamism to the composition.

EXPRESSION She is looking out and away as if something has caught her attention, but we are left to surmise what it might be. The expression and eyes work in conjunction with the position of the body and the movement of the hair to imply something is happening just off frame, and we are seeing the subject's reaction to it.

POST-PRODUCTION An overall desaturation to the image helps the colors gel together. The post-production of this image is similar to the image in the Retouching section of Chapter 7. Most of the time spent on this image was retouching skin to achieve the smooth texture seen here, which contributes to the original goal of accentuating the subject's beauty and visually reinforcing the soft light.

A FIGHTER BY HIS TRADE

Having the desire to create a boxer character for quite a while, I had the opportunity to work with Greg Brown and knew he would be perfect. A character portrait does not have to be 100% real or 100% fantasy. Sometimes the result is an intertwining of the two.

GOALS/CONCEPT This image (**Figure 8.2**), although a character portrait, is an entirely unique character drawn solely from the appearance of the subject. The character was created first and the subject was then selected for the part. I wanted to create a forlorn boxer—an expressive, character portrait study.

INSPIRATION The feel of the image was to be reminiscent of a turn-of-the-century photograph with painterly light and an homage to the early pictorialist photographers of the 20th century like Alfred Stieglitz and Eva Watson-Schütze.

COLOR CHOICES Overall, the image exists in a sepia/brown tonal range. As photographs from the late 1800s and early 1900s commonly had this toning, I sought to recreate it through both styling and post-production. By using both methods, the colors feel more natural and less like a heavy Photoshop technique. The image effect is mostly monochromatic. The background, floor, and skin are brown and the shorts are a neutral black. The only opposing color comes from the red gloves (red projects strength, power, and action, and evokes the "fight or flight response"), but the dullness helps it blend into the other colors more successfully and perhaps suggest to the viewer that the red of the gloves is not meant to be menacing. This creates tension in the image and leads the viewer into a deeper narrative of the character.

WARDROBE The costume was put together from multiple costume rental houses to achieve a look approximate to the period. Greg used his own shoes.

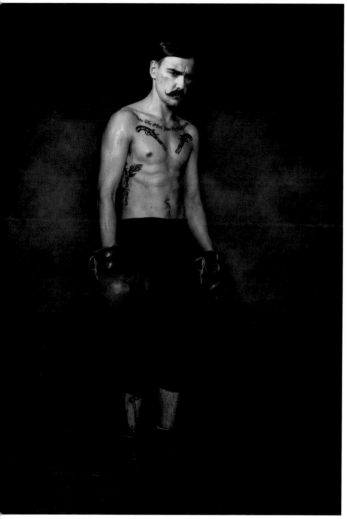

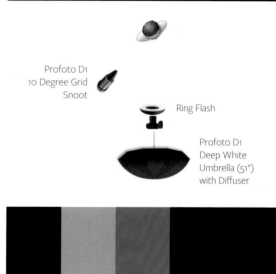

Profoto D1
10 Degree Grid
Snoot

Ring Flash

Profoto D1
Deep White
Umbrella (51")
with Diffuser

8.2 ISO 100, f/8, 1/125th sec.

BACKGROUND The background is a printed, wrinkle-free, polyester material with texture and a vignette. The floor is a printed neoprene, rubber mat meant to look like factory planks. Both are from Denny Manufacturing.

HAIR AND MAKEUP Greg's mustache (his usual styling, not specific to the shoot) and tattoos were excellent details for the character. His hair was slicked and parted and "dirt" was added to his face and body. Fake sweat (a mixture of glycerin and water) was sprayed vigorously to moisten him up.

LIGHTING The key light directly on the subject's face was shaped by a snoot with a 10-degree grid, which created a focused light that added just a touch more illumination to the face than the body. Behind camera, a Large Profoto Deep Umbrella with diffuser controlled overall fill and ensured enough information was visible in the shadows.

Attached to camera, a ring flash was used to accentuate the sweat, muscles, and leathery textures in the image. (For a more detailed explanation of the lighting, see Chapter 4.) The combination of this light created a low-key image with lots of detail in the shadows, and a specular accentuation on the shiny textures creates a feeling similar to a Dutch Golden Age painting.

TEXTURES Surviving photographs from this time are usually awash with texture. This is typically a result of the elements in the image (painted canvas backdrops were relatively common in photo studios and wardrobe was often beautifully embellished) and the wearing of time (scratches and age). Because of this, I wanted to incorporate as much texture as possible in the image.

The background itself has the appearance of a painted texture. The floors appear to be old, wooden planks. The long shorts/short pants (spants?) are ribbed—for no one's pleasure, I assure you. The leather of the boots and gloves is worn yet still has a subtle luster. His skin has added "dirt" but also the shine and texture of sweat. His hair and mustache are slick and shiny. All of this creates visual interest in an image that is mostly lower in dramatic contrast. The textures help draw the viewer's eye around the image and guide where to look.

POSING Greg is posed in an introspective slouch—not quite the power pose one might associate with a boxer. This may lead the viewer to correlate defeat, but it may also be construed as intense meditation and focus.

CAMERA AND LENS This was shot on a Pentax 645Z with a 55mm lens (43.5mm equivalent in a 35mm format). The camera captured significant shadow detail.

The studio space used was relatively small, so a wider angle lens was used. The lens created distortion, making the subject slightly elongated.

DEPTH OF FIELD An aperture of f/8 combined with a relatively wide lens created a wide depth of field and the image is entirely in focus.

CAMERA ANGLE Instead of a low, empowering camera angle, this image is shot from chest level. Although it does not make him appear small in the frame, a slightly higher angle does diminish the appearance of his stature, making him seem less imposing overall.

FRAMING The frame is wide, showing more of the environment, making him feel even smaller in context and projecting an emotional intent of loneliness in the image.

EXPRESSION I asked Greg to lose himself in thought. He looks sad, and the posture of his shoulders is contemplative. The narrative presented lets the viewer create the story: a pensive boxer stands—in spite of whatever is weighing him down on his shoulders—for a photograph. He chooses not to address the camera, instead staying isolated in his own thoughts. We consider what he might be thinking or where he had just been (or is going), creating the narrative in our own mind and extending the context of the image beyond what is directly in front of us.

POST-PRODUCTION The post-production on this closely resembles the image of the boxer in the Retouching section of Chapter 7. Other than some basic cleanup, the image was tweaked for contrast and a warm tone was applied—referencing the aesthetic of prints from the period. The brown tones evoke seriousness and the dulled reds blend into the overall tones, downplaying the otherwise obvious emotional implications of aggression in the image.

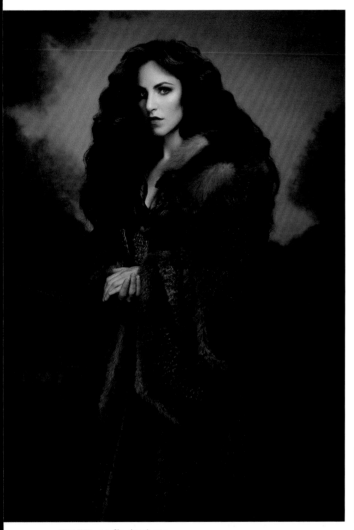

GEAR LIST

- **Camera**: Pentax 645Z with a 90mm lens
- **Lighting**: Four Profoto D1s
- **Modifiers**: Profoto Softlight Reflector (Beauty Dish) with a diffuser, XL Profoto Deep White Umbrella (65") with a diffuser, Profoto Softbox RFi 1x4', Softbox RFi 3x4'

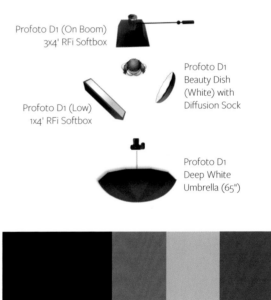

Profoto D1 (On Boom)
3x4' RFi Softbox

Profoto D1
Beauty Dish
(White) with
Diffusion Sock

Profoto D1 (Low)
1x4' RFi Softbox

Profoto D1
Deep White
Umbrella (65")

8.3 ISO 100, f/5, 1/125th sec.

QUEEN OF THE NORTH

The idea behind this image (**Figure 8.3**) was to create a character portrait developed from the subject's personality. Wardrobe, lighting, and color choice all work together to reinforce these concepts.

GOALS/CONCEPT In this character portrait, the subject, photographer Lindsay Adler, and I set out to develop a character based on an exaggerated version of her personality elements. The Queen of the North was a strong, regal, stoic character with a touch of the wild.

INSPIRATION The image was inspired by the monarchy portraits of Flemish painter Anthony van Dyck, but with a wardrobe stylistically similar to the medieval period (and a bit of *Game of Thrones*), creating a powerful figure with a slightly untamed side.

COLOR CHOICES A red wardrobe was selected as Lindsay uses red in her personal branding. The color represents strength and boldness, and it instantly attracts the viewer's eye. Careful consideration of the main color (red) was used to reinforce character traits (strength, action, regality, and power) and create visual interest. The wardrobe and background are complementary colors (the greens recede visually to the red). The remaining colors are mostly neutral—brown, gold, and beige (the sky, skin tone, hair, fur, and embellishments on the dress).

WARDROBE Wardrobe styling was incorporated to help make the subject appear more believable. The items were rented online from a Shakespearean costume shop. While sorting through wardrobe options, the piece shown was one of two chosen for the overall shoot. This was the more "wild" of the two, yet still felt like it would be worn by a medieval queen.

BACKGROUND As landscapes were commonly used behind the subject in portrait paintings, a complementary background was selected. To create visual contrast and help with separation, a lush, green landscape was chosen from Broderson Backdrops in New York. The hand-painted backdrop provided beautiful depth to the scene and helped ground the subject in "place."

HAIR AND MAKEUP The hair and makeup artist helped develop the makeup (a dramatic eye and a natural lip) and hair (lots of hair, so much hair), assisting Lindsay to evolve into character.

LIGHTING Lighting the subject was a Profoto Softlight Reflector (Beauty Dish) with a diffuser (pointed at the face). Behind the camera was an XL Profoto Deep White Umbrella with a diffuser, filling in the shadows and controlling the overall contrast. A small strip softbox (Profoto Softbox RFi 1x4') was camera left, which gave the sparkles on the dress a little pop of highlight. Overall, the lighting is rooted in natural realism, but the light on the face is just slightly more dramatic. A more obvious hair or rim light, for example, would potentially push the image into more of a cinematic sensibility (more modern) and make it feel less like a classical painting.

It was important to make the backdrop not feel flat and two-dimensional, so careful attention was paid to the lighting. If the subject were too close to the background, she would cast a shadow, killing the illusion of the background's depth. To prevent this, Lindsay was moved further from the background. A large hair light was incorporated high and behind the subject. The hair light, a Softbox RFi 3x4' on a boom arm above and behind the subject provided two outcomes. First, the subject had added separation from the background. Second, the sky of the painted backdrop appears to emit light—giving purpose to the hair light—and making the background feel more organic and lifelike.

TEXTURES The textures of the hair and dress offset the smoothness of her face, creating a visual distinction. The painterly texture of the backdrop is slightly visible, but the depth of field makes it subtler.

POSING The pose reinforces strength and regality. The standing position gave her an elongated shape and her hands were clasped in front in a classic pose seen in van Dyck's paintings.

CAMERA AND LENS This was shot on a Pentax 645Z with a 90mm lens (71mm equivalent in a 35mm format). The camera captured a high-resolution image with great detail and shadow rendition, especially useful for printing a large image.

The lens allowed for a slight distortion (making the subject appear taller when shot from below), but the effect remains mostly unnoticeable.

DEPTH OF FIELD An aperture of f/5 slightly softens the background and creates minor separation between it and the subject.

CAMERA ANGLE An upward camera angle empowers the subject.

FRAMING The subject was placed on two apple boxes—the dress was a bit long and the backdrop was a bit tall. I wanted to place her upper body in the open sky of the image for a strong figure and ground relationship. This made her stand out more in an image of otherwise similar shadow and midtones. Below the hands, separation was created through depth of field and complementary colors. Light green streaks through the "ground" add visual interest and break up an area with otherwise little detail.

EXPRESSION The subject is turned away from camera, yet her eyes make direct contact. She is not subtle in addressing the viewer, making her expression compelling and hard to look away from. In what could be an overwhelming dress, the expression and eye contact demand most of the image's attention and bring the focus where it needs to be—solidly with the subject.

POST-PRODUCTION Post-production adjustments helped accentuate colors and achieve cohesion overall. Minor elements were cleaned up. Color correction was used to neutralize the overall image and increase the vibrancy of the red in the dress. A slight green tone was applied to the shadows and a warm yellow-red tone was added to the highlights (this is most apparent in the skin and sky). See Chapter 7 (Figure 7.37) for a before and after of the color toning.

WRAP-UP

There is considerably more at work in a successful image than what may appear during a cursory glance. Over a longer period of time, a successful and cohesive body of work becomes even more vital to attain. The development of personal style is a thoroughly exciting period for any creative—when the value of understanding one's craft and technique opens up an infinite number of doors to a variety of creative paths. By analyzing our own work, we can dissect and home in on the elements we want to see in our work more (or things we wish to see less). We start to construct our own personal narrative and see the progressive change in our work going forward. The examples in this section had diverse goals, subject matter, styling, and lighting, but they achieve cohesion through emotion, tonality, color, and other visual choices. This is what visual style is—the ability to discern the photographer's voice through a variety of imagery.

When first starting out, a checklist may be helpful to think through as many elements of the shoot as possible—making sure to never lose focus on the narrative, story, and goals of the image. Not every element needs to play a dominant role in the image, but thinking through the details will help provide a more successful implementation of the visual tools available.

PERSONAL STYLE CHECKLIST

▪ Goals/Concept	▪ Background	▪ Posing	▪ Framing
▪ Inspiration	▪ Hair and Makeup	▪ Camera and Lens	▪ Expression
▪ Color Choices	▪ Lighting	▪ Depth of Field	▪ Post-Production
▪ Wardrobe	▪ Textures	▪ Camera Angle	

FINAL THOUGHTS

A conclusion in a book like this is a relativity arbitrary achievement, establishing a bookend that doesn't necessarily cap a particular story. Hopefully, this book does not present itself as an end goal, but as a chapter in the process of self-discovery. Learning starts at its own beginning and, if done correctly, doesn't end. Some say that it takes 10,000 hours to master something. Photography requires substantially longer. Each skill—lighting, styling, composition, and post-production—is deserving of that same dedication to mastery.

The goal for this book was to create something that would be applicable to someone at different moments along their path. For me, my favorite books are the ones I read early on in the process, learned a lot from, and then, upon revisiting them years later, learned new things all over again.

In the early stages of a photography career, many people tend to focus completely on techniques. Of course, they are important, which is why a large part of this book is dedicated to them. But techniques alone don't equate to lasting, memorable work with differentiation or impact. Techniques are the words and grammar of the visual language. This language you will use to develop the bigger narrative.

If you consider this entire book as a story, know that Chapter 8, "Personal Style," is the climax. Everything before is the lengthy process of learning the tools and the language—all of it meant to help you express whatever you mean to say. Drama can be the resource of your style, helping to ply the work you create and to make yourself heard. *Your* voice may be bold and purely visual or heavily entrenched in your own personal trials and tribulations. The key to unlocking this is creating work that is authentic to who you are. This is also the hardest step of the whole process. Do not be intimidated. Everyone starts somewhere.

Push yourself. Don't create mundane work. Shoot what is exciting to you. If the image is boring to you, then it will be boring to others. Be you and don't set out to copy. It can be a valuable way to learn, but you can't develop a personal style if you're too devoted to following someone else's. Work on *your* voice using all of the tools discussed here—history, lighting, styling, storytelling, and color. The confluence of all these elements makes the masters memorable. Go be memorable.

INDEX

A

Adams, Ansel, 43, 58
additive color system, 171–173
Adobe Camera Raw (ACR), 170
Adobe Lightroom, *see* Lightroom
Adobe Photoshop; *see* Photoshop
Adobe RGB, 168
Alberti, Leon Battista, 4
ambient light, mixing strobes with, 120, 125
analogous colors, 146
Ancient Egyptian period, 5
Annunciation (Michelangelo), 16
Apelles, 7
Aristotle, 3
Arnolfini Portrait, The (Jan van Eyck), 10
artists, notable
 Baroque period, from the, 28
 Dutch Golden Age, from the, 35
 Early Netherlandish period, from the, 10
 Greek period, from the, 7
 High Renaissance period, from the, 20
 Low Renaissance period, from the, 15
 Mannerist movement, from the, 26
 Medieval period, from the, 10
 Neoclassicism period, from the, 37
 photography, from mid-20th century on, 44
 photography, up to mid-20th century in, 42
 Renaissance in Europe, from the, 22
 Rococo period, from the, 36
 Roman period, from the, 8
 Romantic period, from the, 38
Avedon, Richard, 4, 56

B

backdrops, 156–159
background, 70–71, 72, 155–159
 contrast and, 156
 depth of field and, 155
 lighting and, 72, 156
banality, modern photography and, 44
barn doors, 90–91
Baroque period, 27–30
beauty dish, 89
bit depth, 169–170
black and white, 143
black, 142
Blacks slider (Lightroom), 180

blemishes, removing, 186–189
blue, 137
body of work, 212
Bosch, Hieronymous, 24
bounce modifiers, 95–98
brightness, 134, 174
broad light, 108–109
brolly box, 95
Broncolor Para 88, 95
brown, 140
Brueghel the Elder, Pieter, 24

C

calibration, 168–169
camera obscura, 16
Caravaggio, 27–28
Cartier-Bresson, Henri, 215
case studies, 216–223
 see also lighting setups
catchlight, 83, 106
checkerboarding, 121
Chevreul, Michel Eugène, 133
chiaroscuro, 16, 27
Clarity slider (Lightroom), 180
clipping, 58, 180
CMYK, 171
color
 adjustments in Photoshop, 200–204
 black and white and, 143
 components of, 134, 174
 emotion of, 134
 gamut, 167–168
 harmonies, 143–146
 profile, 167–168
 space, 167–168
 symbolism of, 134
 systems, 171–173
 see also individual colors
Codex Atlanticus (da Vinci), 16
color harmonies
 analogous, 146
 complementary, 144–145
 monochrome, 143
 triadic, 146
Color Picker, 174
color wheel, 133, 144
complementary colors, 144–145
components of color, 134, 174

contrapposto, 6

contrast, 53–54

 falloff and, 86–87

Contrast slider (Lightroom), 180

culling images, 182

Curves adjustment layer, 172–173, 191, 200–201

cyclorama, 156

D

da Messina, Antonello, 14

da Vinci, Leonardo, 15–18

Daguerre, Louis, 40

daguerreotype, 40

David (Michelangelo), 18

Death of the Virgin, The (Caravaggio), 28

decisive moment, 215

Della pittura (Leon Battista Alberti), 4

Develop module (Lightroom), 179–180

diffused light, 64

dimensionality, 53–54

direct light, 64

direction of light, 62–63

dodge and burn, 190–195

Donatello, 14

Dürer, Albrecht, 22

Dutch Golden Age, 30–35

E

Early Netherlandish period, 10

editing images, 182

Eggleston, William, 44

El Greco, 23

experimentation, importance of, 103

exporting for web, 181, 206

Exposure slider (Lightroom), 180

F

falloff, 61

 contrast and, 86–87

feathering light, 61, 121

Figure/Ground, 56–57

fill light, 72

flag, 93–94

focusing light, 88–92

Four Books on Human Proportion (Dürer), 22

French Renaissance, 25

G

gamut, color, 167–168

gear, 213–214

gels, 127

German Renaissance, 22

Gestalt Principle, 56

Ghiberti, Lorenzo, 14

Giotto, 13

Grand Tour, 38

gray, 142

Greek period, 6–7

green, 137

grids, 88–92

Gutenberg printing press, 12

H

hair and makeup, 160

Hals, Frans, 31

hard light, 59

harmonies, color, *see* color harmonies

hierarchy of genres, 4, 30

high-key imagery, 54–55, 178

Highlights slider (Lightroom), 180

histogram, 53, 176–178

history of portraiture, 1–45

 Ancient Egyptian period, 5

 artists in the, *see* artists, notable

 Baroque period, 27–30

 Dutch Golden Age, 30–35

 Early Netherlandish period, 10

 French Renaissance, 25

 German Renaissance, 22

 Greek period, 6–7

 hierarchy of genres, 4, 30

 High Renaissance, 15–21

 Idealism, 5–6

 Italian Renaissance, 11–21

 Low Renaissance, 12–15

 Mannerism, 25–26

 Medieval period, 9–10

 Middle Ages, 9–10

 Modernism (in photography), 42–44

 Neoclassicism, 37–38

 photography, 40–44

 Pictorialism (in photography), 42

 Renaissance in Belgium and the Netherlands, 24

 Rococo period, 35–36

Roman period, 7–9
Romanticism, 38
Spanish Renaissance, 23
Hockney-Falco thesis, 16
hotspot, 61
hue, 134, 174

I

Idealism, 5–6
intent, portraiture and, ix, 53, 115, 151, 215
inverse square law, 71, 86
Italian Renaissance, 11–21
High Renaissance, 15–21
Low Renaissance, 12–15

J

jpeg, 176
Judith Beheading Holofernes (Caravaggio), 28

K

key light, 72
Klosterman, Chuck, 11
kore, 6
kouros, 6
Kritios Boy (Kritios), 6
Kritios, 6

L

Library module (Lightroom), 182
light
ambient, 120, 125
background, 72
broad, 108–109
catchlight and, 83, 106
checkerboarding, 121
diffused, 64
direct, 64
direction of, 62–63
falloff of, 61, 86–87
feathering, 61, 121
fill, 72
flagging, 93–94
focusing, 88–92
hard, 59
hotspot and, 61
inverse square law and, 71, 86

key, 72
light meter and, 76
main, 72
modification of, 64–66
modifiers, 83–85, *see also* modifiers
negative fill and, 93, 122
patterns of, 103–106
position of, 68
qualities of, 59–63
ratios and, 76–80
reflected, 65
relativity and, *see* relativity
rim, 72
scrim and, 82
short, 108–109
size of, 67, 81
soft, 60
specular highlight and, 59, 83
vertical axis and, 110–114
window, 83, 106, 117
light meter, 76
lighting modifiers, *see* modifiers
lighting patterns, 103–106
relative position of light and, 107
lighting ratios, 76–80
lighting setups
one-light, 120–122
three-light, 126–129
two-light, 123–125
Lightroom, 170, 175–185
contrast and, 176–177
Develop module, 179–180
Library module, 182
raw file and, 175–185
sliders, 179–180
Liquify filter, 196–199
location shooting, 116, 156
loop lighting pattern, 105
low-key imagery, 54, 58, 178
luminance masks, 203–205
luminosity, 134, 174

M

main light, 72
Mannerism, 25–26
Medici family, 12, 139
Medieval period, 9–10
meter, light, 76

Michelangelo, 18–20
Middle Ages, 9–10
modification of light, 64–66
modifiers
 barn doors, 90–91
 beauty dish, 89
 bounce, 95–98
 brolly box, 95
 flags, 93–94
 grids, 88–92
 ring flash, 95, 98
 shape of, 83–85
 snoots, 90–92
 specialty, 95–98
Mona Lisa (da Vinci), 16–18
monitor
 brightness, 181
 calibration, 168–169
monochrome, 143
mood board, 160–161
multiple lights vs. single light, 117–119

N

narrative of the image, 215
negative fill, 93, 122
Neoclassicism, 37–38
Niépce, Nicéphore, 40
noise, adding, 205

O

octabox vs. stripbox, 83
one-light setups, 120–122
orange, 139–140

P

Paramount lighting pattern, 104, 107
patterns, lighting, 103–106
 relative position of light and, 107
perception, visual, 50–53
periods of the history of portraiture, see history of
 portraiture
personal style, 211, 223
photography, history of portraiture and, 40–44
 Modernism, 42–44
 Pictorialism, 42
Photoshop, 170–174, 186–206
 color and tonal adjustments, 200–204

Color Picker, 174
Curves adjustment layer, 172–173, 191, 200–201
 dodge and burn, 190–195
 Liquify filter, 196–199
 luminance masks, 203–205
 noise, adding, 205
 removing blemishes, 186–189
 rendering intent, 171
 retouching, 186–206
 sharpening, 205
Pietà (Michelangelo), 18
pink, 139
pixel, 170
plug-ins, 204
portfolio, 212
position of light, 68, 107–109
 vertical axis and, 110–114
post-production, 166–207
Prince, 139
print, developing for the, 181
profile, color, 167–168
ProPhoto RGB, 168
props, 162
purpose, portraiture and, ix, 53, 115, 151, 215

Q

qualities of light, 59–63

R

Raphael, 21
ratios, lighting, 76–80
raw file, 175–185
realism, 16
red, 135
reflected light, 65
relativity
 position of background, 70–71
 position of light and camera, 68–69, 107–109
 size of light and, 67
Rembrandt lighting pattern, 105
Rembrandt, 33–35, 83, 105, 162
removing blemishes, 186–189
Renaissance, see history of portraiture
rendering intent, 171
retouching, 186–204
RGB, 171
rim light, 72
ring flash, 95, 98

Rococo period, 35–36
Roman period, 7–9
Romanticism, 38
Rotalux Deep Inverse Octa, 61, 95–96
Rubens, Peter Paul, 29

S

Saint Matthew and the Angel (Caravaggio), 28
St. Jerome in the Wilderness (da Vinci), 16, 17
Saturation slider (Lightroom), 180
saturation, 134, 174
scrim, 82
Sekonic L-358 light meter, 76
setups, *see* lighting setups *and* case studies
sfregio, 28
sfumato, 16
shadow, 58
Shadows slider (Lightroom), 180
sharpening, 205
short light, 108–109
single light vs. multiple lights, 117–119
Sistine Chapel, 15, 18, 19
Sistine Madonna (Raphael), 21
size of light, 67, 81
snoots, 90–92
soft light, 60
space, color, 167–168
Spanish Renaissance, 23
specialty modifiers, 95–98
specular highlight, 59
 catchlight and, 83, 106
split lighting pattern, 106
sRGB, 168
Steichen, Edward, 44
Stieglitz, Alfred, 41
storytelling, 215
stripbox vs. octabox, 83
studio shooting, 116, 156
style, personal, 211, 223
styling checklist, 154
styling, 151
subtractive color system, 171–173
Szarkowski, John, 44

T

Talbot, Henry Fox, 40
talbotype, 40
Tenebrism, 27

textures, 160
The Garden of Earthly Delights (Bosch), 24
The Last Judgment (Michelangelo), 19–20
three-light setups, 126–129
tonal adjustments, 203–205
triadic colors, 146
two-light setups, 123–125

V

v-flat, 66
van Dyck, Anthony, 29
van Eyck, Jan, 10
van Rijn, Rembrandt, *see* Rembrandt
Velázquez, Diego Rodríguez de Silva y, 29
Vermeer, Johannes, 32–33, 56
vertical axis of light, 110–114
Vibrance slider (Lightroom), 180
View from the Window at Le Gras (Niépce), 40
vignettes, 118
violet, 139
vision, 211
visual perception, 50–53

W

Wacom tablet, 186
wardrobe, 152–154
web, exporting for, 181, 206
Weston, Edward, 43
White Balance slider (Lightroom), 179
white, 141
Whites slider (Lightroom), 180
window light, mimicking, 83, 106, 117
workflow
 case studies, 216–223
 post-production, 182–206

Y

yellow, 136

Z

Zone System (Ansel Adams), 58

Don't close the book on us yet!